My Mother's Cooking

By

Pina Patel

Simple Gujarati Cuisine

Gujarat

India is a very colorful country made up of many different states, languages, dialects, traditions, and flavorful foods.

Gujarat is located on the West Coast of India, near the Indian Ocean. Although located on the ocean, the city's diet is mainly vegetarian. There is an abundant amount of fresh fruits and vegetables, which are cultivated and shipped out all over India. The religion is comprised mainly of Hindus, Jains, and Parsis.

Gujarati food preparation is simple and tasty. Many people think that all Gujarati food is sweet. However, the truth is that it really depends on each individual family. My mother added sugar only to a few recipes, so you will see that most of my recipes also do not call for sugar. Gujarati food is infused with many different taste experiences. In one bite, you can taste sweet, salty, and spicy all at the same time.

A traditional Gujarati meal (thali) consists of two vegetables (shaak), a lentil (dal), kadhi, rotli, or poori, a chutney or raita, and a sweet item.

Some famous traditional Gujarati dishes are dhokra, khandvi, kadhi, basundi, puran poori, and more.

Gujarati vegetarian food is healthy if cooked with limited use of oil and spices. The cuisine is an assortment of green vegetables. The vegetarian diet includes yogurt, ghee (clarifi ed butt er), nuts, vegetables, and lenti ls rich in protein.

The recipes in this cookbook are perfect for the beginner cook and are great, whether you are a meat-eater or a vegetarian. You will find quick, simple staple recipes for everyday meals, as well as flavorful snacks.

The state of Gujarat and the country of India gave the world Mahatma Gandhi. Let us follow his advice: "Eat and live a simple life with higher thinking."

I hope you will enjoy my recipes that were taught to me by my mother and previous generations before her.

Pina

Dedication

I was inspired to write this cookbook by my family, my friends, and my children, and for the next generation of Gujarati vegetarian cooks.

I am dedicating this book to my beloved mother, Shantaben Patel, born 1926, from Ruva, Bharampur, Gujarati. She has been my teacher, inspiration, and "rock" in my life. She taught me the passion of eating healthy, being a great hostess, cooking well, and simple, easy, quick recipes.

I started cooking at a very young age, standing by the side of my mother. She was an awesome cook. I remember she was always in the kitchen, cooking in large batches for eight or more. It was a never-ending job for her, but she loved it!

My parents came to America in the early '50s, and yes, I am a product of immigrant parents. My father arrived in 1952 on a ship and landed in New York Harbor, where he encountered a lot of problems in a new country. My mother and I arrived in 1957. I was five years old, did not speak English, and had never seen a city. I learned quickly. I loved to cook from a very young age. The first non-Indian food that I learned to make was pizza and pasta with a vegetarian sauce.

I am the eldest of six children, so helping my mother was the most important thing to her. I was raised on food and cooking, at my mother's side, telling me to do this and do that and do it this way. I was taught to cook without measuring, just by looking, feeling, and tasting, just like your mother does. This is a special art, to get the dishes to taste the same all the time; it's called "cooking by aashre" (eyeballing). These are great memories! My sisters and I had to take turns doing the cooking, washing up before and after meals, and other chores.

At that time spices and flours were not easily available in all supermarkets. We used to travel to Yuba City, California, to buy them. We made outings out of it with everyone packed in the car.

I am inspired by the young girls in the community today that want to cook but do not like being in the kitchen for hours at a time. The young girls are losing the art of making Gujarati food, or getting confused with what "Gujarati food" is versus "North Indian," "South Indian," etc. It is hard to know, especially when you grow up in America or anywhere outside of India. We mix with so many different cultures that we forget and lose touch with our original heritage.

Things are easily available now in Indian grocery stores and local supermarkets. Vegetables are available in frozen sections but fresh is always the best way to go.

I have tried to make the recipes as simple as possible, with pictures to see what they look like. The ingredients used are fresh, and measured to the best of my ability to make it easier for you. I hope you will enjoy making these dishes as much as I enjoyed putting them together for you.

Eat fresh, stay healthy! Let's get started!

Helpful Hints

IS COOKING AN ART?

Some people think it is and others do not. Some think that it is easy and you can learn it in a few days. Yes, anyone can cook, but it's also about the taste and appearance of the food. I think cooking is an art that can take time to perfect. Once you've mastered the basic cooking methods, it will be easier to cook, and you will learn to pair different ingredients together to get the taste that you really like for you and your family.

To cook faster, learn to clean, cut, and organize spices. Invest in an Indian masala box, and keep your refrigerator organized so it is easy when you come home from a very hecti c workday to pull items out quickly.

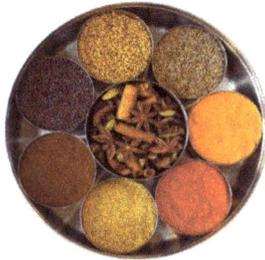

Pick a special time or day to make 2 or 3 different vegetables: half-cook them and store them in the refrigerator for later use. Make extra cooked rice, khadi (that is not cooked), or dal; heat only what you are going to consume.

Prepared food should not be more than 4 days old, even if you store it in the refrigerator. It is healthier to eat fresh food; the best is when you cook and eat it the same day. Remember, nutritional value is lost every day.

UTENSILS

Have a set of different-sized pots from 1 quart to 6 quarts for a family of 4.

- A good steamer is always great to have.
- Find mixing bowls that are not too heavy in weight.
- Cooking spoons, a turner, a good hand blender, and a grater are musts.
- Have two sizes of colanders to wash your fruits and vegetables.
- A rice cooker makes it simple to get perfect rice every time.
- Have a set of accurate measuring cups and spoons.
- Have a set of nonstick frying pans, small, medium and large, with lids.
- Have a small, deep wok, 8 to 10 inches wide.
- Invest in a good blender, food processor, or mixer.

Keep your pots clean; use a good pot cleaner to get the burn and grease off of them.

Clean pots make a difference in the taste of food.

PREPPING

Learn to cut vegetables that are the same shape and size. This helps them cook more evenly.

Try to find faster ways of cutting your vegetables, like investing in a good-quality set of knifes that are very sharp and where the handles are easy on your hands.

STORING AND BUYING

Learn to store your vegetables so they stay fresher longer. Remove them from plastic bags and wrap them in paper towels to help absorb moisture.

Garlic, onions, and any types of potatoes are to be stored in a cool, dry place in your pantry or on your counter in a basket and not in plastic bags. Mushrooms do best when stored in brown paper bags in the refrigerator.

When buying vegetables, make sure they are the freshest. Go to your local farmers market to get the best. Buy in small quantities or just what you need for a few days.

SAUTÉING

Sautéing is what is done at the first stage. Vegetables are added to hot oil or ghee (clarified butter), mixed quickly to coat them with oil, and then cooked at a low heat.

FOLDING

This is the term used for gently combining one mixture into another one without disturbing the batter too much.

VAGHAR/TEMPERING

This is the process of heating oil and adding spices to it, followed by the rest of the ingredients.

Contents

Spices
Let's Fall in Love With Them! Pump Up the Flavor!

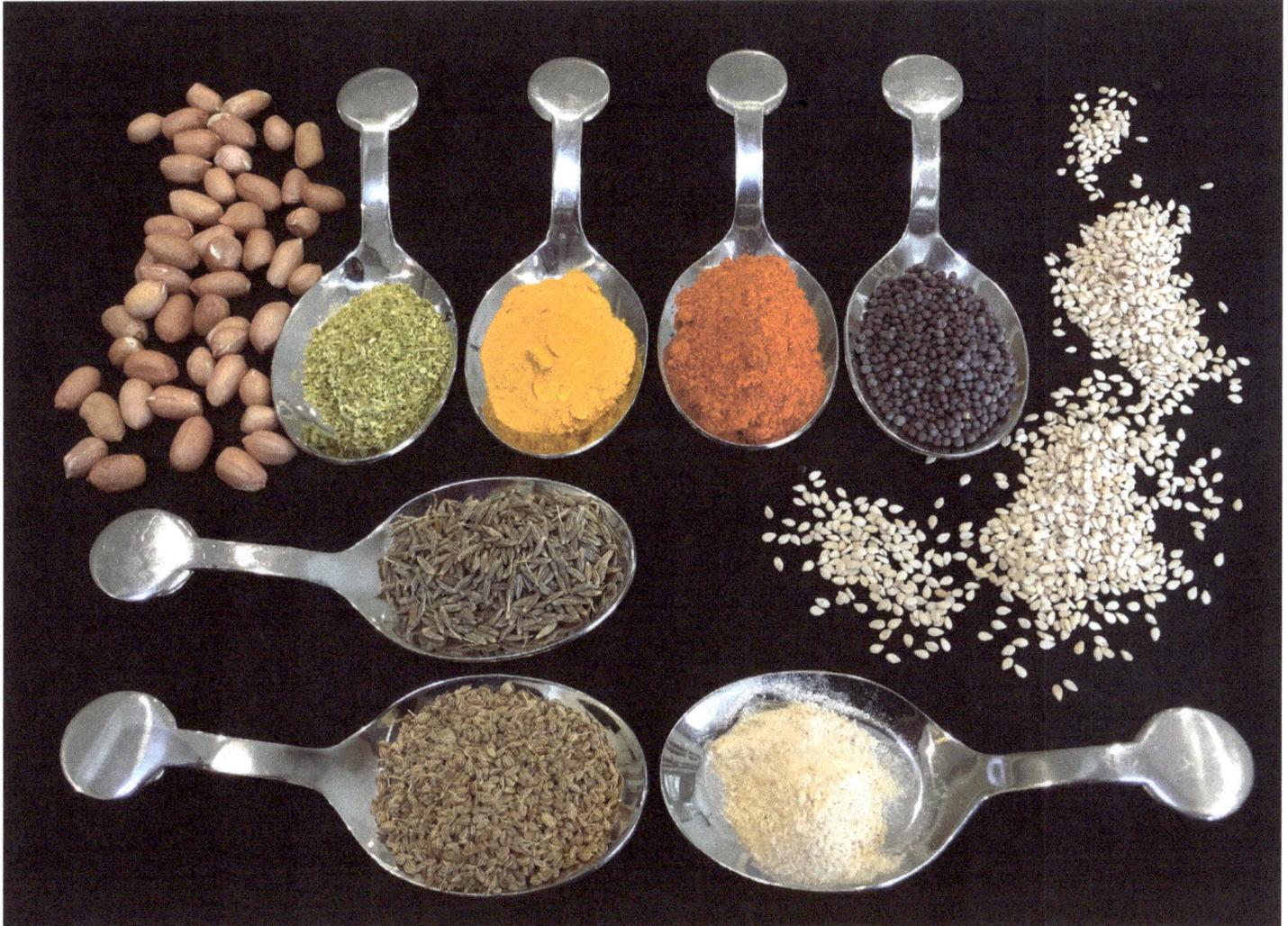

Blending spices is an art that can bring the food to life, depending on the type of spice. Just adding a little spice to your recipes can literally transform the taste of food, and gives you the great feeling of spicy satisfaction.

First of all, let's start with the word "curry." Curry is not a spice; it is a blend of different spices added to food. The word "curry" was invented by the British colonialists in the 18th century because they could not pronounce the real words.

How to Care For Spices

If possible, buy whole spices and grind your own as you need them. The flavor will be more potent. Purchase an inexpensive coffee grinder and keep it strictly for grinding spices. Clean the grinder after every use because of the strong aroma.

Light, moisture, and heat are the worst enemies of spices, so keep them in a tightly sealed container in a cool, dark place. You should not store your spices near your stove or in open racks on the counter.

Spices
Description (Names in English and Gujarati)

Coriander - Sukha Dhana. Whole or Powder

Mostly used in a crushed powder form in recipes, coriander has a strong lemony nutty warm, orange-flavor scent. The dry fruits are known as whole coriander seeds which come from the green cilantro plant.

Red Chili Powder - Lal Marcha, Hot, Whole or Powder

It is used as a spice to add heat to a dish. The heat from the chili's can range from very very hot to mild.

Cumin - Jeeru. Whole or Powder

Pale green oval seeds from the parsley family. It is slightly bitter with a strong aroma. Warm and powerful. It gives all your food a great taste. There is also black cumin which is milder and sweeter.

Turmeric Powder - Hurdar

Warm, slightly bitter. Similar to ginger root but not spicy. Adds a distinctive yellow color to Indian dishes.

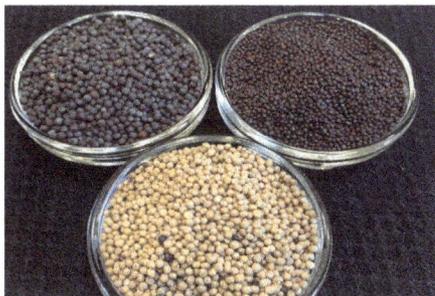

Mustard Seeds - Rai

There are different kinds of mustard seeds-white, large red or small red. They are hot and spicy if eaten raw. Mustard seeds do not have an aroma when dry, but when mixed with water it releases a hot, pungent aroma.

Yellow mustard seeds less pungent and more mellow in flavor. This is the mustard that is commonly called yellow mustard as the seeds are more yellow than white.

Black mustard seeds are very strong and have a distinctive flavor use often in Indian cooking.

Small mustard seeds are also used in cooking or as a garnish for certain dishes (ex. Dhokla).

Fenugreek - Methi

Very bitter, pungent, strong; use sparsely.

Carom - thymol seeds - Ajmo/Ajwain

Has a strong taste like celery seeds if eaten raw. Once sautéed in oil, it gets milder, but the flavor comes out when it marinates in the food. Use sparsely.

Asafetida - Hing

Hing is known for its intense and unpleasant flavor when raw. When added in small quantities to cooking, this spice adds a distinctive flavor to your food. It also helps digestion. Hing is a spice used when tempering & vaghar. This spice is optional for you to use in my recipes. It will leave a lingering aroma in your home.

Other items to have are cooking oils like corn, peanut, sunflower oils, (not olive oil), raw peanuts, sesame seeds, black pepper, baking powder, salt, sugar, Gol-Jaggery (Indian raw brown sugar).

Spices
Description (Names in English and Gujarati)
Advanced Spices to Have on Hand

Cinnamon - Taj

Not too spicy; with a subtle fragrance.

Cinnamon sticks are made from long pieces of tree bark that are rolled, pressed, and dried. It is slightly bittersweet and hot at the same time. It has a wonderful and powerful aroma.

Cardamon - Elaichi. Green Whole or Seeds

Citrusy and bitter, strong taste, great aroma, Ground seed of the ginger family. The seeds are between ¼ and 1-inch long. Comes in regular (greenish white) and black varieties. Greenish white is preferred with a smoother taste. Has an intense, sweet flavor and a pungent aroma.

Cloves - Lavang

Very powerful and warm. Can be bitter and hot tasting if used in large quantities. Brown dried flower buds of an evergreen tree in the myrtle family. It is strongly pungent and bittersweet.

Saffron - Kesar

Rich but subtle. Perfumed and honey like; will add color and flavor to your food. Mostly used in rice recipes or desserts. The worlds most expensive spice. Use a few strands at a time.

Nutmeg - Jaifal
Strong, warm, nutty with a sweet flavor

Fresh Items to Have on Hand

Ginger - Aadu Fresh
Lemony, slightly hot, used in most Asian cooking Often dried and ground (suth) or "crystallized" with sugar. It can be bitter while also sweet, warm, and somewhat woody.

Serrano Chili's - Lila Murcha
There are many different varieties of chili's.

The recipes in this book calls for using either serranos or thai chilis. Both are hot, spicy and packed with great flavor. You don't need to use many to spice up your food. Jalapeños are also spicy, but I don't recommend using them in these recipes. The spice level is often hard to judge and the skin has a bitter taste.

Garlic - Lasan
The root bulb is made of sections called cloves that are protected by a layer of thin skin and held together by additional layers of skin. Pungent, warm, aromatic, sweet and spicy at the same time. Whole cloves, minced, granulated and powdered forms are commonly used.

The Art of Vaghar - Tempering

What is vaghar, or tempering? It is a cooking technique used in the cuisines of India, Bangladesh, Pakistan, and Sri Lanka, in which whole spices (and sometimes other ingredients as well, such as dried chilis, minced ginger, garlic, etc.) are roasted briefly in oil or ghee to release essential oils and enhance their flavors, before being poured (together with the oil) into a dish. Tempering is also practiced by dry-roasting spices. Tempering is typically done at the beginning of cooking, before adding the other ingredients, or it may be added to a dish at the end of cooking, just before serving (as with Lentil, Gujarati Daar, Khadi, Dhokla etc). Vaghar brings rich spices and flavors to your dish

It is very important that your vaghar/tempering does not get overdone. This process should be done quickly; be careful not to burn the vaghar/tempering as this will change the flavor of your dish.

Tip: The mustard seeds will splatter slowly if you add them to cold oil. You should cover it partially, but only when the mustard seeds are popping, and do not cover completely. You do not want the steam to condense, or the water droplets will land in the oil and you might get burned. At fi rst the seeds will pop slowly, and then they will start popping fast all at once. When this happens, add your hing (also known as asafeti da), remove from heat, and pour over your vegetables or add them to it. Take care when adding vegetables to the vaghar. Practi ce a few ti mes and you will be a pro at it. Good luck!

Let's Talk Lentils - Beans

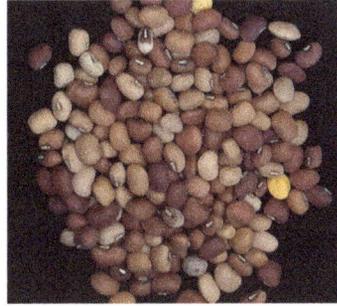

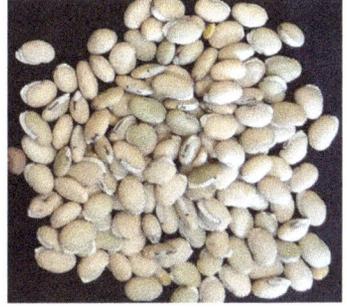

Lentil and beans are the world's oldest legume. Cultivated over centuries throughout the world, they are a staple food for all cultures.

Any kind of lentils, like dried beans, chana dal, lima beans, mung beans, or black-eyed peas, is a great source of protein, iron, minerals, and vitamins, with a lot of fiber and complex carbohydrates. If you're dieting, a cup of lentils will keep you full and satisfied for a long time.

Beans: An edible seed, typically kidney-shaped, growing in long pods on certain leguminous plants.

Cooking dried beans can be challenging as they usually need to be soaked for several hours. There are several options you have:

- Stovetop
- Slow Cooker
- Pressure Cooker

Lentils: A high protein pulse which is dried and then soaked and cooked prior to eating.

Lentils are easier and faster to cook than beans. They do not require a long soaking process as beans do. Adding spices and herbs to cooked lentils will transform them into a tasty dish or soup. Just adding a little coriander powder, salt, chili powder, and fresh cilantro and putting in some fresh tomatoes with some onions and a little ginger can get your taste buds going and your blood flowing. Do you want to learn how to make lentils? Then follow the recipes and experiment with different spices.

Lentils and beans come in different forms. I have explained with pictures how lentils and beans can look different. When a bean is whole it is called a kathor; when it is split it is called a dal or dar. Whole lentils & kathors are usually made in a dry form, whereas dal (split lentils) are wet with gravy.

Lentils can be cooked and added to salad or a rice dish, or used to make a soup base. Add fresh veggies to your lentils, sauté them with onions and tomato, spice them up, or add them to your pasta dish. Use your imagination on how to get your protein for the day.

Washing Beans - Lentils: Washing is a very important step to remove any debris from them. Wash them in the pot you are going to cook or soak them in. Add water and scrub them by rubbing them between the palms of your hands. The water will be milky white. Discard the water and repeat (about 4-5 times) until the water is clear.

So get to know your lentils. Each one tastes different; isn't that amazing?

Different Forms of Lentils

Kathol

Kathor means it is a whole bean cooked; if a lentil is split and cooked it is called a dal.

Mung beans - Mug

Mung beans are small green-colored beans that come in three different ways: whole, split with the skin, or split without the skin. The whole is used in sprouting as well as cooked. The split is used as a dal or mixed into a rice dish or used to make dessert. Mung has a sweet taste, is light, and is the easiest of all lentils to digest.

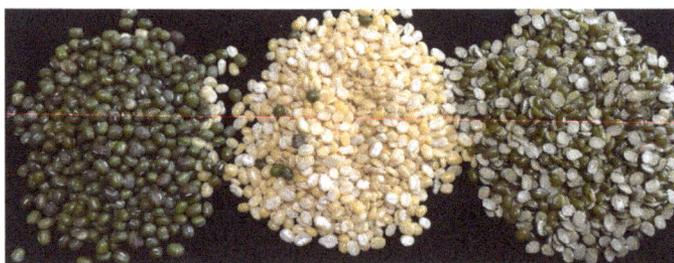

Pigeon pea - Tuvar

The pigeon pea or tuvar lentil is a staple in Gujarati cooking.

This lentil is a small beige bean, yellow inside when split. It is used to make Gujarati dal and comes oily or dry. Oil helps to preserve the dal, but it must be washed numerous times before cooking.

While the whole and split dal are the same lentil, the composition lends different tastes. Whole tuvar has a rich, heavy, nuttier taste, while the split dal has a sweet, light taste.

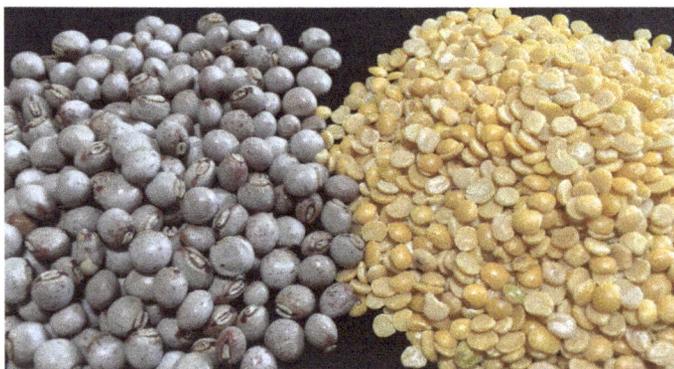

Black gram - Urad

Whole ones are small black beans. Split without skin they are white; split with skin they are black and white. Very high in protein; small portions will fill you up quickly. Urad flour is used to make papad (papadum).

Urad dal has an earthy flavor and heavy, sticky texture; it can be cooked alone or mixed with another lentil.

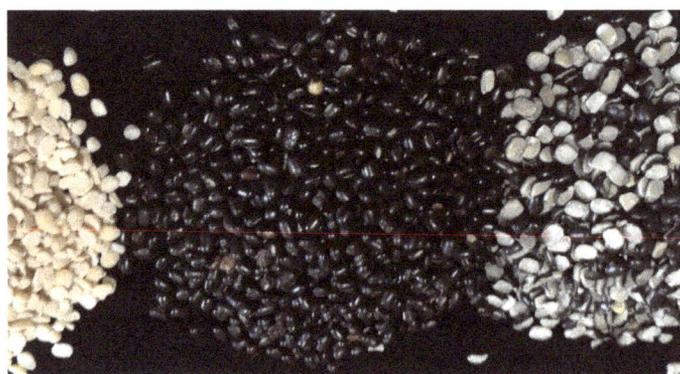

Garbanzo beans - Chana

The large chana beans are called kabuli chana; the small brown ones are called desi chana. Split they are yellow, called chana dal.

The whole desi chana needs a lot of soaking, while chana dal cooks very easily and quickly. Great to use as a soup base.

Chana are slightly nutty in taste. The brown ones are earthier in flavor and have a drier texture.

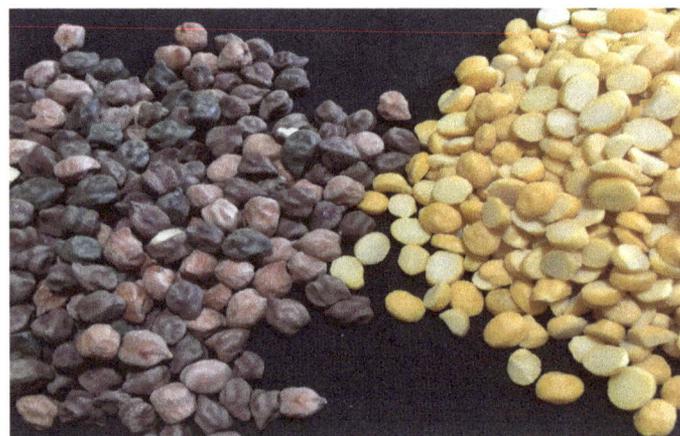

Hyacinth beans or butter beans - Vaal

Famous Gujarati tasty bean. The flavor of this bean is particular to Gujarati cooking and found mainly in this region. This bean is close to what Americans might know as a butter bean.

There are two kinds of vaal: sweet ones that are white or brown in color, and bitter ones with a greenish tint. The split ones are called vaal ni dal. Whole ones are called vaal.

The greenish beans have a strong and somewhat bitter taste; the white ones are less bitter in taste. Split ones come in both green and white. Whole vaals can be sprouted to make vaal ni dal.

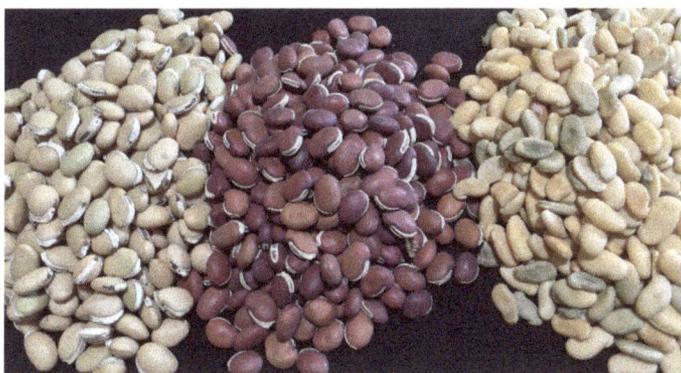

Red lentil - Masoor

Masoor is a brown-skinned lentil; split it is orange on the inside, with an earthy, pleasant flavor. Masoor dal is common in Northern India, is sweet in taste, and is used in soups and stews.

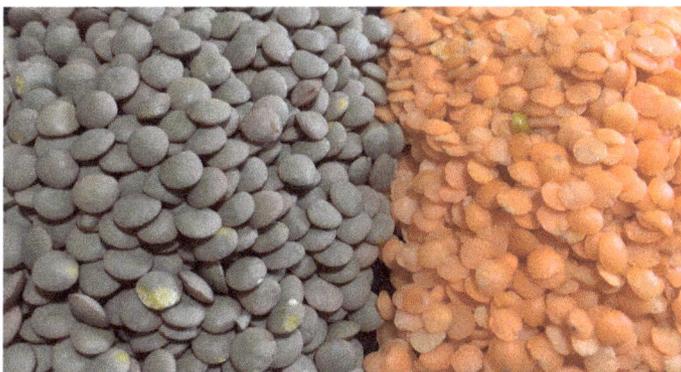

Muth

Looks like the mung bean but brown in color. Used whole or sprouted, is just delicious in taste, cooks easily.

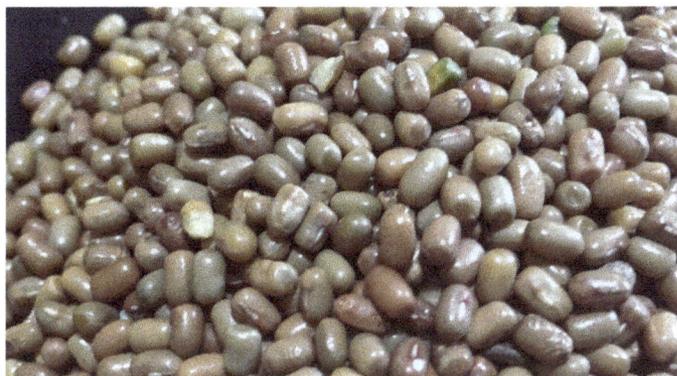

Adzuki - Choli

They look like mung beans, but brown in color. Cook whole or soak and sprout them. Cooks easily; the taste is nutty and sweet with a nice texture.

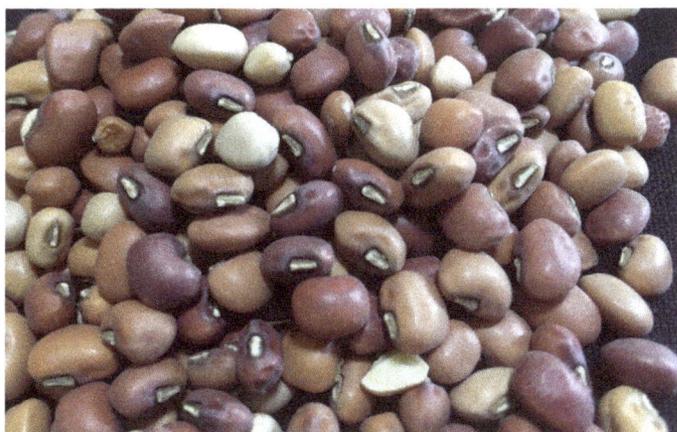

Healthy Grain Mix

This is a grain mix that is found in typical Gujarat homes. It is used to make the famous dhokla and handavas. It can also be added to other dishes, like muthiyas, to give a crispy texture.

For making bhakaro - handvo

Yield: 2½ cups

- 2 cups jasmine rice or long-grain rice
- ¼ cup chana dal
- ⅓ cup green with skin mug dal or whole mug
- ⅓ cup tuvar dal, oil free
- ⅓ cup of orange masoor dal
- ⅓ cup whole black-eyed peas

Mix and grind to a coarse meal (like a cornmeal) using a mixer, mill attachment, or a mill grain grinder.

Dhokla mix

(Same process as the bhakaro mix)

Yield: 3¼ cups

- 2 cups jasmine rice or long-grain rice
- 1¼ cup of chana dal
- ¼ cup urad dal (opti onal)

Store in an airtight glass jar until ready to use.

How to Make Homemade Yogurt (Dahi)

Homemade yogurt is very easy to make, tastes great, and costs you just pennies! Homemade yogurt tastes a lot better than store-bought and also has a lot fewer preservatives. Use this yogurt to make kadhi, chaas, and raitu. Eat your yogurt with fruit, oats, or flaxseed powder, sprinkle it with nuts, make smoothies; the ideas and recipes are endless. The first time you make it, you might feel it's a difficult process, but actually it is very easy. Once you have made your first batch, you will use your own homemade yogurt to start each batch after that. Please read the directions first before starting.

A big benefit of eating yogurt is that it is a digestive aid. Let the creamy stuff ease your tummy troubles. The probiotics (beneficial bacteria) in some yogurts balance the microflora in your stomach, which can aid with digestion as well as keep you regular.

If you are vegetarian, you should use buttermilk instead of store-bought yogurt to make your first homemade as many yogurts contain gelatin, which is made from animal bones. Always keep ¼ cup or more from your homemade yogurt to use as a starter for your next batch.

Cook and cool time: 1 hour

Setting time: 8–12 hours (depends on the weather)

INGREDIENTS TO START YOUR FIRST BATCH:

- ½ gallon of regular or 2% milk
- ¼ cup of store plain bought yogurt (plain; do not buy flavored yogurt) or use ½ cup regular buttermilk, (yogurt or buttermilk should be at room temp before adding to warm milk).

DIRECTIONS:

In a heavy pot, heat milk until it comes to a boil, stirring it constantly and making sure it doesn't burn or stick to the bottom or boil over.

Heat your oven to warm for about 10 minutes and turn it off; or, if you live in a very hot climate, you don't need to use your oven.

Take off heat and cool till cool to the touch. (To cool faster, you can put the milk pot in a larger container filled with cold water.) Do not cool in refrigerator.

Once it has cooled down, remove a ¼ cup of the milk and place it in a medium bowl. Add the yogurt or buttermilk and mix well.

Add the mixed milk and yogurt or buttermilk to the rest of the milk; mix or stir well.

Transfer the milk into small containers or one large one. Cover and set aside or in the warm oven for 6–8 hours. Do not disturb the container until the milk is set. If you live in a cold climate, it may take longer for the milk to turn to yogurt; leaving it overnight is the best way, or start early in the morning and let it sit all day.

The longer you leave the yogurt out, the more sour-tasting it will become.

After the yogurt is made, you can store it in the refrigerator for up to 7–10 days.

Use yogurt to make a sandwich spread or as a base for your salad dressing, or just enjoy it plain with your favorite fruit, nuts, etc.

Important: always save some yogurt from your batch to make your next yogurt.

Enjoy!

Ghee - How to Make Ghee
(Clarified Butter)

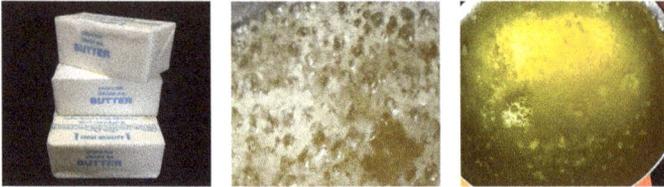

Ghee is clarified butter, butter that is melted with the milk solids removed. A healthier way of eating butter, ghee originated in India. Everyone eats ghee and uses it like butter, as a spread for toast and for cooking. Ghee has a very nice nutty taste. It is lactose friendly, doesn't spoil easily, and is rich in vitamin A, D, E, and K. It is also great for cooking because it can heat to a higher temperature than butter without burning. It can be used as a shortening in baking and cooking, and is a much healthier alternative to butter and margarine.

Once the ghee is done, it can be stored in a jar or poured into a small baking tray. Place it in the refrigerator for a few hours until it becomes solid, and cut into small 1x1-inch pieces to make it easier to use. I advise keeping it in the refrigerator for freshness and aroma. Do a layering method: one layer of ghee cubes, a layer of plastic wrap or wax paper, then another layer, and so on.

You can purchase ready-made ghee from an Indian or health-food store, but the one made at home is tastier, fresher, and lasts longer. Once you master the art of making ghee, you will find it easy to make, and you will not buy the store brand again!

Cook time: 30 minutes

YOU WILL NEED:

- 6- to 8-quart pot
- Fine strainer or cheesecloth

INGREDIENTS:

- 3–5 pounds salted or unsalted butter (your choice of brand)
- 2–3 tablespoons water or 2–3 ice cubes

DIRECTIONS:

Unwrap all the butter and add it to the pot; heat on high heat until it is all melted.

Lower heat and let it simmer, stirring occasionally; never leave it unattended. At first it will be cloudy-looking, then bubbling, and slowly it will become clear. The bubbles will become light; this will indicate that it is done. Make this at medium to low heat. It you think it is going to boil over, lower heat or remove it from stovetop and let it cool down, and then return to stove to finish the process.

Once it turns clear, drizzle water or add ice cubes slowly, a little at a time. It will sizzle (be very careful when doing this process). Let it simmer for about 1 minute, then remove from stove and set aside. You do not want to overcook the ghee; it will turn red and the taste will change. It should be light yellow in color. This process separates the fat from the butter.

Let it cool for about 5 minutes. Let the salt and fat contents settle to the bottom. Using a cheesecloth or fine strainer, slowly strain the clear ghee in your container. Only strain the clear butter; you do not want any of the fat solids to enter the clear ghee. This will spoil the ghee and its flavor.

Discard the fat. Store ghee as directed above.

Enjoy eating and cooking with ghee!

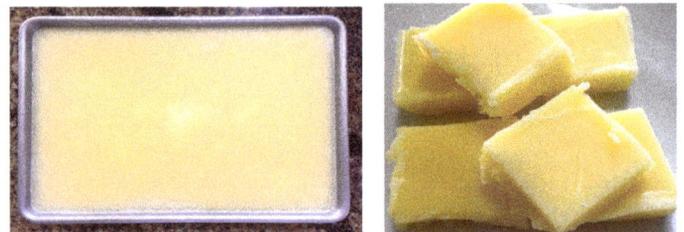

Breakfast

Baked Beans on Toast

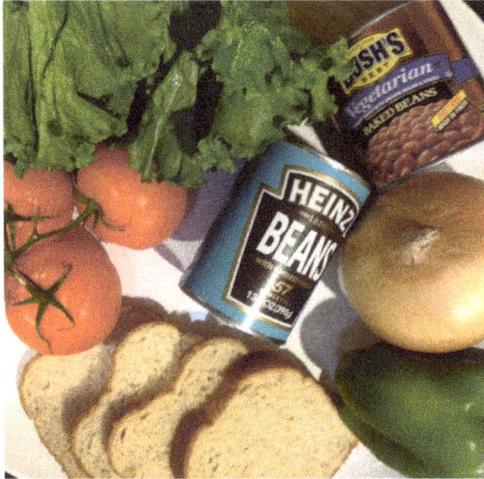

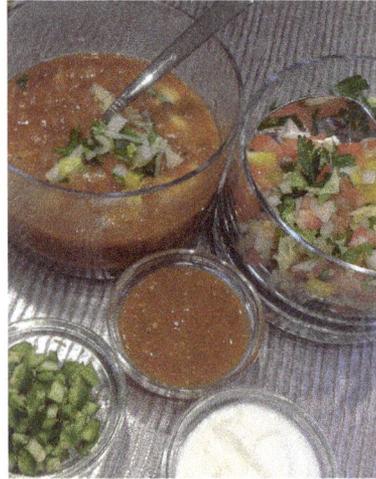

Great to serve for breakfast or lunch, easy to make, tasty, very filling, and packed with protein for the day. Start the day off spicy or mild!

SERVES 3–4

Prep time: 15–20 minutes; it just depends on how fast you chop!

INGREDIENTS FOR SALAD:

- ½ cup finely chopped white or sweet onions
- 1 cup finely chopped tomatoes
- ½ cup finely chopped cilantro
- ½ cup finely chopped bell pepper (red, green, or yellow)
- 4–5 serrano or jalapeño peppers, finely chopped (optional)
- 1 cup finely chopped lettuce (iceberg is my preference)

INGREDIENTS FOR THE BEANS - VAGHAR:

- 1 cup finely chopped onion
- 1 teaspoon oil
- ⅛ teaspoon ajwan seeds (optional)
- 1 cup grated cheese, like mild cheddar (your choice)

- 2 16-ounce cans vegetarian baked beans or beans that you prefer, drained
- 2 tablespoon red salsa (store-bought)

DIRECTIONS:

Mix tomatoes, onion, lettuce, and bell pepper in a bowl together and set aside to serve.

Keep serrano chilis and cilantro in small separate bowls.

Direction for the beans:

In a small pan, add oil, heat, then add ajwan seeds and roast a few seconds.

Add ½ cup onions. Sauté at medium heat until clear or slightly red.

Add beans, let heat, then add salsa.

Heat again, then sprinkle grated cheese on top and let it melt. Remove from heat.

Serve with a small bowls of sour cream, salsa, and chopped serrano chilis. Toast your bread, butter it, then top with some beans, the salad mix, sour cream, and chilis. enjoy!

Masala Oatmeal

You thought about having oatmeal for breakfast but didn't because you don't like the taste. You don't want the same boring cinnamon and brown sugar on top. Try oatmeal this way – see if it will change your mind!

SERVES 2

Prep and cook time: 15 minutes

INGREDIENTS:

- 1 cup steel-cut oatmeal, instant or regular (I recommend the 3 minute steel cut oatmeal for faster cooking.)
- ½ to 1 teaspoon grated chili (optional, or to taste)
- 1 teaspoon grated ginger
- ½ teaspoon salt (to taste)
- ⅛ teaspoon turmeric powder (optional)
- ¼ cup plain yogurt
- 2 cups water for instant, OR 4–5 cups of water for regular. Add all ingredients to water, and cook as directed on package
- 1 teaspoon ghee or butter (optional – gives it a nutty taste)
- 2 tablespoons finely chopped cilantro (garnish)

USE DIRECTIONS ON PACKAGE.

If you want thinner oatmeal, just add more water and simmer for 1 minute.

Serve with other items for breakfast

Dhebras Savory Pancakes

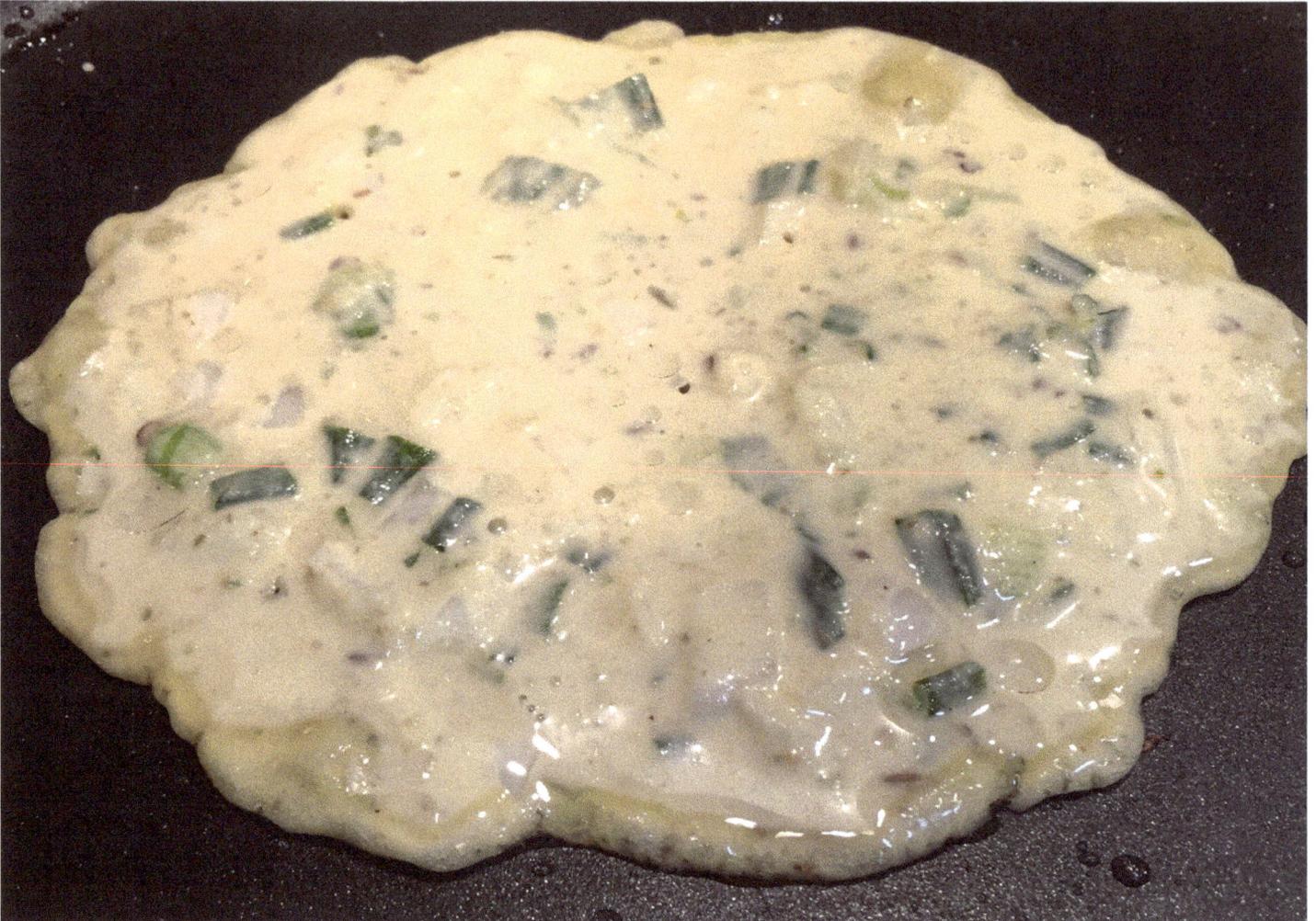

Another great breakfast, one dish meal or after-school snack: healthy, soft, and spicy pancakes.

You can make them with onions (in the recipe below) or use any of the following vegetables: dudhi, fresh dill, spinach, raw grated papaya, fresh methi (fenugreek), or kale.

Make them thick and serve them with syrup. Spread ghee on them, or eat them alone. Make them thin like a crepe and stuff them to make a breakfast burrito with your desired cooked veggies. The ideas are endless. Make a large batch of batter and have it ready for anytime.

If making a batter to be used later, do not add desired vegetables until ready to prepare.

Serves 4 (8–10 pieces)

Prep time: 15 minutes

Ingredients:

- 1 cup chana flour(besan flour) or juwar/sorghum flou
- 1 cup whole wheat flour
- ½ cup pancake mix or Bisquick mix
- 1½ cup hot water (add more if needed)

- 2 tablespoons oil
- ½ cup yogurt
- 1½ teaspoon salt (to taste)
- 1 teaspoon cumin
- ¼ teaspoon turmeric powder
- 1 tablespoon coriander powder
- 2 tablespoons fresh ginger
- 4 serrano or jalapeño chilis (to taste)
- 3 cups finely chopped fresh green onion
- 2 cups finely chopped white or yellow fresh onions

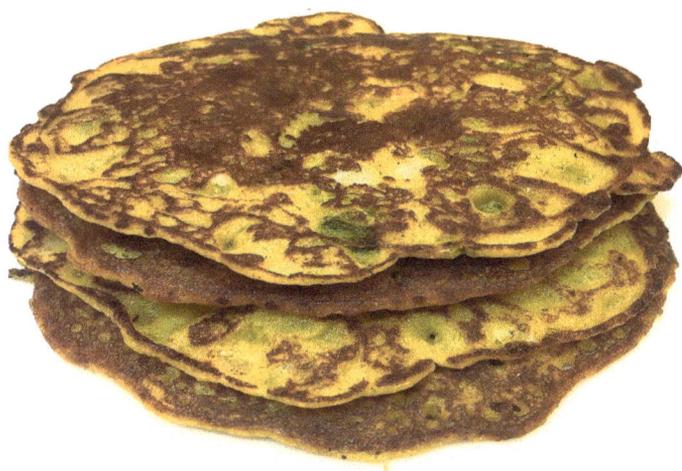

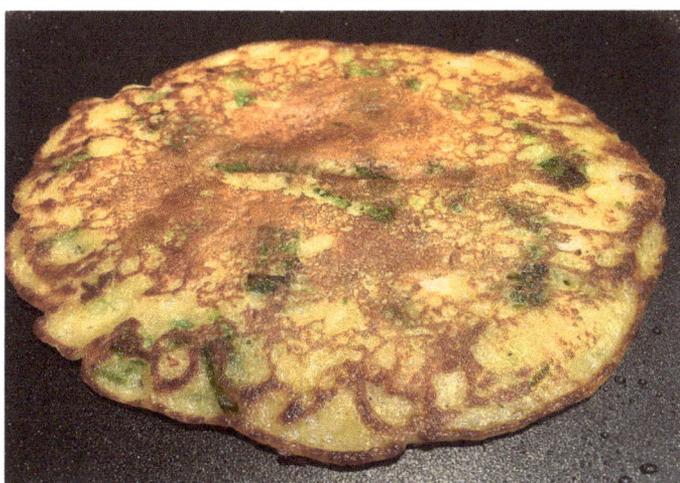

DIRECTIONS:

Method 1: Using a food processor: Add flour and oil and mix. Add yogurt and spices and drizzle in the water (do not add the green or fresh onions or vegetables). Remove to a bowl, add your chopped green and dry onions, mix. Set aside for about 10 minutes or more. If you need to make the batter thinner, add water in small amounts. Batter should be thin enough for you to spread it evenly (the onions will release water and batter will get thinner).

Method 2: Mixing by hand: Mix all flours together in a bowl. Add oil and mix again. Mix in yogurt and spices. Add water in small amounts and mix until batter is thin and smooth (not lumpy). Add your chopped green and fresh onions and mix. Set aside for 10 minutes or more. If you let the batter marinate for about 1 hour or more, the dhebras will be softer and tastier.

Heat nonstick pan or skillet on medium heat. Brush skillet with cooking oil and let skillet heat (test skillet to see if hot enough: add a few drops of water and if it sizzles, it is ready).

Using a medium size spoon, pour ¼ cup of mixture into pan. Spread the mixture into a 6–8-inch round (like a crepe & dosa) by using the back of the spoon. Drizzle a teaspoon of oil around the edges of the pancake (or use a spray bottle for your oil).

Drizzle some oil around the dhebra. Let cook until light brown at medium heat (check to see underneath by lifting a little edge of the dhebra). Flip over and cook again.

Cook until the edges start to leave the pan and the bottom is a light brown, 1 minute or less. Flip and cook for 2 minutes or more. Continue to make the rest of the pancakes.

Serve hot. Make them small or large. Serve with marmalade, spicy pickles, butter, yogurt, or chutney. Or make it like a breakfast burrito – stuff it with other vegetables or eggs.

Store extra batter in refrigerator up to 4 days.

Note: Make your batter the night before or let it marinate for a few hours to really get the flavor of all the spices. Add your choice of vegetables just before making them.

Enjoy!

Instant Khatta Puda
Spicy Crepe

SERVES 4 (12-14 CREPES)

Prep and cook time: 30 minutes

INGREDIENTS:

- 1½ cup rice flour (bought in Indian store, Koda brand if possible)
- ½ cup pancake mix (your choice)
- 1 teaspoon salt
- ¼ teaspoon turmeric powder
- 4 chilis (to taste)
- 1 tablespoon ginger
- ½ cup yogurt (the more sour the better)
- 2 tablespoons oil
- 2½ to 3 cups very hot water

DIRECTIONS:

Using a blender or food processor, add flour, add oil, and mix.

Add yogurt and all spices and blend.

Add 2½ cups of water slowly through funnel and mix. Blend for 1 minute.

Empty into a bowl. The mixture should be thinner than a pancake mixture. Let the batter marinate for about 15–20 minutes if you have time.

Taste the mixture. If you want it more sour, add lemon juice or ½ teaspoon of lemon flakes. Mix.

Heat your skillet. To check if your skillet is heated, try a few drops of water; if it sizzles, it is ready.

Add a teaspoon of oil to the skillet. With a deep spoon, pour 2 spoonfuls or ⅓ cup of batter and make a round circle by using the back of the spoon. Start swirling from the center and work your spoon to the outer area, just like you make a pancake (you have to work fast).

Let it cook for less than 1 minute. Check the bottom by lifting the end to see if it is light brown. Turn over and cook for about 1 minute.

Serve with ghee, marmalade, or pancake syrup.

Makai no Chevdo
Corn for Breakfast

This is a great quick-and-easy breakfast dish or just a snack when you are having friends over for tea. You can also serve as an appetizer with crackers.

SERVES 4

Prep and cook time: 20 minutes

INGREDIENTS:

- 2-15 oz. cans of corn, drained or 30 oz. defrosted frozen corn roughly crushed, or 6-7 cob fresh corn grated
- 3-4 serrano chilis
- 2 cloves of garlic
- ¼ cup cashew pieces or roughly crushed raw peanuts (optional)
- 1½ cup milk
- ½ teaspoon salt (to taste)
- ½ teaspoon sugar (optional)
- 4 tablespoons oil
- Dash of turmeric powder
- ½ cup cilantro to garnish

INGREDIENTS FOR VAGHAR:

- ½ teaspoon mustard seeds or cumin seeds
- Hing (optional)
- ½ to 1 teaspoon sugar (optional – if using fresh corn, delete sugar)
- Fresh cilantro

DIRECTIONS:

Using a food processor on pulse, crush garlic and chilis, add corn, peanuts or cashews, and pulse several times until corn is half crushed.

Take a nonstick pan and add oil, heat, then add mustard seeds and let them pop.

Add hing and corn mixture and sauté over lower heat.

Add corn mixture, sauté for about 2 minutes, and add milk.

Continue cooking until all milk is evaporated, then add sugar.

Garnish with cilantro, diced tomatoes, or red bell peppers.

Serve warm with toast, butter biscuits, or sev.

Note: if using fresh or frozen white corn, omit the sugar, and cook corn mixture longer. If using almond & soy milk, the consistency and taste of this recipe will change.

Scrambled Masala Tofu

Breakfast is a very important meal; it starts you on the right track for the busy day. Serve this to the whole family. Tofu is packed high in protein.

SERVES 4

Prep and cook time: 20–30 minutes

INGREDIENTS:

- 16 ounces fresh tofu, firm or extra firm
- 3 tablespoons olive oil or regular cooking oil
- 1 teaspoon cumin seed
- 1 cup grated cheese, mild cheddar or your choice.
- 1–3 serrano chilis, grated (optional – depends how spicy you like it)
- ⅛ teaspoon turmeric powder (optional – gives it yellow color and is good for your health)
- 1½ teaspoons coriander powder
- 1 teaspoon salt (to taste)
- ½ teaspoon black pepper (to taste)
- 1 cup chopped onion
- 1 cup chopped mushrooms
- 1 cup chopped bell peppers (any color)
- ½ cup chopped fresh cilantro

DIRECTIONS:

Before you begin, drain tofu: crumble it and drain on a few layers of paper towel to remove excess water (it also cuts down on your cooking time).

Chop all vegetables and set aside.

Heat oil in nonstick frying pan or skillet on medium heat.

Add cumin seed, let them roast for a few seconds until slightly red.

Add your crumbled tofu, lower the heat, and cook tofu until all water evaporates (5–7 minutes).

Add all chopped vegetables, stir. Cook at least 5 minutes and stir occasionally.

Add salt, black pepper, grated serrano, turmeric powder, and coriander powder.

Mix well and cook on low heat for about 5 minutes, until water is absorbed.

Sprinkle cheese on top, let the cheese melt, top with chopped fresh cilantro.

Serve on toasted bread of your choice, add a side of potatoes or cereal.

Bon appetite!

Vagharelo Rotalo
Refried Tortilla

Vagarelo rotlo, or rotli (spicy flatbread crumbled) is one of most common Gujarati breakfast items. It is easy and quick and great for leftovers.

So you have a few tortillas or rotlis left over that are a day or older, what do you do with them? Let's cook them with spices and yogurt to make a meal or snack or have it for breakfast. This is a very small country village dish, but it is worth making. You can save your le@ over rotli's & rotla's and store them in the refrigerator, or use store-bought rotlis, rotla's or thick hand-made white corn tortillas. To make fresh tortillas see page 99.

SERVES 4

Prep and cook time: 30 minutes

INGREDIENTS:

- 8–10 medium-sized day-old rotlas (tortillas) OR 16 pieces of rotlis
- 4 cup of water for Rotala's or 2 cups of water for Rotli's
- ¾ cup plain yogurt
- 1 teaspoon salt (or to your taste)
- Dash of turmeric powder
- 2 cloves of garlic (optional)
- 2 tablespoons of roughly crushed raw peanuts
- 4 chilies (to taste)
- garnish with chopped cilantro

INGREDIENTS FOR VAGHAR:

- 5 tablespoons oil
- ½ teaspoon of mustard seeds
- Dash of hing

DIRECTIONS:

Using your hand or a food processor, crush the rotli's or rotla's into fine pieces.

Grate your garlic and chilis, set them aside.

Add oil to a frying pan, heat, add mustard seeds and let them pop. Add hing, then your crushed rotla's.

Mix, stirring constantly at low heat until the mixture is crispy and a light-brown color.

Add yogurt, mix, then add spices, then half of the water. Mix and simmer at low heat for about 5 minutes.
Add the rest of the water and cook unti the water evaporates. The mixture should be soft (add more water if needed to soften).

It should have some gravy to it. This dish will start getting harder as it cools. Reheat if you want to serve later. Serve alone or with side of sev.

Batata Poha
Flat Rice with Potatoes

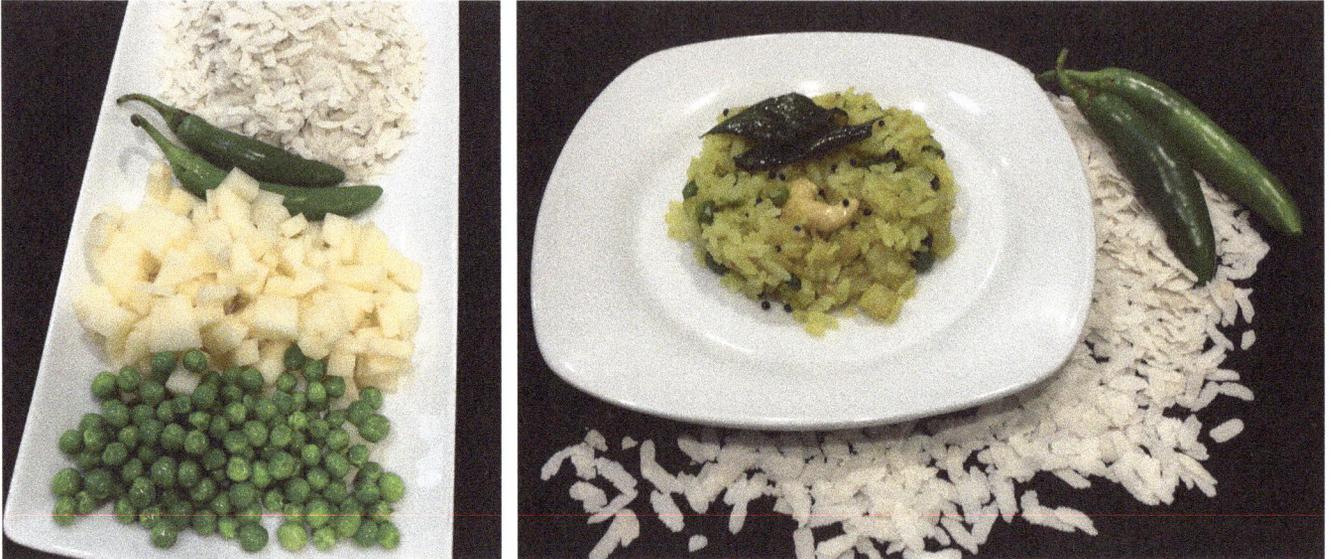

A quick dish for breakfast or when having friends over for tea.
A favorite with children. Also a great after-school snack!

SERVES 4

Prep and cook time: 30 minutes

INGREDIENTS:

- 3 cups thick Poha (do not use thin Poha)
- 1 cup peeled and diced potato
- 2 tablespoons grated ginger
- 1 clove grated garlic
- 1 teaspoon salt (to taste)
- 3 grated chilis (to taste)
- ¼ teaspoon turmeric powder
- ¼ cup cashews or raisins
- 2–3 tablespoons of lemon juice (to taste)
- 1 teaspoon sugar
- ¼ cup chopped cilantro for garnish

INGREDIENTS FOR VAGHAR:

- ¼ cup oil
- 1 teaspoon mustard seeds
- 9–10 curry leaves (optional)
- Dash of hing

DIRECTIONS:

Gently wash the Poha with cold water. Rinse them 2–3 times by changing the water, then soak in cold water for about 1 minute. Drain and set aside.

Mix all spices together.

Heat oil and toss in the mustard seeds, let them pop.

Add curry leaves and hing, then your potatoes. Sauté for about 1 minute at high.

Lower the temperature and add your cashews or raisins. Sauté until the cashews are a light red color. Lower the heat.

Add in remaining spices and mix, folding in gently your soaked Poha's.

Cover and let cook on low for a few minutes. Taste for salt and hot spices. Add lemon juice and gently mix together.

If you feel that the mixture is too dry, drizzle a little bit of water and mix again.

Garnish with cilantro. Serve with sev, chutney, and a cup of tea!

Appetizers

Patra

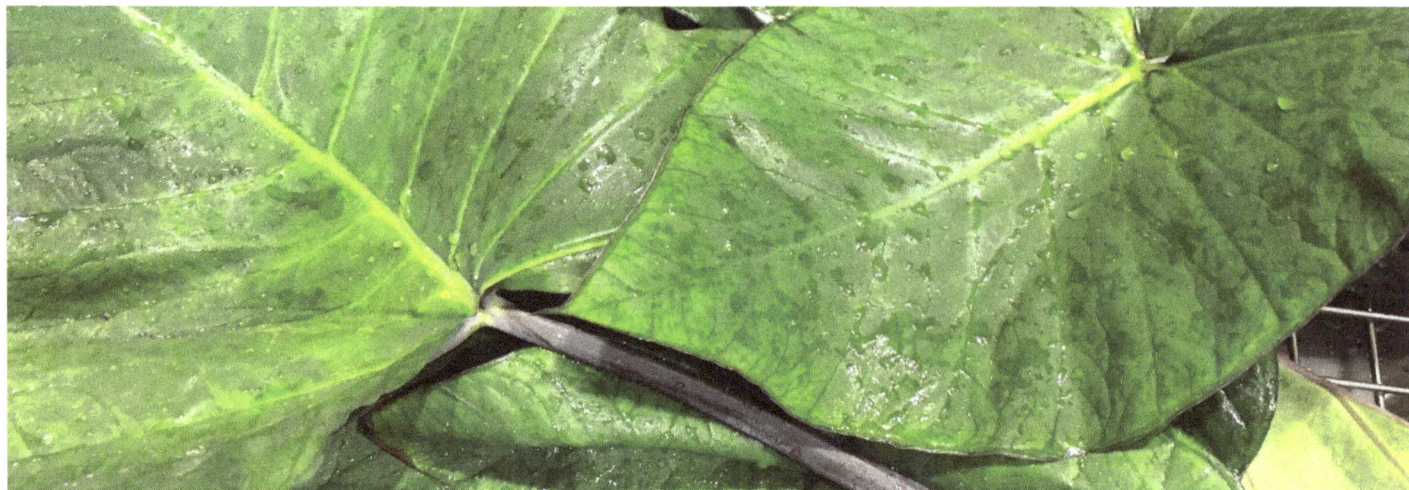

Patra: A Gujarati specialty. A delicious, tasty dish, different in many ways. It takes time to make but it's well worth it. A great make-ahead dish you can freeze to have on hand when having guests. Serve with tea, as an appetizer, or as a side dish.

There are many versions of this batter; I find this one to be the tastiest. The list of ingredients is overwhelming but worth it. This batter can be made in a large batch and frozen for later use, and this cuts down the time in making this recipe. I make a large batch and freeze it into small batches. So handy to have.

Use a food processor to make the batter, or mix it by hand. The food processor is the best and fastest way to make the batter, because it will chop and blend everything at one time.

Making patras takes some cooking skills and practice; making them with taro leaves is the easiest. Buy your taro root leaves at an Indian grocery store. (You need to get the green leaves with the purple veins. The ones with the green veins sometimes irritate the throat after eating, but they are still edible.) You can also make patras from spinach leaves, cabbage leaves, or even large kale.

Patras can be made two different ways: You can make mini roasted patra rolls by using small leaves to make small rolls, which you can just roast and sauté in oil in a frying pan. Cook on low until tender. OR you can make them in large rolls and steam them. The steamed versions can be eaten hot with just oil drizzled on them, or you can cut them up into pieces and roast them, or cut them into half-round, thick pieces and deep-fry them for a crispier version. Both methods are just as tasty. Serve hot or cold, sautéed, steamed, or fried.

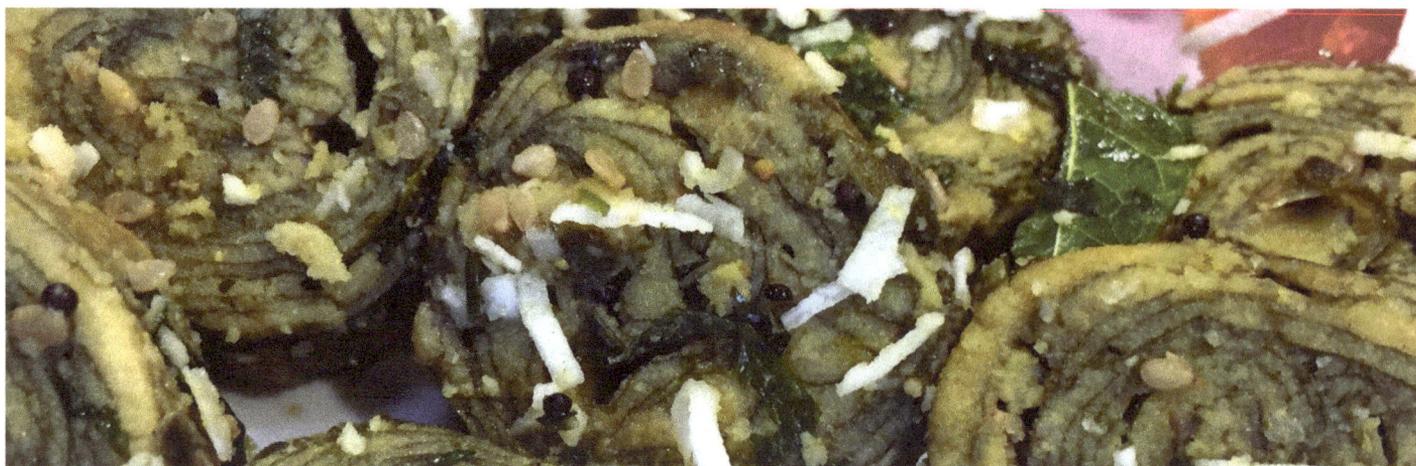

Taro Leaf Batter

Prep and cook time: 2 hours

TARO LEAVES:

- 12-14 large leaves (for steamed)
- 20-30 small leaves 0r 12-14 large (for sauteeing)

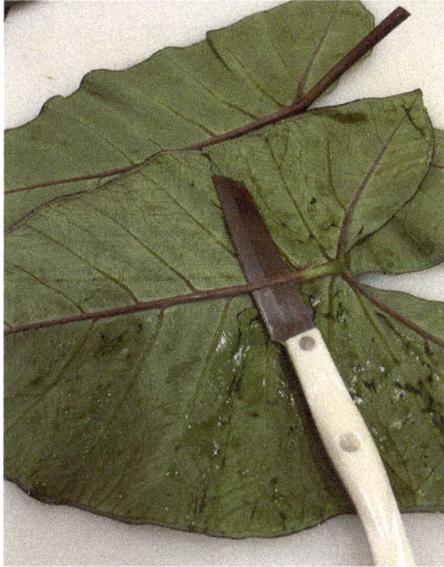

INGREDIENTS FOR BATTER:

- 4 cups chana flour (besan flour)
- 5 green chilis
- 5 large cloves garlic
- 3 tablespoons ginger
- 1½ tablespoons salt
- 1 teaspoon turmeric powder
- 3 tablespoons tamarind chutney or lemon juice
- ½ cup grated gol-jaggery (more if needed)
- ½ tablespoon garam masala
- ½ teaspoon clove powder (more to taste)
- 1 teaspoon cumin
- 2 tablespoons coriander powder
- 1 tablespoon red chili powder
- ¼ teaspoon hing
- ½ teaspoon baking powder or kharo
- 6 tablespoons oil
- 2¼ cups water

INGREDIENTS FOR VAGHAR:

- 5 tablespoons oil

- 1 teaspoon mustard or fenugreek seeds
- Dash of hing
- 2 tablespoons sesame seeds

DIRECTIONS:

Add flour to food processor, or mix by hand. Add oil, mix, add all spices and drizzle in 1 cup water.

Combine well and then add remaining water to make a smooth, thin, lump-free batter. Place batter into a bowl.

Marinate for about ½–1 hour or more. The batter will thicken as it marinates.

Wash the taro leaves, pat dry, and devein them like the picture above. Separate the leaves into two piles, medium and large sizes.

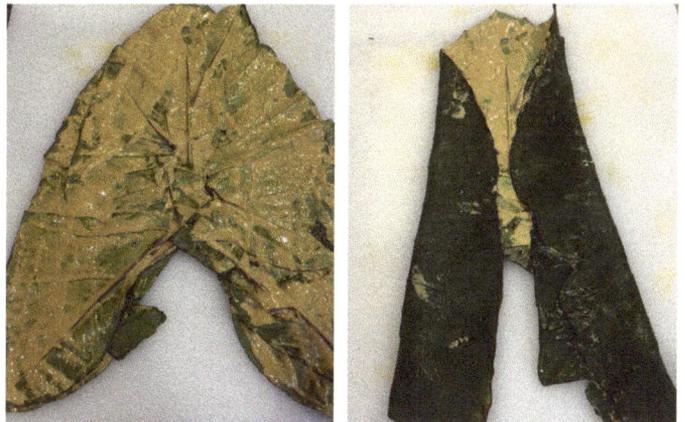

DIRECTIONS FOR STEAMING:

Take one large leaf and spread a thin layer of batter with your hand on the back side of the leaf, the part with the veins.

Put another leaf on top and spread a thin layer of batter on that, (you make need 4 leaves to get a nice large roll) then fold in the sides and spread a light batter on top of the sides.

Now, take both bottom sides of the leaf and fold them halfway up to the top of the leaf, then roll it tight to form a round cylinder as in the picture below.

Continue this process with all the leaves. If you have some batter left, freeze the batter for later use.

Get your steamer ready (or use a rice cooker with a steamer insert).

Fill it halfway with water, bring to a boil, lower heat to medium, then add one layer to the steamer.

Cover and let them steam for about 5 minutes, then add your next layer. Continue this until all rolls are in the steamer.

Cover and cook at medium heat for 30 minutes. Remove carefully, let cool, and cut them into round slices or desired shapes.

Serve warm, drizzled with oil, fry them, or roast them. Or freeze steamed patra for later use.

DIRECTIONS FOR VAGHAR:

Add 5 tablespoon of oil to a frying pan, heat oil, add mustard seeds, and let them sputter.

Add Hing, then your cut-up patras. Sautee them for about 5 minutes. Add sesame seeds. Remove from heat and garnish with fresh-grated coconut and cilantro.

Omit vaghar if deep-frying them for crispier patras.

DIRECTIONS FOR SAUTEEING:

Use the same batter but just use one large leaf. Spread the batter, fold in the sides, and roll tightly. Do this to all leaves and cut into 2-inch-sized pieces.

Add about 5–6 tablespoons of oil, heat at medium, and place patra pieces in one layer. Cook on low for about 1 minute, covered, then turn them all over. Add another layer and so on, cover for 1 minute, toss them or flip them over again, and continue cooking until they are a golden color, about 15 minutes (add more oil if needed).

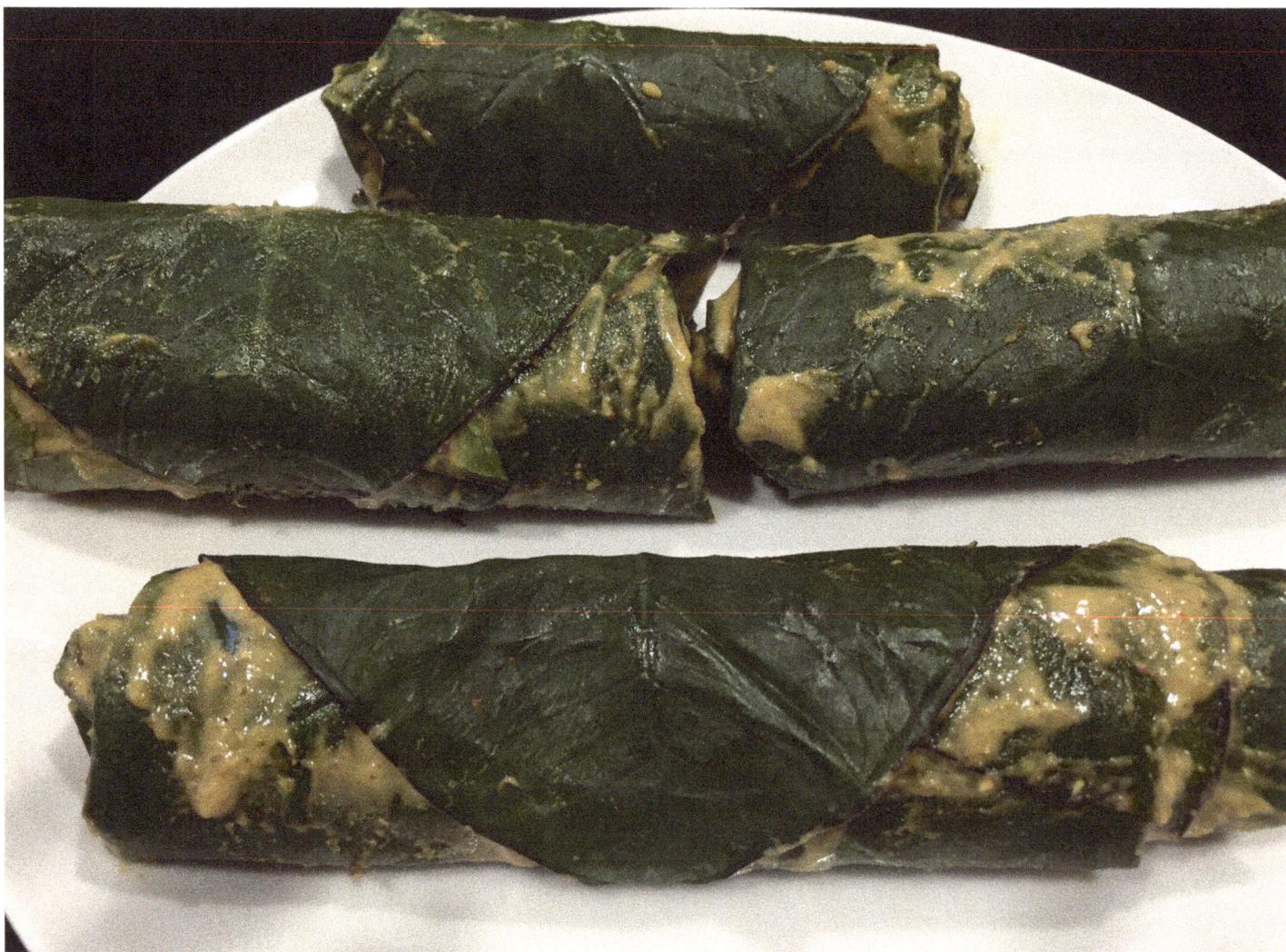

Khatta Dhokla - Idra

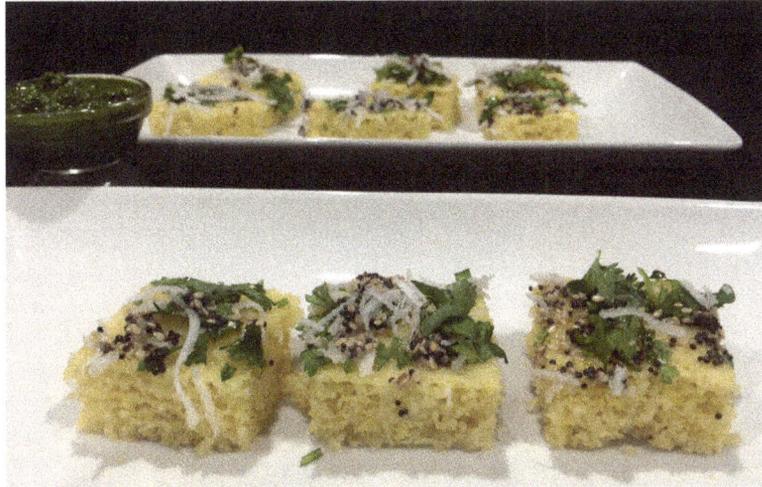

Dhoklas are a light, spicy, and spongy lentil cake & bread made from a rice and lentil meal. Gujaratis are known for eating dhoklas all the time. My mother was an expert at making khatta dhokla. The word "khatta" means sour; the tartness comes from the yogurt fermentation. Some like them just a little sour and others like them very sour; the choice is yours. Fermentation takes longer if you want them tart.

First a batter is made by soaking and fermenting, a 12-hour process. You will then need a steamer that will fit a small steel plate or aluminum pie pan, or you can use a special dhokla maker pot, which can be purchased at an Indian grocery store (pictured below). I suggest you invest in dhokla maker because you can use it for other recipes.

The directions below may seem like a complicated process, but the second time will be much easier.

Eat warm, served with green chutney or a chutney of your choice on the side. They can be reheated or roasted after they are cold. They are also known as idara. You can buy ready-made dhokla meal from an Indian grocer, or grind it yourself using my recipe, also contained in this book. Make this recipe as an appetizer, snack, or breakfast.

Before you begin, read through the recipe, and get all your ingredients ready. There are three different ways to make the batter:

- Dhokla can be made by using my meal, which you can grind yourself in a food grinder, or invest in a large coffee grinder, grind to a cornmeal-like texture using the correct setting on the grinder. Grind extra Dhokla mix so you have more meal on hand for later use.
- Method 1 : You will need to soak jasmine rice and chana dal for hours or overnight and blend into a soft puree before mixing in the spices.
- Method 2 : Buy dry Dhokla mix or instant Dhokla mix from an indian grocer and follow the directions on the package.

SERVES 6–8 (6 TRAYS)

Prep time: 16 hours

Cook time: 15 minutes

YOU WILL NEED:

- Dhokla or idli maker or steamer*
- Mixing bowl with cover
- Mixing bowl for batt er before steaming
- *If you don't have an dhokla & idli maker, you can use a regular steamer and use small trays that will fit in your steamer.

INGREDIENTS:

- 6 cups of my dhokla mix (see dhokla mix recipe pg. 10)
- 1 tablespoon urad fl our (opti onal)
- $\frac{2}{3}$ cup oil
- ½ cup yogurt (less if yogurt is very tart)

5 cups warm water (3 cups of water if you are soaking rice and dal)

3 to 4 green grated chilis (to taste)

2 tablespoons grated ginger

1 teaspoon salt

1 teaspoon baking powder or kharo

1/8 teaspoon turmeric powder.

Eno fruit salt, or baking soda to help it rise (used just before cooking)

INGREDIENTS FOR VAGHAR TOPPING:

- 2 teaspoons mustard seeds
- ¼ cup oil
- 2 tablespoons sesame seeds
- Hing powder

DIRECTIONS:

Place my blended meal or store-bought meal in a large bowl.

Add oil and mix well until all the flour is coated with oil.

Add yogurt, turmeric powder, and baking powder or kharo, then mix in 1 of cup of water at a time (4 cups total). You will get a thick batter.

Mix well, add salt. The mixture will absorb all the water. You may need ½ to 1 cup more water after a few hours. You should have a smooth, thick, lump-free batter.

Fold in chilis and ginger.

Cover and set aside in a warm place or a warm oven. If you live in a very warm climate the fermentation time will be only 5–6 hrs. The more it ferments the more tart it will get.

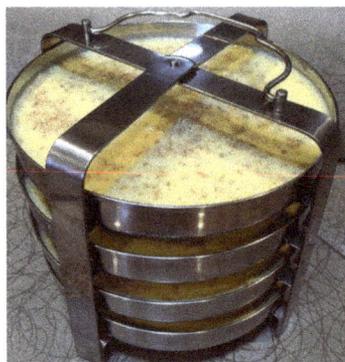

DIRECTIONS FOR STEAMING DHOKLA:

Get your steamer ready by filling with water and heating the water to boiling point, then lower to simmer (water should not touch the steamer part).

Stir the batter like you are beating it. Taste the batter for spiciness; add more grated chilis if needed.

Get your trays and grease them lightly with oil. Set them aside. If you are using a steamer, then only one tray can be made at a time.

If you have small trays, like 10-inch diameter size, for each tray you will need 1 cup of batter, so measure out your batter to the amount of trays you have in a bowl (e.g. for 2 trays add 2 cups, or 4 trays add 4 cups, etc.).

Add Eno only to the batter that you are cooking now. Eno will become flat if left premixed and dhokla will not rise.

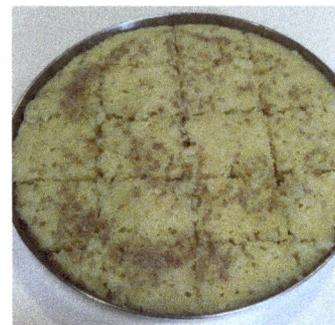

Add ¼ teaspoon of Eno plus a 1tsp of water for each cup of batter. If you don't have Eno and are using baking powder, use the same measurement but you will not need to add water. Fold in the Eno or baking powder quickly and pour batter evenly into all the trays. Tray should be half way full. You need to keep room for the batter to rise. Sprinkle some sesame seeds on top of the batter.

Place the trays into the steamer, cover, and steam at medium heat for 20–25 minutes. Test by sticking a fork into the center; if it doesn't come out clean, continue cooking for a few more minutes.

Remove from steamer and let them cool. Garnish with cilantro.

Eat them hot with vaghar on top or just drizzle with oil and enjoy them with a cup of chai. Serve warm or cold with chutney and sev (optional) on the side as an appetizer. Dhoklas will be the hit of the party.

DIRECTIONS FOR VAGHAR:

Heat oil in a small butter pan, add mustard seeds, let them pop. Add hing and sesame seeds. Spoon over your dhokla trays with a spoon, cut and serve hot.

Bhakaro
Handavo - Multi Grain Bread

A high-protein, savory lentil-mix bread. You can make it with any of the following vegetables, or mix two together: 6 cups grated dudhi (squash), 3 cups of chopped methi (fenugreek leaves), 3 cups of fresh tuvar (slightly crushed pigeon peas), or 3 cups fresh or frozen whole vatana (peas) and diced carrots.

Marinated and baked in the oven, it's delicious. Serve it for breakfast, lunch, or appetizers, or take it on the road. Great for a make-ahead appetizer. Serve with a side of cucumber raitu & raita.

SERVES 6-8

Prep and cook time: 3 hours

You will need:

9 × 11 casserole tray, or 24-cupcake baking tray

Ingredients:
- Vegetable of your choice
- 2 cups of my mix (page 10), or buy ready-made handavo mix
- 2 cups of chana flour (besan flour)
- 3 chilis, grated (to taste)
- 3 tablespoons grated ginger ▪ ½ cup oil
- ½ cup yogurt or lemon juice of one small lemon
- ½ tablespoon salt
- 2–3 cups of warm water
- 1 tablespoon coriander powder
- ¼ teaspoon turmeric powder
- 1 teaspoon Eno fruit salt OR baking powder (optional)
- 2 tablespoons sesame seeds
- 1½ cup chopped cilantro

INGREDIENTS FOR VAGHAR TOPPING:
- 1 tablespoon mustard seeds
- ¼ cup oil
- 2 tablespoons sesame seeds

DIRECTIONS:

Mix your flour and Handavo mix together, then add oil and mix until all the flour is coated with the oil.

Add in yogurt or lemon juice and mix 2 cups of water slowly, until you get a loose batter. The batter will soak up the water, so you will need to add more later (1 cup).

Add in all your spices except for the eno fruit salt or baking powder. Cover and let batter marinate for 1 hour or more in a warm place, the longer the better.

DIRECTIONS FOR BAKING

Preheat Oven to 400

Add your desired vegetables, mix, taste for salt and spiciness, and add more if needed.

Add your eno fruit salt or baking powder and mix. Pour batter into tray evenly.

DIRECTIONS FOR VAGHAR TOPPING:

Heat oil in a small butter warming pan, add mustard seeds, let them sputter. Remove from stove and slowly drizzle the hot oil over the batter, using a spoon. Top it off with the sesame seeds, and make sure that the mustard seeds are evenly spread out.

Place tray in the oven on the second rack from the bottom. Cook at 400 for 15 minutes until the sides start to bubble and it looks slightly red on top. Lower temperature to 350 and continue cooking for another 25–30 minutes. The bhakaro should be light red on top, and edges should also look red. Remove from oven, let cool, cut into pieces, and remove from tray with a steel spatula. Serve with a chutney or raitu.

Sabudana Vada
Tapioca Vada

Tasty, crunchy, and make-ahead. Your guests will love this different type of wadas and ask you for the recipe. These wadas are simple and easy to make, and make a great snack or appetizer.

SERVES 4

Soaking time: 4 hours at least

Prep time: 30 minutes

INGREDIENTS:

- 1½ cup small or medium-sized sabudana (tapioca)
- 2½ cups hot water
- 3½ cups finely ground raw peanuts
- 3 chilis grated (to taste)
- 1 teaspoon red chili powder
- 2 tablespoons grated ginger
- 2½ teaspoons salt
- 2 teaspoons coriander powder
- 2 tablespoons oil
- 4 tablespoons lemon juice
- Dash of turmeric powder
- 2 tablespoons finely chopped cilantro
- 2½ teaspoons sugar
- 3–4 cups oil for frying

DIRECTIONS:

In a bowl, soak the sabudana in warm water. Cover them with water for at least 2–4 hours or overnight. The longer the soaking the better – all tapioca are different, so soaking 4 hours at least is a must!

Drain the soaked sabudana in a colander, set aside. While the sabudana are draining, get your spices together.

Grind chili and ginger to a paste.

Grind peanuts to a fine texture.

Check to see if the sabudana are drained. If you feel they are too wet, spread them out on a few layers of paper towels for about 10 minutes to soak up the extra water.

Mix all the ingredients together, then combine with sabudana and peanuts. Mix, then knead until a soft dough is formed (add a few tablespoons of water if needed). Taste the dough; it should taste sour and slightly sweet. Add more lemon juice and sugar if needed.

Wash your hands and grease them with oil. Form a smooth, soft ball. Cover and let marinate for about 1 hour or place it in the refrigerator overnight.

Take your dough with greased hands and make small golf-ball sized balls (23–25). Pat balls flat into 2-inch patties on greased foil (or wear latex gloves and make the patties on your hand).

In a small, deep skillet, add oil and heat on medium. Place about 3–4 patties in the oil (they may stick to each other but just separate them while they are in the oil with a fork). Turn over, and fry until both sides are a light-orange color. They should puff up. Drain on a paper towel and serve warm. They will become soft after they cool.

Note: If you are frying later, cover patties with plastic wrap until ready to fry. They can be left out for a couple of hours.

Serve hot with your favorite chutney or ketchup.

Khatta Vada

A very traditional, delicious, unique Gujara4 fritter that you should definitely make. These delicious fried vada's are easy to make and tasty, hot or cold with tea, as an appetizer or a lunchbox snack.

Yield: 60–80 pieces

SERVES 6–8

Prep time: 10 minutes

Marinating time: 5 hours in hot climate, 12 hours or more otherwise

YOU WILL NEED:

Deep pan or wok for frying

INGREDIENTS:

- 1½ cups yellow cornmeal
- ½ cup juwar flour (if you do not have juwar flour, increase chana flour to 1 cup)
- ½ cup chana flour/besan flour
- ½ cup whole wheat fl our
- 3 tablespoons grated green chilis (8–10 pieces) ▪ 3 tablespoons grated ginger
- 1 can corn, or 15 ounces frozen or fresh, coarsely crushed
- ¼ teaspoon turmeric powder
- ½ tablespoon salt
- 1 tablespoon coriander powder
- 1 tablespoon coarsely crushed whole coriander
- 1 cup plain, tart yogurt
- 1 teaspoon baking powder or kharo
- ¼ cup oil
- ½ - ¾ cup warm water
- ½ cup finely chopped cilantro
- 4 cups oil for frying

DIRECTIONS:

Mix all the flours together using your hands.

Add oil, mix until all the flour is incorporated with oil, add baking powder, then mix in yogurt.

Add water a little at a time to make a smooth, thick batter. Batter should be thick enough for you to make a dollop with your fingers. Batter will not thicken as the batter sits. So, it's important that you add the water slowly.

Mix in the rest of the ingredients, except for cilantro. Cover and set in a warm place. (Warm oven for 15 minutes at 170 degrees, turn off oven and place covered batter in for a few hours or overnight.) Taste for saltiness before making.

DIRECTIONS FOR FRYING:

Heat oil to 275 degrees in a deep small wok or deep pan. Heat about 5 minutes on medium heat or test by dropping a piece of batter into the oil, it should slowly start to sizzle.

Before frying varas, mix in chopped cilantro. Use a spoon or mini ice cream scoop to drop batter into the oil.

Fry at medium heat until they are slightly red, turning them while they fry.

Drain on several layers of paper towels. Continue with the rest of the batter.

Serve with other accompaniments.
Note: batter can be stored in refrigerator or frozen for later use.

Batata Vada
Potato Ball Fritters

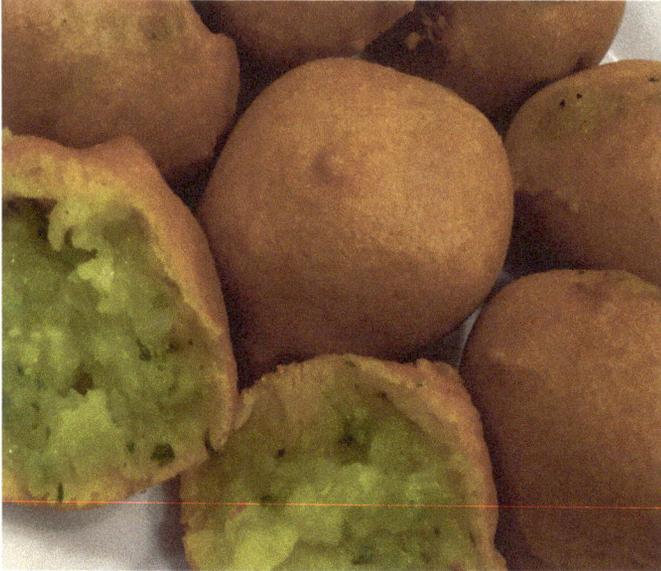

Spiced mashed-potato balls dipped in a chana flour batter and deep-fried, served with green chutney or ketchup. Hot batata vadas with a cup of hot coffee or tea on a cold day – what a treat!

SERVES 4

Prep and cook time: 1 hour

YOU WILL NEED: DEEP FRYING PAN OR WOK

Ingredients for stuffing:

- 4–6 medium potatoes (4 cups)
- 3 cloves garlic, grated
- 1 teaspoon grated ginger
- 2 green chilis (to taste)
- ¼ cup chopped fresh coriander leaves
- 1½ teaspoons salt (to taste)
- 2 teaspoons sugar
- ⅛ teaspoon turmeric powder
- 1½ tablespoons lemon juice

Ingredients for batter: ■

1½ cups chana flour (besan flour)
- 1 teaspoon salt
- ½ teaspoon of baking powder
- 1 teaspoon of red chili powder
- 1 tablespoon of hot oil
- 1 cup water to make a thick batter

DIRECTIONS:

Boil, cool, peel and roughly mash potatoes; set aside.

Grate green chilis, garlic, and ginger. In a bowl, add all the above stuffing ingredients and, using your hands, mash potatoes roughly. Taste for how spicy you would like them; add more chilis if needed.

With lightly greased hands, make golfball-sized balls of the above mixture.

Cover and set aside, or refrigerate until ready to fry, but for 1 day only.

DIRECTIONS FOR BATTER:

Mix flour and dry ingredients together, then add hot oil. Add water slowly to make a smooth batter by hand or with a hand mixer. Set aside or refrigerate until ready to make.

Have a plate lined with 3 layers of paper towels ready to drain the batata wadas.

FRYING THE BATATA VADAS:

Heat at least 3 cups of oil for frying. You can test that the oil is ready by placing a few drops of batter in the oil. If the batter sizzles and comes up to the top, you know the oil is ready. Once oil is at the frying temperature, lower to medium heat.

Dip the potato ball into the batter, covering it completely. Place 3–4 pieces in the oil at a time. Keep turning them over until they turn a golden color.

Drain on paper towels. Repeat process until all balls are fried.

Serve hot with chutney or ketchup.

Mixed Veggie Bhajiya
Mixed Veggie Fritters

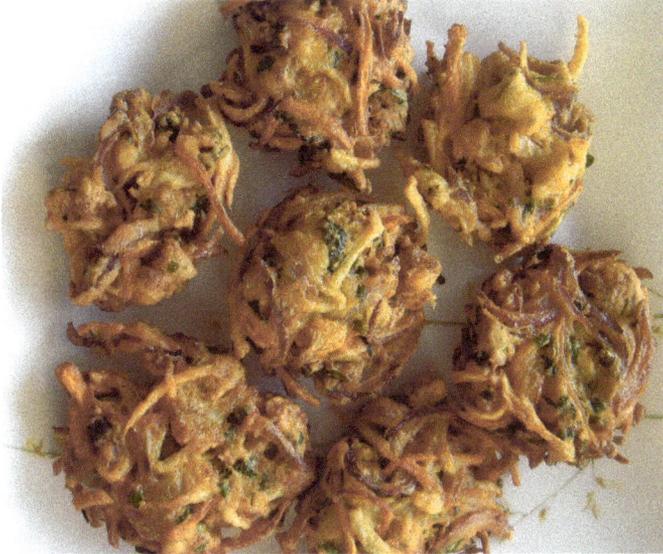

These mixed-vegetable bhajiyas or fritters will be a hit! Crispy, spicy, and light. Eat them hot, and serve them with a green or tamarind chutney.

SERVES 4

Preparation and cook time: 1 hour or longer

You will need:

Deep frying pan or wok

INGREDIENTS:

- 1 cup chana flour (besan flour)
- ½ cup whole wheat fl our
- ½ cup yellow cornmeal or coarse semolina
- 3 long green onions
- 1 large shredded potato
- 1 cup fi nely chopped spinach
- 1 cup diced chopped onion
- ½ cup each diced red and yellow bell peppers
- ½ cup fresh or canned corn, drained
- ½ cup chopped cilantro
- 1 tablespoon salt
- ⅛ teaspoon whole ajmo/ajwain
- ⅛ teaspoon turmeric powder
- 3 green chilis (to taste), grated
- 1 teaspoon fresh lemon juice (opti onal)
- 1 tablespoon grated ginger
- 1 tablespoon coriander powder
- eno fruit salt or baking powder
- Dash of hing
- 4 cups of oil for frying

DIRECTIONS:

Mix the flour together and add salt. Mix in onions first and set aside.

Chop the rest of the vegetables and mix them all in the flour.

Add in the remaining spices and knead well. Do not add the Eno or baking power until ready to fry.

Let this marinate for at least 30 minutes or longer. Water will release from all the vegetable and that will help form a nice batter. Batter should be thick; add a little water only if needed.

Heat at least 3 cups of oil into a deep wok & pan for frying. You can test that the oil is ready by placing a few drops of batter in the oil. If the batter sizzles and comes up to the top, you know the oil is ready. Once oil is at the frying temperature, lower to medium heat.

Fold in the Eno or baking powder. Mix.

Take a round spoon or mini ice cream scoop and drop some small batter balls into the hot oil. Do 7–8 pieces at a time, or more if they will fit in the pan.

Flip them over and over again until they are a light brown. Remove and drain on a paper towel; continue until all the batter is completed.

Enjoy and serve with your favorite chutney!

Bhajiya
Fritters

Oh, what a treat on a cold rainy day! Bhajiyas make a fantastic snack or can be served as an accompaniment. You can't just stop eating at one! Serve with drinks, afternoon tea, or as an appetizer for your next party.

Make them using 2 to 3 combinati ons of vegetables of your choice! example: ⅛-inch thick potatoes slices, round slices of onions, chilis, thick slices of bell peppers, large florets of cauliflower, mushrooms cut in half, sliced eggplant, or zucchini.

SERVES 8

Preparation and cook time: 30 minutes

YOU WILL NEED:

- Small wok for frying
- Slotted spoon to drain

INGREDIENTS:

- 2 cups chana flour (besan flour)
- 2 tablespoons coriander powder
- ½ teaspoon turmeric powder
- 1 teaspoon salt
- 1 teaspoon freshly crushed black pepper
- 1 teaspoon red chili powder or 2 green chilis, grated
- ½ teaspoon baking powder
- 1½ cups cold water
- 1 tablespoon hot oil (mix in just before frying)
- 3 cups of oil to fry

DIRECTIONS:

Make batter by hand or use a food processor or hand mixer. Batter takes about 5–10 minutes. Make ahead and marinate, or use right away. The batter should be slightly thick so it sticks to the vegetables but not too thin. Mix all ingredients together and add water slowly to make a smooth, slightly thick batter. Taste the batter; it should be slightly salty and spicy.

Cut vegetables of your choice into desired pieces. If using potatoes, peel and slice 1/8 to 1/4 inch thick.

Heat at least 3 cups of oil into a deep wok & pan for frying. You can test that the oil is ready by placing a few drops of batter in the oil. If the batter sizzles and comes up to the top, you know the oil is ready. Once oil is at the frying temperature, lower to medium heat.

Dip each vegetable piece in batter, coating all sides. Drop 5–6 pieces at a time slowly in the hot oil. Cook 3–4 minutes, turning them until light brown. Drain on paper towels. Repeat this process until all vegetables are fried.

Serve hot with chutney or ketchup on the side.

Tuver Na Muthiya
Pigeon Peas Dumplings

A great-tasting, high-in-protein, make-ahead item. Stays fresh up to 5 days in the refrigerator. A great snack, side dish, or aft ernoon tea accompaniment. You can make these muthiyas with fresh & frozen tuvar or dry whole tuvar lentil.Learn to use a pressure cooker.

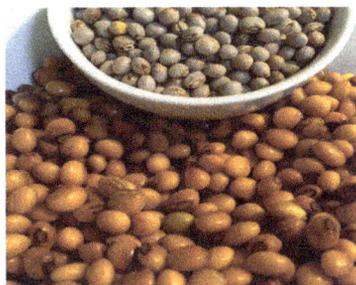

This is a 3-step process, but it is worth it. I have tried to make it as simple as possible.

Makes about 80–85 pieces

Prep time: 1 hour or 12 hours

METHOD 1

1 heaping cup of dry whole tuvar (toor), washed and soaked in 6 cups of water for up to 12 hours or overnight. Wash and remove all unsoaked tuvar. Cook in a pressure cooker with ¼ teaspoon baking powder. Drain, roughly mash half of the tuvar, and leave the other half whole.

METHOD 2

If you want to step up the process, in a large 3-quart glass bowl, add tuvar. Fill ¾ of the bowl with water, microwave for up to 10 minutes, then cover for 2 to 3 hours.

After the soaking is done, wash and check that there are no hard, unsoaked pieces left; discard those. Use pressure cooker, with ¼ teaspoon baking powder to cook (whistle 3 times). Roughly mash half the tuvar and leave half whole.

Method 3

If you don't want to soak the tuvar, wash and add to pressure cooker, wirh water tp cover the dal about 1 inch and cook until 5 to 6 whistles with ¼ teaspoon baking powder. Roughly mash half of the tuvar and leave half whole.

METHOD 4

You can make these muthiyas with fresh or frozen green tuvar. If making with fresh or frozen, use 2 cups of fresh tuvar; boil them until soft. Fresh & frozen tuvar muthiyas taste different from dry-soaked ones. Try both versions to determine which ones you prefer.

Prep time for dough: 45 minutes

STEP 1: INGREDIENTS FOR DOUGH

- Dry, fresh, or frozen tuvar, cooked as directed above
- 1½ cup juwar flour (sorghum) or whole wheat flour
- 1 cup dokla mix or yellow cornmeal

½ cup chana flour (besan flour)

2 tablespoons fresh grated ginger

5 serrano chilis (to taste)

3 pieces grated garlic

¼ teaspoon turmeric powder

1½ tablespoons coriander powder

½ cup chopped cilantro

2 tablespoons oil

2 teaspoons salt (to taste)

½ teaspoon sugar (optional)

1 tablespoon plain yogurt

¼ teaspoon hing

3 cups cold water

¼ teaspoon baking powder or kharo

5 tablespoon extra oil to roast the muthiyas

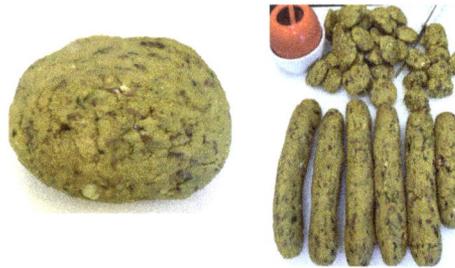

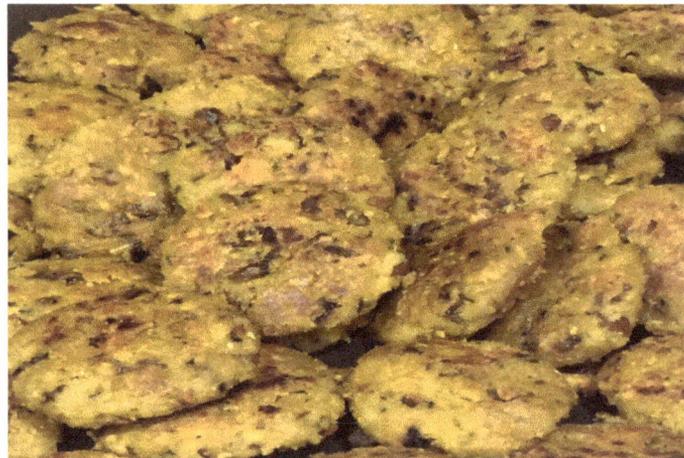

STEP 2: GET ALL YOUR SPICES READY

Blend your ginger, garlic and chilis.

STEP 3

Mix together all three flours, mix in oil and set aside. In a large 12-inch non stick frying pan, add 3 cups of water. Add all the above ingredients, mix in the flour mixture until is it smooth and lump free. Turn your stove on medium heat and keep mixing until a smooth batter is formed. The batter will become a soft dough. Make sure that it is not lumpy, but well mixed. Cover and lower the heat to lowest setting. Let it cook for 5 minutes, stir, and continue cooking for another 10 minutes. The texture will change, becoming smoother.

Remove from stove and let it rest for 10 minutes, covered.

STEP 4: LET THE DOUGH COOL

Take about ¼ of the dough and keep the rest covered. Using a cutting board, place the dough and knead with greased hands, forming a few 10-inch balls. Take each ball and roll into smooth 8- to 9-inch-long cylinder shapes. With a knife, cut into ½ -thick pieces.

Now take each piece and roll into ball and make it flat, like a small coin. Repeat this process until all are done.

STEP 5: SAUTÉING - ROASTING BEFORE SERVING

Using a 10-inch nonstick frying pan, add 5 tablespoons of oil, heat, and place half of your ready-rolled muthiyas in. (To make some later, make 2 batches and refrigerate one in an airtight container for later use.)

Stir gently until all the muthiyas are coated with oil; keep stirring or tossing them at high heat for about 2 minutes. Then lower heat to low and roast them until golden brown. (If your heat gets too hot, they will get burn spots on them.)

Note: You can bake them in the oven at 350 degrees on a greased cookie sheet and spray oil on top. They will be harder than the pan-fried ones.

Serve warm or cold with tea, your favorite raita, or plain yogurt.

Dudhi na Muthiya
Roasted Bottle Gourd Dumplings

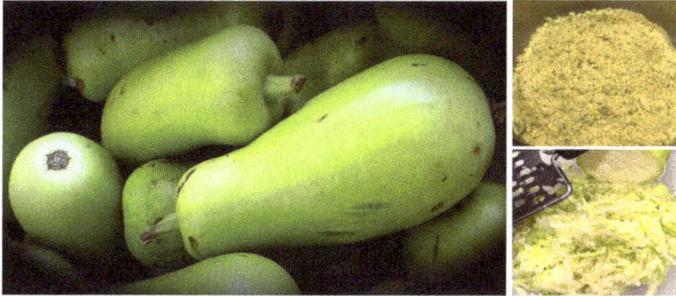

A Great make-ahead recipe. Nice crunchy items for appetizers, snacks, or a one-dish meal to have with raita or just plain yogurt. Will keep for a few days refrigerated.

SERVES 4–5

Prep and cook time: 45 minutes

YOU WILL NEED:

- Large nonstick frying pan with cover

INGREDIENTS:

- 1 medium-sized long, green, tender dudhi/bottle gourd grated (yields 4 cups)
- 1 cup chana flour (besan flour)
- 1 cup juwar flour/sorghum or whole wheat flour
- ¼ cup yellow cornmeal
- 3 to 4 cloves garlic, grated (optional)
- ¼ teaspoon turmeric powder
- 1 teaspoon whole cumin seeds
- 1½ teaspoon salt
- 4 green chilis (to taste), grated
- ¼ teaspoon sugar
- 1 tablespoon coriander powder
- 1 teaspoon red chili powder
- ½ teaspoon baking powder or kharo
- $\frac{1}{3}$ cup oil
- ½ cup finely chopped cilantro
- $\frac{1}{3}$ cup oil for cooking

DIRECTIONS:

Peel the dudhi and grate it. Squeeze out the water from the dudhi and keep the water aside to use later.

Note: If you plan to make these later, you can grate the dudhi and sprinkle it with 1 teaspoon of lemon juice and refrigerate; this way the grated dudhi will not turn dark. Squeeze out water just before using.

Mix all three flours together, add oil, and mix until all the flour is lightly coated.

Add the rest of the spices and mix; taste for salt and spiciness. Add the grated dudhi into the flour mixture; mix well.

Knead lightly until a dough is formed. Do not let this dough sit too long or it will release water and the dough will get too soft to handle. If the dough is too hard even after resting, use the reserved water as needed.

Wash your hands and then grease them lightly. Make small dumplings and form them into flattened ovals or balls. Example is shown in the picture below. Place them on foil or a tray. Repeat until all formed. You will have to work quickly.

Heat ⅓ cup oil in a large nonstick frying pan for 1 minute, then lower to medium.

Lay them in the frying pan in a single layer (you will make two batches). Let them cook covered for about 1 minute, then turn them over and cook for 1 minute. Remove from pan and make 2nd batch, then add the first batch back into the frying pan and cover. Cook on low.

Turn occasionally until golden-brown, about 20–25 minutes. Cook them uncovered for the last 10 minutes. The muthiyas should be crispy and a light-red color.

Serve warm or cold with raita, tea, or appetizer. Great when traveling.

Papri No Lot
Khichu - Rice Dumplings

Rice flour that is steamed and spiced up, a very favorite dish in Gujarati homes as a street food. Eat as a snack or serve at parties as an appetizer! It is important to buy super fine rice flour or the brand mentioned below; other brands may need more water or will turn out dry.

SERVES 4

Prep and cook time: 1 hour

YOU WILL NEED:

- 4-quart pot with a steamer, dhokla maker, or rice cooker

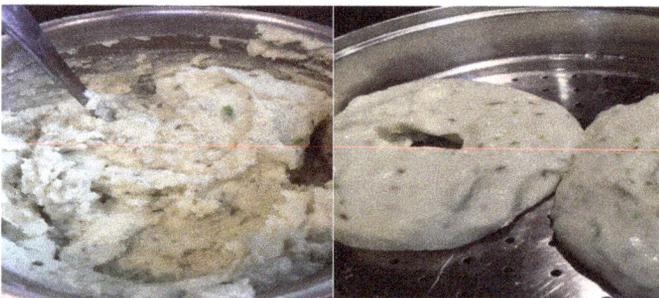

INGREDIENTS:

- 1 pound super-fi ne rice fl our (I recommend the Koda brand found in Indian grocers)
- ½ tablespoon salt
- ½ tablespoon whole cumin
- ½ teaspoon ajmo/ajwain(optional)
- ½ tablespoon kharo or baking powder, leveled
- 4 serrano chilis, grated, or ½ tablespoon of white or red chili powder
- 4 cups boiling water

INGREDIENTS FOR CHUTNEY:

- 3 serrano peppers
- 1 large clove garlic
- ⅛ teaspoon salt
- ⅛ teaspoon oil

Directions:

Get steamer ready with 4-5 cup of water and heat.

Boil 4 cups of water in a small pot to use to make the dough.

Measure your flour and combine the salt, cumin, chili or chili powder, and baking powder. Mix well and slowly add the boiling water in small amounts, making sure all the dough is incorporated. The dough should be like mashed potatoes.

Bring steamer to low heat and let the dough cool to the touch. Mix with your hands, separate into 6–7 pieces, and form round balls (dough will be sticky – wetting your hands helps in forming the balls or logs). Flatten it and make donut hole in center or form long logs (to the size of the steamer). Place them in the steamer as you form them and cover. Repeat until all the balls or logs are formed.

Make sure that the lid is big enough that the steam stays inside and has room to move around. (If you see the steam coming out the sides of the lid, take a piece of foil and line the edge of the steamer so that the lid fits on snugly.)

Steam for at least 30–40 minutes on medium heat. The color of the dough will change to a light green if using green chilis or reddish if using red chili powder.

Blend Chutney ingredients together

Cut dough up into small pieces, serve hot with chutney, drizzle with oil and top with sesame seeds. If serving at a party as an appetizer, mix all pieces with chutney and topping and serve with toothpicks inserted into each one or arranged on a platter.

Dudhi na Muthiya - Steamed Bottle Gourd

What a tasty breakfast, snack, side dish, or make-ahead item to take on the road. Serve with raita, plain yogurt, chutney, or some drizzled oil when they are fresh and hot, or cut them into small pieces once they are cold and refry them and make them crispy. Serve with tea or coffee.

When buying dudhi, pick a nice green, firm, tender, and slim one. The very big ones will have a lot of seeds in them, which you don't want to use.

The first time you may find it hard to make, but once you get the hang of it, it will be worth it!

SERVES 4

Prep and cook time: 1 hour

YOU WILL NEED:

- Steamer, or rice cooker with steamer insert

INGREDIENTS:

- 1 medium-sized peeled and grated dudhi/bottle gourd (yields 4 cups)
- 1½ cups whole wheat flour/sorghum or juwar flour
- ½ cup of yellow cornmeal or dhokla mix
- ¼ cup chana flour (besan flour)
- 1 tablespoon grated ginger or garlic (optional)
- 4 to 5 green chilis, grated (to taste)
- ¼ cup chopped fresh cilantro
- 1 tablespoon coriander powder
- 1 tablespoon yogurt (opti onal)
- 1 teaspoon salt
- $\frac{1}{8}$ teaspoon turmeric powder
- 1 tablespoon whole cumin
- ¼ teaspoon baking powder or kharo
- 4 tablespoons oil
- ¼ cup of water
- 1 teaspoon lemon juice
- 2 tablespoons soaked yellow mung dal (optional)

DIRECTIONS:

Grate the dudhi, sprinkle with lemon juice, lightly mix, and set aside.

In a large mixing bowl, mix all flours with oil, then mix in yogurt and remaining spices. Set aside.

Get your vegetable steamer ready; water should be at least 3 inches below steamer colander.

Combine flour and grated dudhi. The mixture will get softer as you knead it and the dudhi releases water. Add water if needed, a teaspoon at a time. Add yellow mung dal if desired. Dough should be super-soft, because the flour will absorb all the water as it cooks. To make super-soft muthiyas, as a rule you must always have more vegetable than flour.

Wash and lightly grease hands with oil. Make about 7 to 8 pieces of soft balls and then form them into donuts or long cylinder shapes.

Place them in the steamer in a single layer with a little space in between them and cover. Let the first layer cook for 5 minutes and then start your next layer on top.

Cover and let steam for a total of 25–30 minutes at medium heat.

To check, stick a fork in it; if it comes out clean, then muthiyas are ready to serve.

Serve warm, drizzle some oil and enjoy!

OR,
refry and roast:

Cut cooled muthiya into small pieces and add 2 tablespoons of oil to frying pan.

Add 1 teaspoon mustard seed, let them pop.

Add 1 tablespoon of sesame seeds and curry leaves (optional).

Add muthiya and sauté them at medium heat until golden brown. Add cilantro and serve.

Note: you can make muthiya using one of the following: finely shredded cabbage, spinach, fenugreek leaves (methi), fresh chopped dill or khaatho luono (verdolagad spinach), or zucchini.

Vegetable Dishes

Bharela Raingan na Ravaiya
Stuffed Eggplants

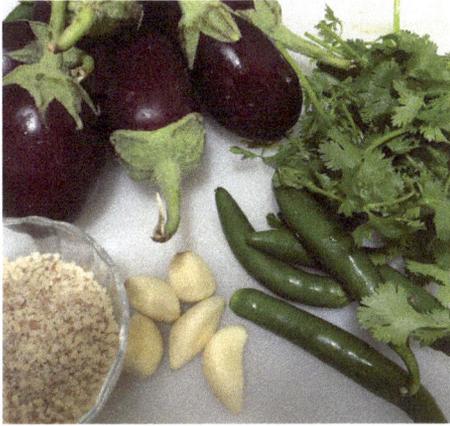

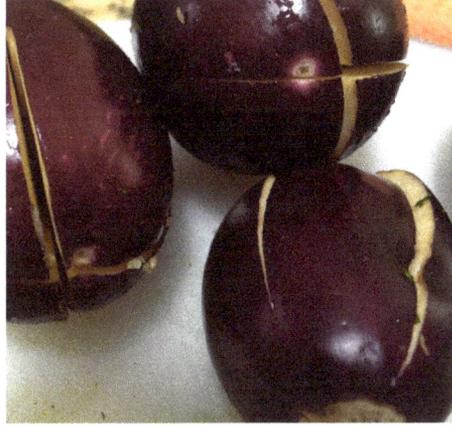

Indian eggplants – this is a very Gujarati dish, packed with lots of flavor. A dish that everyone loves with a good gravy. Rich and satisfying, it goes great with khichari.

Helpful hint: always buy a few extra eggplants; some may have too many seeds in them, or they might be black inside, you will know only after you cut into them.

SERVES 4–5

Prep and cook time: approximately 45 minutes

YOU WILL NEED:

- 4-quart pot or a wide 12-inch-deep pan

INGREDIENTS:

- 2 small potatoes, peeled and cubed into large pieces
- Eggplants Use one of options of the eggplants listed below.
 - A - 10-12 small round Indian eggplants
 - B - 4 Chinese long black eggplants, cut into 4 inch long pieces and then crisscrossed for the stuffing
 - C - 5-6 Italian eggplants, cut into two pieces and then crisscrossed for the stuffing.
 - D - Chinese and Italian eggplants,will cook faster and need less water: start with 2 cups of water and add more water as needed
 - E - 1 large globe eggplant cut into 5-1 inch pieces, these cook super –fast, will use less water and will become slightly mushy
- 2 cups of water

INGREDIENTS FOR STUFFING:

- 1 cup finely crushed raw peanuts
- 1½ teaspoons salt
- 3–4 cloves garlic, grated
- ½ teaspoon red chili powder
- ½ teaspoon turmeric powder
- 1 tablespoon coriander powder
- 2–3 green chilis, grated
- 1 teaspoon whole cumin
- 1 teaspoon sugar
- ¼ teaspoon baking powder (use if stuffing small round Indian eggplants only)
- $\frac{1}{3}$ cup oil or more (the stuffing should not be dry; it should be moist and not fall apart)
- ¼ teaspoon hing (opti onal)
- ½ cup chopped cilantro
- 2 tablespoons chana flour/besan (optional to make a thicker gravy)
- extra cilantro for garnish

DIRECTIONS:

Mix all ingredients together. Set aside.

In a large bowl, get cold water ready for the freshly cut eggplants. We do this because we do not want the eggplants to turn dark before cooking. All eggplants should be submerged in water.

Wash all eggplants and cut off tops. Cut and scrape off the thorns, then cut from bottom to top in a crisscross fashion, but not all the way through the top; add to cold water. Peel the potatoes and cut them into large pieces.

Make your stuffing by hand or add all spices to a food processor and use the mix button to grind the peanuts, then pulse several times to make it into a coarse mixture. Taste for salt and heat. You need it slightly salty for the eggplant portion.

Take about a teaspoon of stuffing and stuff the eggplant; do this process until all eggplants are stuffed. There should be some stuffing left over, set aside.

Using a 4-quart nonstick pot or a deep pan, add $\frac{1}{3}$ cup oil, then the diced potatoes and eggplants, and add enough of the 2 cups of water to cover the eggplants ¾ of the way (see picture on the side).

Bring to a boil, add the extra stuffing on top, then cover and simmer at low heat until eggplants are soft (at least 25 minutes). Stir gently, but do not break the eggplants. Make sure they don't stick to the bottom. To check if the eggplants are done, take a fork and gently poke the eggplants. If it goes in easily and the skin looks soft they will be done.

The gravy will become a little thicker once it cools. If the gravy is too thick, add a little water and cook for a few minutes. Serve with rice, roti, and another vegetable. Garnish with chopped cilantro before serving.

Tip: if you have peanut allergies, omit peanuts, substitute ½ cup of chana flour (omitting the 2 tablespoons in the ingredients), and add 2 tablespoons sesame seeds and some dry coconut.

Slow cooking is the best.

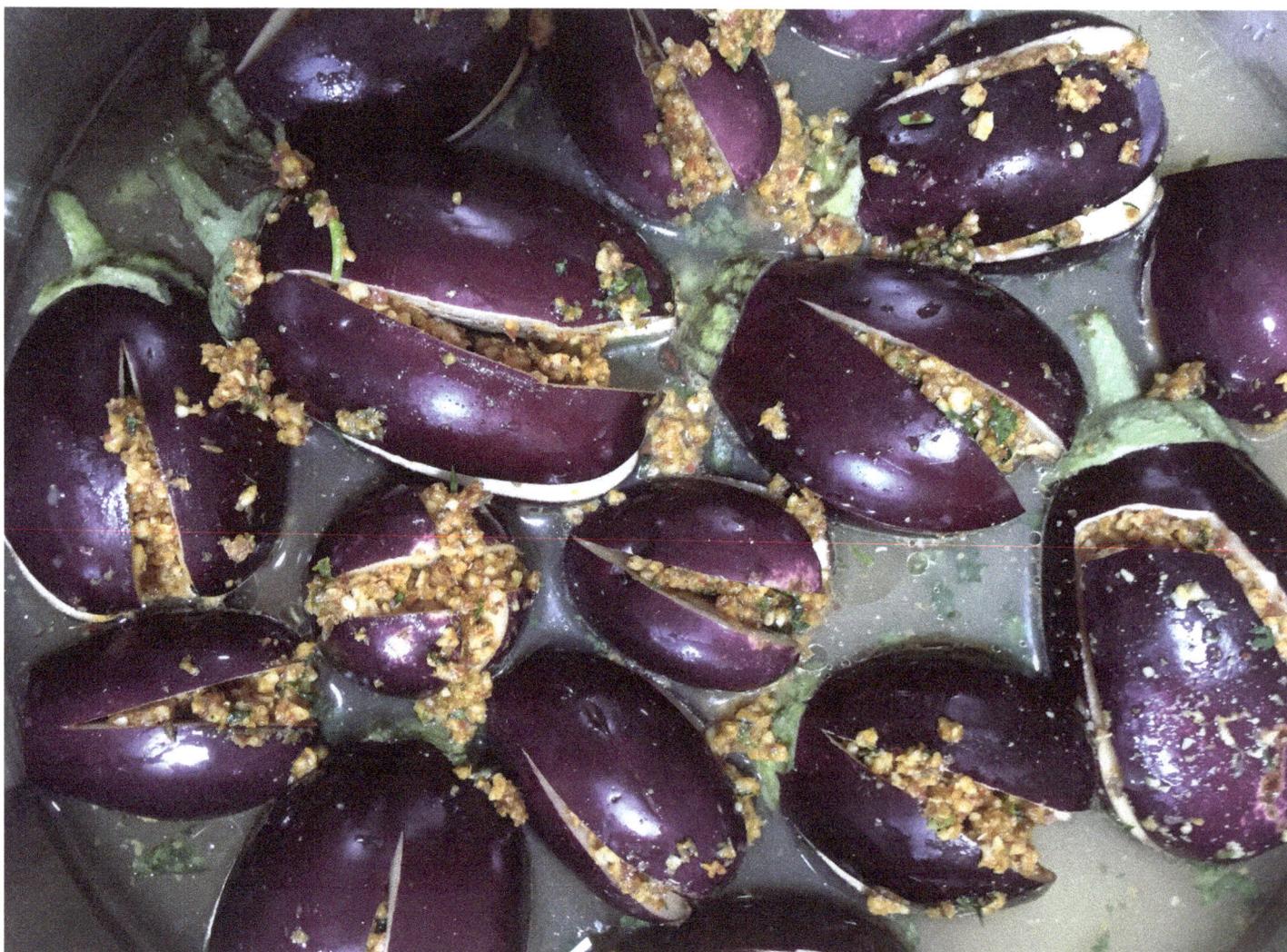

Raingan with Lima Beans
Eggplant with Lima Beans

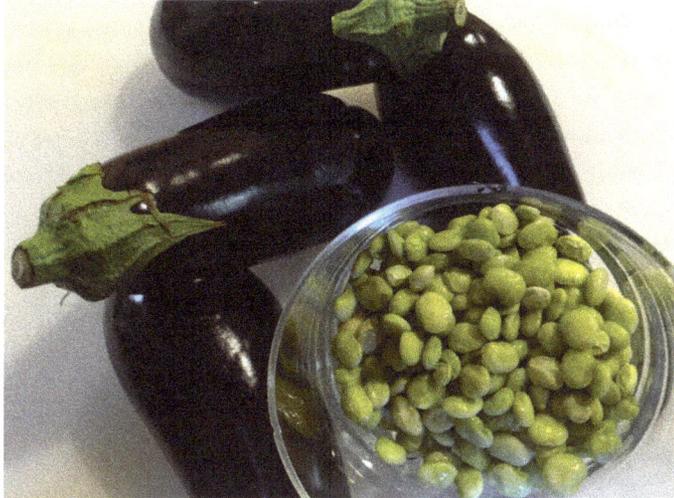

There are so many different types of eggplants. You can fry them, boil them, and bake them. The ways to cook them are endless.

This recipe is a quick and easy way to make it tasty. Cook with any one of the following vegetables: frozen lima beans, frozen peas, frozen tuvar, fresh or frozen black-eyed peas, or just potatoes. Try all the different variations

You can use globe, Chinese, or Italian eggplants. When you buy an eggplant, look for a nice, blemish-free, slightly soft, not super-hard eggplant (they will have seeds inside).

SERVES: 3–4
Prep and cook time: 30 minutes

YOU WILL NEED:
- 4-quart pot

INGREDIENTS:
- 1 large globe eggplant
- 1 cup of any vegetable of your choice (lima beans, potatoes, peas, fresh or frozen tuvar)
- 2–3 cloves garlic (optional)
- 3 green chilis (to taste), grated
- ½ teaspoon red chili powder
- 1 tablespoon coriander powder
- 2 cups of water
- ½ teaspoon turmeric powder
- 1 teaspoon salt (to taste)
- ½ teaspoon sugar (optional)

INGREDIENTS FOR VAGHAR:
- ¼ cup oil
- 1 teaspoon mustard seeds
- Dash of hing (optional)

DIRECTIONS:

Defrost your frozen vegetables. If using potatoes, peel, dice, and soak in cold water. Wash the eggplant, dice, and soak in cold water.

Make vaghar: using a 3- to 4-quart pot, add oil. Heat, add mustard seeds, and let them pop. Add hing, then add all your eggplant and vegetables.

Mix ingredients well. Add 2 cups of water along with salt and cover. Bring to a boil and let it cook for about 5 minutes.

Add all the remaining spices and let simmer until eggplants are soft and done, adding more water if needed to have a nice gravy. Taste for salt or add more chilis to make it spicier.

Serve with another veggie roti, rice, kadhi, or raita.

Raingan Vatana nu Shaak
Quick Eggplant with Peas

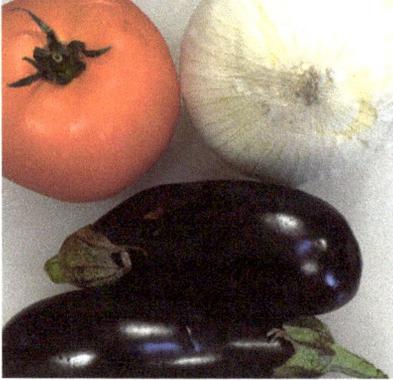

A colorful, thick stew dish. Can be served with plain rice, but best with khichari with yogurt on the side, with or without rotli or rotlas (tortillas). It will have enough gravy so you can really enjoy the favors with yogurt.

SERVES 4

Prep and cook time: 40 minutes

YOU WILL NEED:

- 4-quart pot

INGREDIENTS:

- 1 large white or yellow onion, chopped
- 5 Italian eggplants or 1 medium-sized large globe eggplant, cubed
- 1 large tomato, diced (yields 2 cups)
- 1 cup peas, fresh or defrosted
- 1½ teaspoons salt
- ½ teaspoon sugar
- 1½ tablespoons coriander powder
- ¼ teaspoon turmeric powder
- 1 teaspoon red chili powder (to taste)
- 2 cups water
- Fresh chopped cilantro for garnish

INGREDIENTS FOR VAGHAR:

- 5 tablespoons oil
- 1 teaspoon cumin seeds
- Dash of hing (optional)

DIRECTIONS:

In a pot, add oil and heat. Add cumin seeds and roast until slightly red. Add a dash of hing.

Stir in onions, tomatoes, peas, and salt, mix well.

Cover and let cook for about 2 minutes at medium heat.

Add eggplant, remaining spices, and water. Bring to boil and lower to simmer. Cook, covered, until eggplant is cooked and soft (about 20 minutes or more if needed).

If you feel you would like more gravy, add more water slowly until you get your desired gravy. Continue cooking for a few extra minutes after adding more water.

Garnish and serve warm.

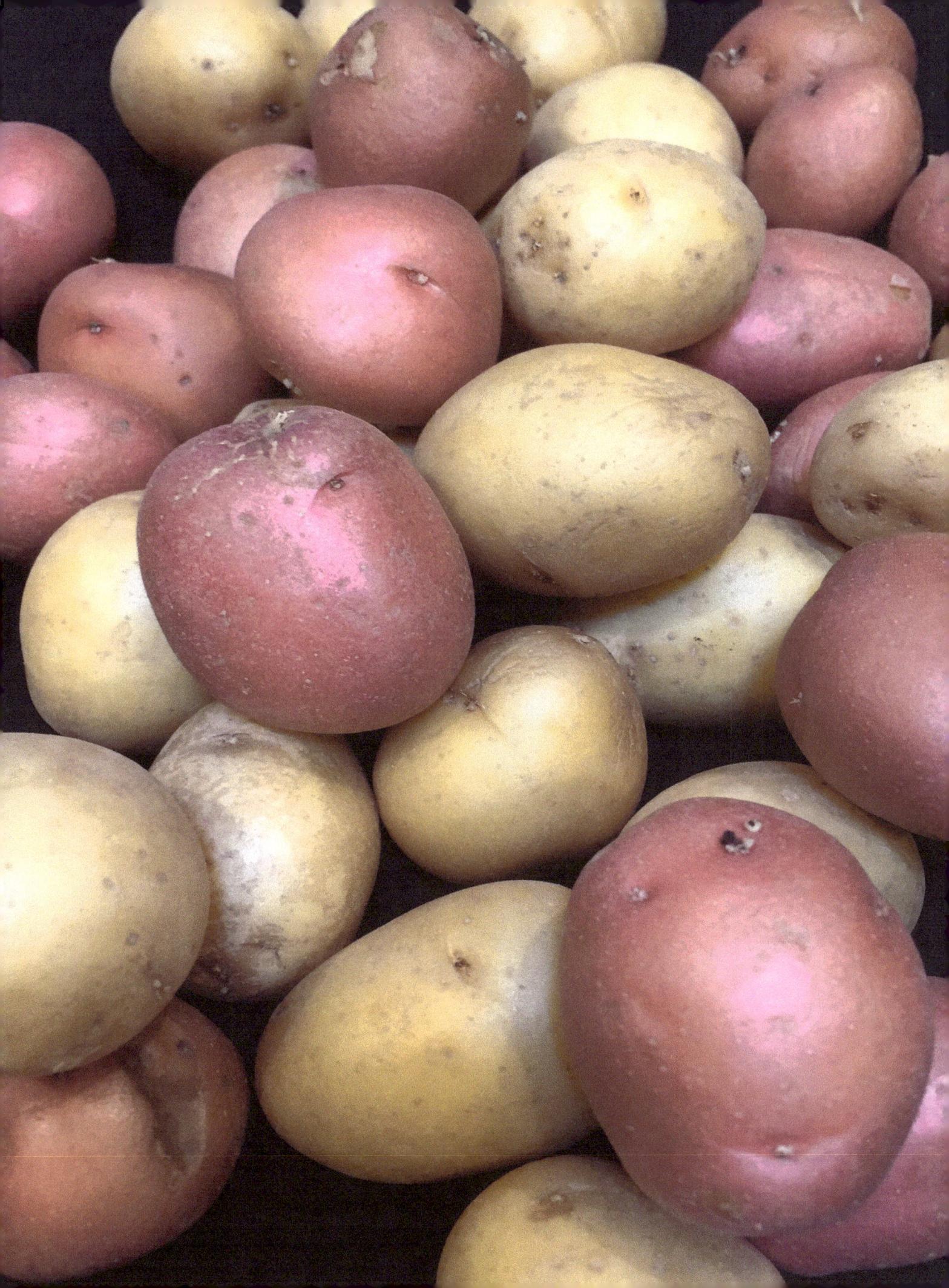

Dry Mixed Batata nu Shaak
Dry Potatoes

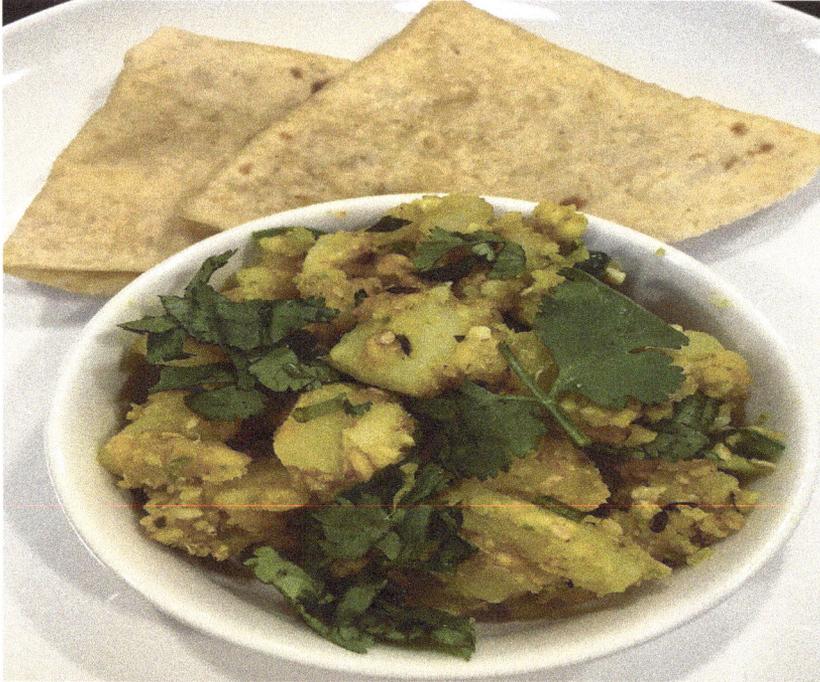

Bataka nu shaak & potato – delicious and tasty! A "no frills" recipe, this is a dry-spiced potato dish. There are many versions of this dish (wet or dry), all delicious with pooris or rotli, raitu, rice, and Indian pickles on the side. You can make another vegetarian shaak to accompany it with a gravy to complete the meal.

SERVES 2

Prep and cook time: 25 minutes

INGREDIENTS:

- 4 cups one-inch diced potatoes (3 medium potatoes, red or white)
- ½ teaspoon salt (to taste)
- ⅛ teaspoon turmeric powder
- 1 teaspoon coriander powder
- 3 green grated chilis or 1 teaspoon red chili powder (optional) to taste
- 2 to 3 cloves of garlic
- 1 tablespoon sesame seeds
- 1 teaspoon lemon juice (optional)
- ½ cup chopped fresh cilantro

INGREDIENTS FOR VAGHAR:

- 4 tablespoons oil
- ½ teaspoon cumin seeds
- Dash of hing

DIRECTIONS:

For a soft version, boil potatoes, making sure they are cooked all the way through. Put them in cold water to speed the cooling and stop the cooking process. Remove skin and cut into small cubes. For a crispier version, cube raw potatoes, peeled or unpeeled, and put them in cold water so they don't change colors.

In a medium-sized nonstick frying pan, add oil and heat. Add cumin seeds and let them roast until slightly red, then add the dash of hing.

Add the potatoes and sauté them for 1 minute at high heat. Lower heat to low and let them roast for a few minutes.

Add salt and turmeric. Mix well and cover (only for soft version) and cook at low heat for about 5 minutes.

Add the rest of the spices and cook until soft at low heat.

Add lemon juice and fresh cilantro and serve with your other favorite dish. Enjoy!

Methi Batata nu Shaak
Fresh Fenugreek with Potatoes

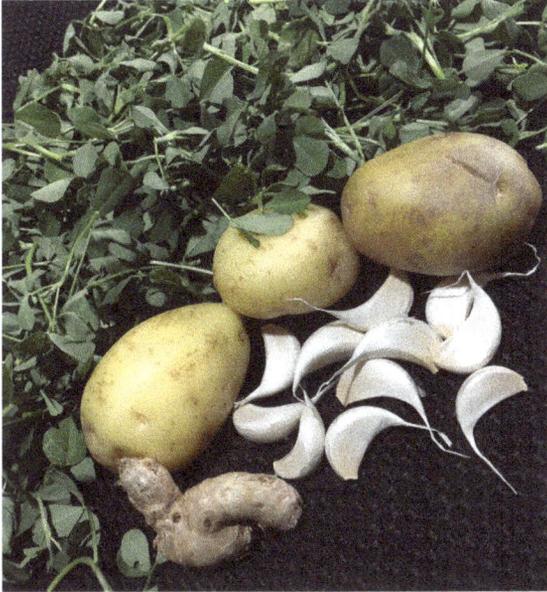
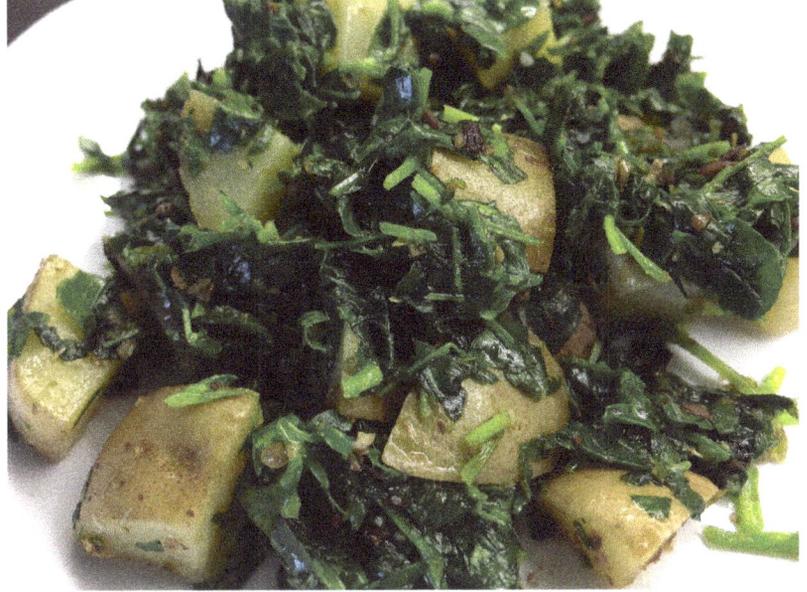

A different type of green spinach, methi is slightly bitter. Mixed with potatoes, this dish has a unique taste. You can use regular spinach to make this dish too.

SERVES 4

Prep and cook time: 1 hour

INGREDIENTS:

- 3 cups boiled potatoes
- 6 cups fresh methi/fengreek leaves or frozen thawed
- 1 tablespoon grated ginger
- 1 teaspoon salt
- ½ teaspoon turmeric powder
- 1 tablespoon coriander powder
- 2 green chilis (to taste), grated
- ½ teaspoon sugar (optional)

Ingredients for vaghar:

- 3 tablespoons oil
- 1 teaspoon Mustard or fenugreek seeds
- Hing-dash

DIRECTIONS:

Boil potato in lightly salted water until the skin cracks. Remove from heat and put them in cold or ice water. Let them cool, remove skin, and cut into cubes.

Clean the fresh methi leaves by taking each stem and plucking the leaves; you can use the tender stem on the top.

Wash and finely chop. Spread on a towel to absorb the excess water. Air dry for about 30 minutes or more.

Heat oil in a frying pan, add mustard seeds and let them pop, or add fenugreek seeds and let them turn slightly red. Add in your potatoes, sauté, and add in all spices. Cook for few minutes on low.

Mix in your methi leaves and remove from heat.

Cook again for a few minutes just before serving.

Serve with rice, kadhi, another vegetable, and rotli.

Kanda Batata nu Shaak
Onions with Potatoes

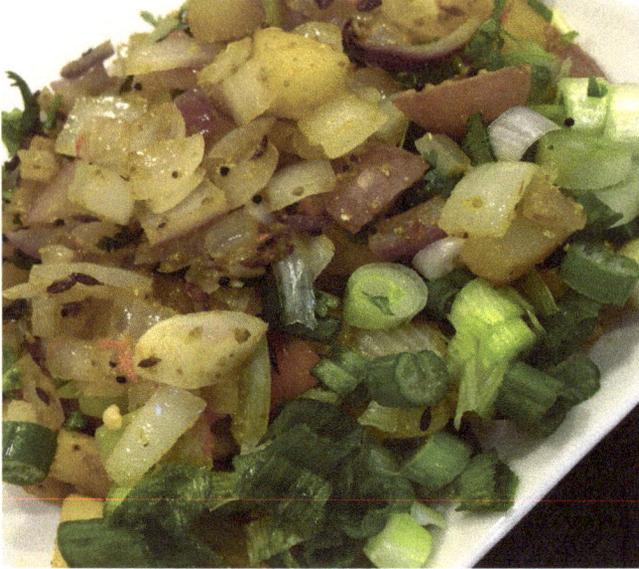

This is a very common recipe for a potato-and-onion dry vegetable dish. The sweetness of the onions is accented by the mild spices and goes well with bhakri, rotli, or khichari.

SERVES 4

Prep and cook time: 25 minutes

INGREDIENTS:

- 3 large white onions, chopped (yields 4 cups)
- 2 medium potatoes, diced (yield 2 cup)
- 1 teaspoon salt
- ½ teaspoon freshly crushed cumin
- ¼ teaspoon turmeric powder
- 1 teaspoon red chili powder
- 1 serrano chili, grated (to taste)
- 1 tablespoon coriander powder
- ¼ teaspoon garam masala (optional)
- Cilantro to garnish

INGREDIENTS FOR VAGHAR:

- 4 tablespoons oil
- 1 teaspoon cumin
- ¼ teaspoon fenugreek or mustard seeds
- 8-10 curry leaves (optional)
- Dash of hing

DIRECTIONS:

Peel onions and potatoes and dice them evenly.

Heat oil to warm, add cumin and fenugreek seeds, and roast until slightly red. Add curry leaves and a dash of hing.

Toss in the potatoes and add salt. Sauté on high heat for at least 5 minutes.

Lower heat and cover. When halfway cooked, add in the onions and all the remaining spices. Cook until potatoes are soft.

Garnish and enjoy!

Batata nu Khaatu Shaak
Sweet and Sour Potatoes

A sweet-and-sour potato dish with gravy served with Gujarati dal and bhat (rice). A favorite during celebrations, with lapsi.

SERVES 4

Prep time: 1 hour

YOU WILL NEED:

- 3- to 4-quart-deep pan

INGREDIENTS:

- 4 medium-sized potatoes or 6 cups, boiled, peeled, and cubed
- 2 tablespoons grated ginger
- 3 cloves garlic, grated
- 4 green chilis, grated (to taste)
- 3 tablespoons gol (jaggery)
- ¼ teaspoon turmeric powder
- ½ tablespoon salt (to taste)
- 1 tablespoon coriander powder
- 2 tablespoons thick tamarind sauce or lemon juice (more to taste)
- 1 tablespoon sesame seeds
- 1 tablespoon crushed raw peanuts
- Water to cover potatoes

For garnish, use fresh or dry coconut and cilantro

INGREDIENTS FOR VAGHAR:

- 5 tablespoons oil
- 4 whole cloves
- 4 small sticks cinnamon
- 1 teaspoon mustard seeds
- 1 teaspoon cumin seed
- Dash of hing
- ¼ cup oil

DIRECTIONS:

In a pot, heat oil to warm. Add mustard seeds and let them start popping. Add cumin, cloves, and cinnamon. Roast for a few seconds, add hing. Lower the heat and stir in your ginger, garlic, chilis, and roast at low heat. You will smell the aroma.

Add in your potatoes and stir. Add water to about ½ inch above the potatoes.

Add remaining ingredients, bring to a boil, and cover the pot. Let simmer at low for about 10 minutes.

Add more water if you would like more gravy. The gravy should be on the thicker side. (To get a thicker gravy, you can smash about 1 cup of the potatoes before you start the vaghar process.)

Before serving, garnish with fresh or dry coconut and cilantro.

Note: you can add puree tomatoes if you desire.

Serve hot with rotli, poori or paratha, Gujarati dal, and basmati rice.

Mix Vegetable nu Shaak

A vegetable dish that is a favorite with children.

Prep and cook time: 30 minutes

YOU WILL NEED:

- 3-quart pan

INGREDIENTS:

- 2 medium-sized potatoes (white or red), washed, peeled, and cubed
- 1 cup frozen peas
- 1 cup French beans
- 1 small carrot, peeled and diced (you can buy frozen mixed vegetables to make this faster)
- ½ teaspoon salt (to taste)
- ⅛ teaspoon turmeric powder
- 1 teaspoon coriander powder
- 3 green chilis grated (to taste)or 1 teaspoon red chili powder (optional)
- 1 tablespoon grated ginger
- ¼ cup chopped fresh cilantro (garnish)
- 1 to 2 cup of water to more

INGREDIENTS FOR VAGHAR:

- 3 to 4 tablespoon oil
- ½ teaspoon cumin seeds or ajmo/ajwain
- Dash of hing (optional)

DIRECTIONS:

Make vaghar: in a medium 2-quart pot, add oil, heat, add cumin seeds or ajmo, and roast until slightly red.

Add hing and immediately add all your vegetables and mix well. Add water to cover vegetables.

Bring to a boil and then lower the temperature. Cover and cook for about 3 minutes, then add all remaining spices and cook until potatoes are done. Add more water if needed or if you would like a little more gravy.

Garnish with cilantro.

Papadi nu Shaak
Indian Beans

Papadi is a very Gujarati dish. There are so many different kinds of Papadis (beans): green, red, purple, with or without seeds. Cook just the pods, or open them and cook only the beans, or mix half pods (Papadi) with half beans. The beans inside are called "lilva" and the dry forms are call "val."

These Pods are very delicious but each fresh pod must be deveined before cooking, it will take some time to prepare, but are worth the time. Ready to cook frozen beans are available in Indian supermarkets as surti, papri, and lilva.

Cook them alone or add a little bit of eggplant to it to get a thicker gravy.

When buying papris, remember that the ones that have seeds have to have the seeds removed. Cook only the seeds – pods will not cook. Papri that are just flat pods without seeds will cook as is. Make sure to check!

SERVES 4

Prep and cook time: 45 minutes or longer

YOU WILL NEED:

- 4-quart pot

INGREDIENTS:

- 1 medium-sized globe eggplant or 4 Italian eggplants, diced and soaked in cold water ▪ 6 cups of papadi or half papadi and half lilva ▪ ¼ teaspoon turmeric powder
- 2 tablespoon coriander powder
- 1 teaspoon salt (to taste)
- 3 to 4 green chilis, grated (to taste)
- 2 cloves grated garlic
- 1 tablespoon grated ginger
- 1 to 2 cups of water

INGREDIENTS FOR VAGHAR:

- 5 tablespoon oil
- 1 teaspoon ajmo/ajwain
- Dash of hing
- ⅛ teaspoon baking powder or kharo

DIRECTIONS:

Add oil to the pot, add ajmo, and let the seeds get slightly red.

Add hing and baking powder, mix in papri & lilva.

Add water to cover papri and cook for about 2 minutes on low.

Add in the eggplant. Mix and add salt, then cook on low for about 5 minutes. Eggplant will release some water.

Mix in remaining spices and continue cooking until eggplant is soft and mushy. The vegetables should have a little bit of gravy; add water if needed.

Asparagus in Spicy Sauce

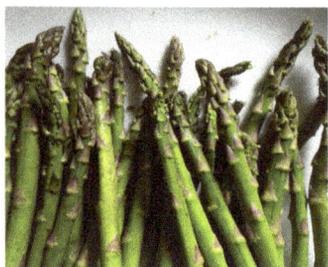

A Western vegetable with twist of Gujarati sauce. Wow! Different and tasty. Something different – let's say it's fusion. It's sweet and spicy. This will be a winner for you and your guests!

Buy nice green, tender asparagus, not too thin. You will use only ¾ of each asparagus stem; the bottom 1 inch will be discarded. The top 3 inches is the nice tender part; the slightly white part of the stem will have too much fiber in it, so discard that. Wash and cut into 1-inch pieces.

For this recipe, you will need to steam the asparagus for only about 1 minute (it's important that they should be crisp, not over-steamed). Steam by using a steamer or pot with a colander on top. Add water to half of the pot at least, bring water to a boil, and add asparagus in the colander. Cover, then check to see if the asparagus is half cooked, but not overdone. 1–2 minutes in the steamer should do it. Remove asparagus and cool on a plate. Set aside.

SERVES 4

Prep and cook time: 45 minutes

YOU WILL NEED:

- Deep-dish pan

INGREDIENTS:

- 1½ pounds of tender asparagus, lightly steamed
- 4–5 tablespoons oil
- 3 tablespoons chana flour/besan
- 1 teaspoon salt
- 1 tablespoon grated fresh ginger
- 5 to 6 green chilis
- 2 teaspoons sugar
- 1 teaspoon coriander powder
- ⅛ teaspoon turmeric powder
- 1½ to 2 cups water
- ⅓ cup chopped cilantro for garnish

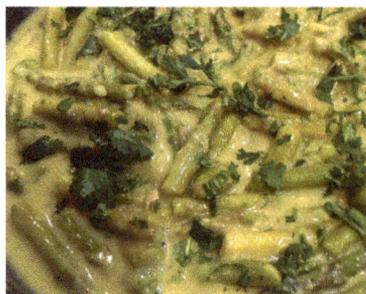

INGREDIENTS FOR VAGHAR:

- 4–5 tablespoons oil
- 1 teaspoon mustard seeds
- Dash of hing (optional)

DIRECTIONS:

In a deep-dish frying pan, add oil. Heat, add mustard seeds, let them pop, lower heat, and add hing.

Mix in chana flour and sauté at low heat, until light red color (3–4 minutes).

Add all spices except the fresh cilantro, mix well.

Slowly whisk in 1 cup of water, making sure the batter is smooth. Add more water and let the mixture simmer on low heat about 5 minutes. The sauce should be thin at this stage, and will thicken up as it cools. Taste the sauce for salt or spiciness; add more if needed.

Remove from heat, mix the steamed asparagus into the batter, and set aside.

Cook on low heat when you are ready to serve. If the sauce is too thick, just add a little water to thin it out.

Garnish with cilantro. Serve with plain rice, another veggie, and Gujarati kadhi or raita on the side with a nice lentil and rotli. You are all set for a nice meal.

Fansi nu Shaak
French Beans

A quick, tasty dish. Use it as a side with your other dishes.

SERVES: 4

Prep and cook time: 45 minutes

YOU WILL NEED:

- 3- to 4-quart saucepan

INGREDIENTS:

- 6 cups chopped French beans, fresh or frozen
- 3 medium-sized cloves garlic, grated
- 1 teaspoon salt (to taste)
- 3 green chilis, grated
- ½ teaspoon turmeric powder
- 1 tablespoon coriander powder
- 2 cups water
- ½ cup whole raw peanuts
- 1 tablespoon sesame seeds (optional)
- 2 tablespoons chopped fresh cilantro
- Extra cilantro for garnish

Ingredients for vaghar:

- ½ teaspoon ajmo/ajwain
- $\frac{1}{3}$ cup oil

DIRECTIONS:

Wash beans and snip off ends, then cut the beans about ½ inch long, or split them down the middle and cut them into ½-inch pieces.

Heat oil in a 3- to 4-quart pan. Add ajmo seeds, roast the seeds for 20 seconds or until slightly red, then add hing.

Mix in the beans, add enough water to cover them, and bring to a boil. Add salt, cover, and simmer for about 5 minutes.

Add the remainder of the spices and cook until beans are done. If you would like more gravy in the beans, add water and simmer for a few extra minutes.

Garnish with cilantro. Serve with another vegetable, rice, kadhi, and rotli and make it a full meal.

Flower nu Shaak
Cauliflower

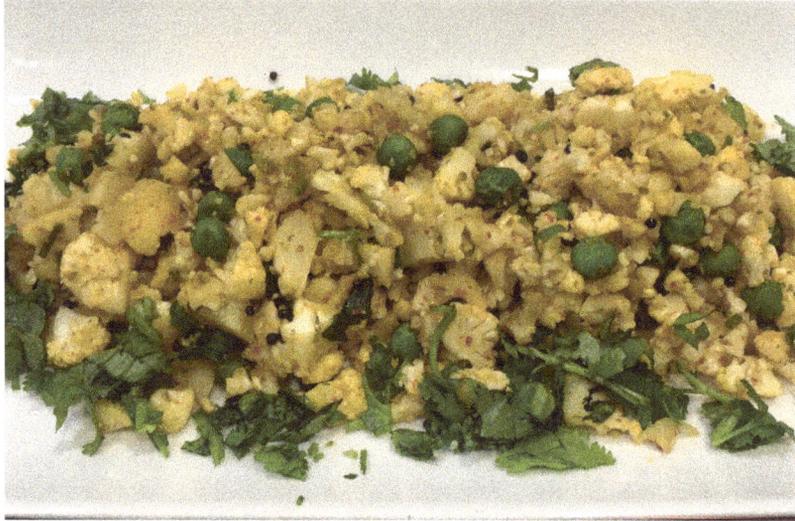

Cauliflower, another quick, great vegetable to make for dinner. Add peas or potatoes or mix all three to make a tasty dish. Fresh cauliflower is an excellent source of vitamin C. It is very low in calories: 100 grams of the fresh cauliflower has only 26 calories.

SERVES 4

Prep and cook time: 30 minutes

INGREDIENTS:

- 4 to 5 cups chopped cauliflower
- ½ cup fresh or frozen peas (if using fresh peas, boil first, then add to cauliflower)
- ½ tablespoon coriander powder
- ¼ teaspoon turmeric powder
- 4 green chilis (to taste), grated
- ½ teaspoon red chili powder
- 1 teaspoon salt

INGREDIENTS FOR VAGHAR:

- ¼ cup oil
- ½ teaspoon mustard seeds
- Dash of hing

DIRECTIONS:

In a sauté pan, add oil, heat, and add mustard seeds. Let mustard seeds sputter.

Add hing, toss in your peas, and sauté for about a minute.

Add cauliflower and spices, mix well, and cook on high for about 1 minute. Lower heat and cook, stirring occasionally, until cauliflower is tender.

Remove from heat and garnish with fresh cilantro.

Variation: You can mix in any two of the following vegetables: peas, potatoes, or bell peppers. Grated or finely chopped cauliflower alone tastes great also.

Brussel Sprouts nu Shaak

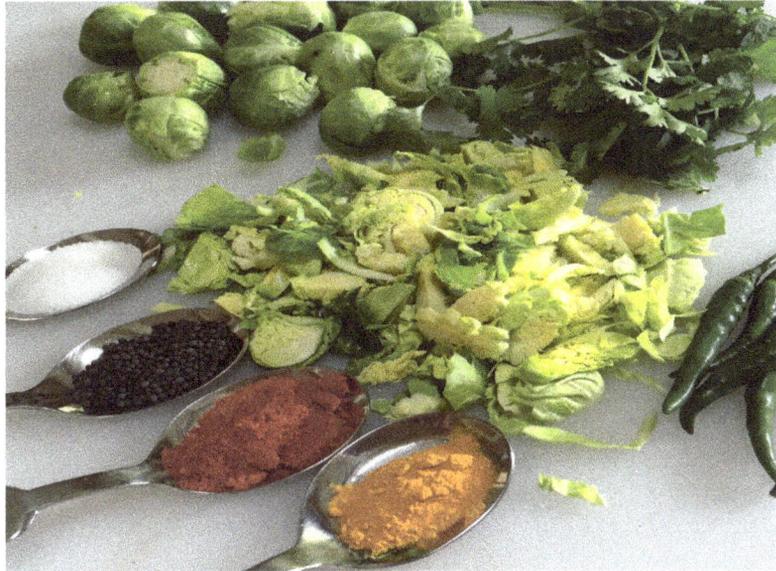

I know a lot of you will say, "Oh no, not Brussels sprouts!" But do you know they are a great source of protein, with a lot of fiber, minerals, and antioxidants? Brussels sprouts are winter vegetables, oval and small in size. They are of the same family as the cabbage and other leafy veggies. So, try my recipe and see if it will change your mind about Brussels sprouts.

SERVES 4

INGREDIENTS:

- 12–16 ounces of nice green Brussels sprouts, finely chopped or quartered
- 2 to 3 cloves garlic, grated
- ½ teaspoon salt (to taste)
- ⅛ teaspoon turmeric powder (opti onal)
- 3–4 green chilis (to taste), grated, or 1 teaspoon red powder
- 1 tablespoon coriander
- ¼ cup water

Fresh cilantro (optional garnish – remember it adds a lot of flavor with a pinch)

INGREDIENTS FOR VAGHAR:

- ½ teaspoon mustard seeds
- 3 to 4 tablespoon oil
- Dash of hing

DIRECTIONS:

Wash and take the top leaves off each sprout, chop them the way you like.

In a frying pan, add oil. Heat at medium temperature. Add mustard seeds, let them start popping, and lower the heat.

Once they stop popping, add hing and then add Brussels sprouts. Mix and cook until it sizzles.

Lower temperature to low, cover for a few minutes, stir again, and add salt. Sprinkle with 2–3 tablespoon of water, cover, and cook for 5 minutes.

Add the remaining spices and cook at low heat, covered, for about 5 more minutes. Check to see if they are soft, and keep covered until you are ready to serve them.

Garnish with cilantro. Serve with other veggies, rice, or meat. A great side dish!

Reheat at low heat, uncovered, to eat later.

Note: You can cut them in half and blanch them in lightly salted water for faster cooking, or toss them into hot oil and quickly fry them, then cook them as directed above. Try different versions.

Enjoy!

Dudhi Chana nu Shaak
Bottle Gourd Squash

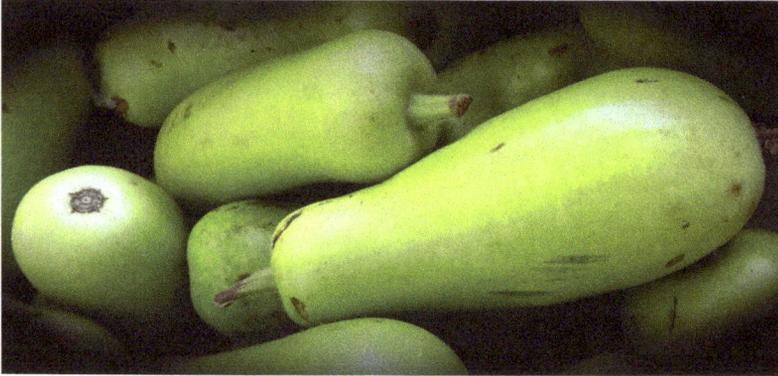

A nice combination of dal & lentil with dudhi from the squash family.
A favorite of many, this dish cooks fast and is simple and easy.

Buy nice thin green dudhi; if they are too fat, they will be high in fiber and tough, which will not cook well. If you can't peel it, that means it is too fibrous, so do not use. If there are too many seeds, remove them.

SERVES 4

Prep and cook time: 30 minutes

YOU WILL NEED:

- 3- to 4-quart pot

INGREDIENTS:

- 1 cup chana dal, washed several times and soaked in warm water for 30 minutes
- 1 large dudhi/bottle gourd(should yield 6 cups), peeled,cubed into 1 inch pieces
- 2 tablespoons grated fresh ginger ▪
3 green chilis, grated
- ¼ teaspoon turmeric powder
- 1 tablespoon coriander
- 1 teaspoon salt (to taste)
- ½ teaspoon of sugar (opti onal) ▪ 2
to 3 cups of water
- Cilantro to garnish

INGREDIENTS FOR VAGHAR:

- 4 tablespoons oil
- 1 teaspoon mustard seeds
- Dash of hing (optional)

DIRECTIONS:

Heat oil in pot. Add mustard seeds and let them pop. Lower heat and add hing.

Add drained chana dal with 3 cups of water. Cook until dal is soft; add more water if needed.

Mix in dudhi and add all the spices. Dudhi will release water, but if not add another cup of water after a few minutes.

Cook until dudhi is translucent and soft; add more water if needed to make a gravy.

Reheat at low temp and serve warm with another side dish.

Lal Bhaji nu Shaak
Red Spinach

*A red leafy spinach, very tasty, easy to make, and mostly found in Asian markets.
It's sold in large bunches–you might think that the large bunch will be too much, but you are mistaken!*

Wash well, take each stem and break off the leafy part with some tender stems, and discard the stalks. (You can use the stalks but you have to peel each one, which is a lot of work – but if you are up to it, chop them up and cook with the leaves.)

Wash the leaves well, then drain in colander. Leave wet. Chop by hand or pulse to medium size in a food processor.

SERVES 2–3

Prep and cook time: 1 hour

YOU WILL NEED:

Frying pan or deep-dish pan

INGREDIENTS:

- 1 large bunch red spinach, washed, drained, stalks removed, finely chopped (yields 3 pounds)
- 6–7 cloves garlic, grated or finely chopped
- ½–1 teaspoon salt (to taste)
- 3–4 green chilis, grated (to taste)
- 1 tablespoon coriander powder
- 2 cups chopped onions, your choice (optional)
- 2 tablespoons water

INGREDIENTS FOR VAGHAR:

- 3 tablespoon of oil
- ½ teaspoon mustard seeds
- Dash of hing (optional)
- ⅛ teaspoon baking powder or kharo

DIRECTIONS:

Blend garlic and chilis. Set aside.

Add oil to a medium frying pan, heat, add mustard seeds, lower heat, let them pop. Add baking soda or kharo and hing.

Add onions and sauté for 1 minute. Add chopped spinach and sauté for a few minutes.

Add salt, stir, cover, and cook at low heat for about 5 minutes.

Add remaining ingredients, mix, cover, and let it cook until soft.

Keep sautéing at low heat. The spinach will dwindle down to about ¼ of the amount.

Turn off stove and cover; let it finish cooking.

Serve hot with another one of your favorite vegetables and rotli, or it goes great with kichadi.

Tameta Vatana nu Shaak
Tomatoes and Peas

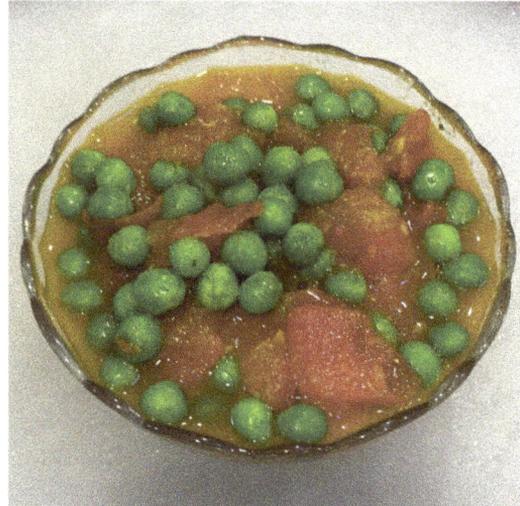

A light sweet-and-sour dish made with simple spices and a tomato gravy.

SERVES 4 (WITH ANOTHER SIDE DISH)

Prep and cook time: 20 minutes

YOU WILL NEED:

- 3- to 4-quart pot

INGREDIENTS:

- 4 cups of frozen or fresh peas
- 2 cups diced fresh tomatoes
- 1 tablespoon coriander powder ▪ 1 teaspoon salt
- ½ tablespoon of red chili powder (to taste)
- ¼ teaspoon turmeric powder
- ½ cup water or as needed

INGREDIENTS FOR VAGHAR:

- 5 tablespoons oil
- 1 teaspoon cumin seeds
- Dash of hing

DIRECTIONS:

Make vaghar: add oil to pan and heat, add cumin seeds, let them turn slightly red.

Add hing, sauté in your tomatoes, and cook for about 1 minute.

Add all spices, mix, add ½ cup of water.

Cook until tomatoes are soft and cooked.

Add peas and enough water to cover them. Cook at low heat for about 5 minutes. If using fresh peas, cook until peas are soft.

This dish should have a gravy to it; add more water if needed.

Garnish with cilantro and coconut, or add sev to give a twist to the dish.

Variation: add potatoes or cauliflower to this recipe and cut down on the peas.

Tindora nu Shaak

A very exotic vegetable that looks like small cucumbers. I LOVE the taste; very different and light. The flesh has a crunchy texture with a mildly sweet taste. It can be cooked, but can also be grated raw to make raitu. Slice them thin and mix them with pickle masala, or make a chutney with them to serve as a condiment. This is a very primary vegetable found in India, Thailand, and Vietnam.

When buying tindora, they should be nice, green, thin, and not soft. You should always buy a few extra pieces, because some of them could be overly fibrous ones; you will know this when they are hard to cut or are red inside. Discard these. Wash them thoroughly and cut a small piece off each end of the tindora one by one. Cut them in half and then another half (4 pieces) or slice them into thin round shapes.

SERVES 4
Prep and cook time: 45 minutes

YOU WILL NEED:

- Deep-dish frying pan

INGREDIENTS:

- 2 pounds of tindora, washed and cut
- 3 cloves garlic or 1 tablespoon ginger, grated
- 3 green grated chills (to taste)
- 1 teaspoon salt (to taste)
- 2 tablespoons coriander powder
- ¼ teaspoon turmeric powder
- ¼ cup chopped cilantro for garnish

INGREDIENTS FOR VAGHAR:

- 3 tablespoons oil
- 1 teaspoon mustard seeds
- Dash of hing
- ⅛ teaspoon baking powder or kharo (optional)

DIRECTIONS:

Using a deep-dish frying pan, heat oil, add mustard seeds, let them sputter. Add hing and baking powder.

Toss in your cut tindoras and mix well at high heat for about 2 minutes.

Add salt, mix, and cover; cook at low heat for 5 minutes, stirring occasionally.

Add in remaining spices and continue cooking until tindoras are soft, or leave them a little undercooked; you can finish cooking them when you reheat before serving.

For a party, cut them ahead of time, or half-cook them and refrigerate; cook thoroughly before serving.

Turiya Choli nu Shaak
Chinese Okra with Chinese String Beans

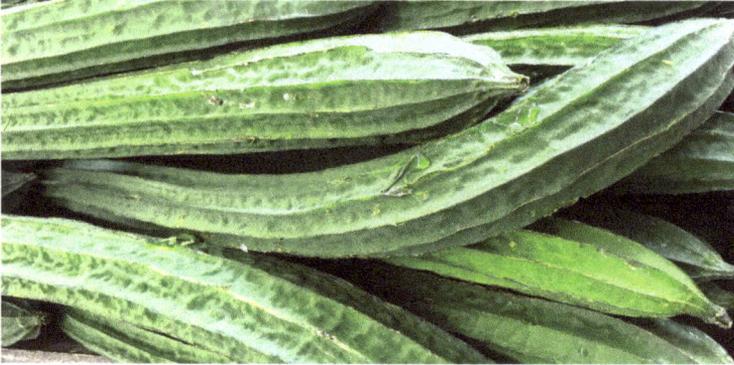

Turiya – a long, thin, green squash with sharp ridges. Not a lot of flavor, but has a nice texture and cooks quickly. Buy 1 extra turiya because sometimes they are bitter.

SERVES 4

Prep and cook time: 30 minutes

YOU WILL NEED:

- 4-quart pot

INGREDIENTS:

- 4 long, thin, green turiyas
- 1½ cups long string beans or 1 cup frozen and 1/2 cup fresh black-eyed peas
- 4 green chilis (to taste), grated
- 4 cloves medium-sized grated garlic
- 1 teaspoon salt
- ¼ teaspoon turmeric powder
- 1½ tablespoons coriander powder
- ¼ teaspoon freshly ground black pepper
- ¼ teaspoon garam masala (opti onal)
- ½ - 1 cup water

INGREDIENTS FOR VAGHAR:

- ¼ oil
- 1 teaspoon mustard seeds
- Pinch of baking powder
- Dash of hing

DIRECTIONS:

Peel the turiyas, starting with the ridges, then lightly peel the rest, leaving some of the skin on.

Wash and cut a small piece off the end and taste it; sometimes they are bitter. If it tastes bitter, cut one inch off the end and taste again. Sometimes only the top part is bitter. If it is bitter, then you have to throw the turiya away. Do this process with all of them. Cut the good turiyas into cubes and set aside.

Wash your string beans, cut ends off both sides, and chop them into ½ pieces.

Add oil to your pot, add your mustard seeds, let them pop, and add dash of hing.

Add your veggies, mix. Add salt and baking powder, stir, lower heat, cover, and cook for about 2 minutes.

Add all remaining spices, then cover and cook at low heat for about 15 minutes. The turiyas will release water.

If you would like to have more gravy, add ½–1 cup of water, depending on how much gravy you would like.

Cook for a few minutes more; taste for salt and spiciness.

Serve with another vegetable and a side of rice, dal, khadi, and rotli.

Val nu Verdo - Soya Bean Sprouts

A great source of protein, fresh, light in calories, and quick and easy to make.

The most common sprouts found in Asian markets are mung bean, but these are soya bean sprouts (check before purchasing).

SERVES 4

Prep and cook time: 45 minutes

YOU WILL NEED:

- 3- to 4-quart pan or pressure cooker

INGREDIENTS:

- 1½ pounds soya bean sprouts
- ⅛ teaspoon of turmeric
- 4 green chilis, grated (to taste)
- 1 teaspoon salt
- 1 teaspoon coriander powder
- 3 large cloves garlic, grated
- enough water to cover the sprouts

INGREDIENTS FOR VAGHAR:

- 3 tablespoons oil
- ½ teaspoon ajmo /ajwain seeds
- ¼ teaspoon baking powder or Indian kharo

DIRECTIONS:

Wash soya bean sprouts with cold water, drain and chop into 2 inch pieces.

Make vaghar: in a 3- to 4-quart pan, add oil, heat, add the ajwan seeds, and let them roast until slightly red.

Mix in hing and baking powder, then add sprouts. Mix well, and add enough water to cover 1 inch above your sprouts.

Bring to a boil and lower to simmer for about 15 minutes.

Add the spices and cook until the soya bean sprouts are tender. Add more water if needed.

Garnish with cilantro and serve with another vegetable, kadhi, rice, and rotli or rotlas. Reheat before serving if needed.

Note: use a pressure cooker if you know how to use one; 2 whistles will do.

Bharela Marcha - Stuffed Sweet Peppers

SERVES 4–5

Prep and cook time: 1 hour

One of my favorite dishes to make. People find it different as well as tasty; unlike jalapeños, these bright-colored peppers are not spicy. Use yellow wax peppers or mix different colors together to make a very attractive looking dish.

Important note: if you use spicy jalapeños (which are all green), omit the green or dry chili powder in the ingredients and remove seeds.

INGREDIENTS FOR STUFFING:

- 20–25 sweet peppers, yellow, red, orange, etc.
- ¼ cup + 3 tablespoons of oil
- 1 cup chana flour (besan flour)
- 1 teaspoon salt
- ¼ teaspoon turmeric powder
- 3 grated green chilis or 1 teaspoon hot red chili powder (to taste)
- 1 tablespoon coriander powder
- 1 teaspoon whole cumin
- ½ medium lemon, juiced
- 2 to 3 teaspoons dry (sugarless) or fresh-grated coconut
- 2 tablespoons Indian brown sugar (jaggery /gol) (to taste)
- ¼ bunch cilantro, chopped

INGREDIENTS FOR SAUCE (VAGHAR):

- 3 medium-sized fresh tomatoes, diced (canned tomatoes can be used, or diluted tomato paste – fresh is always better)
- $\frac{1}{3}$ cup oil
- 1 teaspoon mustard seeds
- 1 teaspoon cumin seeds
- ¼ teaspoon salt
- ⅛ teaspoon red chili powder
- $\frac{1}{3}$–¼ cup water
- Cilantro for garnish

DIRECTIONS:

Wash peppers, cut the tops off, and scoop out the seeds. Slit them in the center but not all the way through. Soak in cold water.

In a nonstick frying pan, add oil, heat at medium heat, add the chana flour, and mix well. Sautee at low heat until the flour turns a light reddish-brown. It will release a very nice aroma (if you find the flour too dry, add a little more oil). The flour will be dry in the beginning and will release the oil as it cooks (5–7 minutes). As the flour starts cooking, it will become lighter and fluffier; this means that it is almost done.

Remove from heat, add all the stuffing ingredients, and mix. Taste for saltiness and how spicy you want it. If necessary, add more green or dry chili powder. The stuffing should be a little spicy and sweet, and you should taste the lemon.

Set aside and let the mixture cool, then mix with your hands.

Using your hand or a teaspoon, lightly stuff the peppers with the cooled stuffing; do not pack the stuffing in hard. You will have some stuffing left over – keep it aside.

In a large frying pan, heat oil, add mustard seeds, and let them pop. Add cumin seed and diced tomatoes.

Add salt, chili powder, and water; sauté for 1 minute at lower heat.

Arrange the stuffed peppers on top of the tomato mixture. Cover the frying pan, and let them cook from the steam at low heat for 10 minutes. Add the leftover stuffing and continue cooking at least another 15 minutes.

Test the peppers with a fork. They should be soft and moist.

Garnish with cilantro and serve warm with other veggies and rice or meat.

Enjoy your stuffed peppers! Share with your friends!

Undiyu

Undhiyu – the ultimate dish of Gujarat, a slow-cooked, delicious, mouth-watering recipe.
This recipe takes time and patience. So many vegetables are in this dish, but the main vegetable is surti papdi (Gujarati papdi).

I have made it easier and also used less oil. You can make this dish on the stovetop in a large Dutch oven or a nonstick heavy pot, on low heat, but you must attend to it. For stress-free cooking, use the oven.

Traditionally it was made in a clay pot, which really brings a wonderful taste to it. You can invest in a clay pot from any Asian store and cook it in the oven, or just use a large, deep dish. This is a great make-ahead dish.

You can buy fresh surti papdi or frozen. If fresh, you have to clean each papdi pod, wash, and devein it –this can take a long time, but it is worth it. You can clean and wrap papdi in a paper towel and store the beans for few days in the refrigerator to get a head start. It's your choice, but fresh is the best way to go!

Prep and cook time: 1½ hours

YOU WILL NEED:

- Deep tray for oven cooking or a nonstick Dutch oven, or deep pot for stove cooking.

Vegetables:

- 8 small baby eggplants or Italian long eggplants, washed, tops cut off, and cut crisscross from bottom if you want to stuff them, or into large pieces if you don't
- 2 medium potatoes or 16 tiny boiling potatoes, washed and diced
- 2 pounds of surti papdi, frozen or fresh
- 2 cups of fresh, peeled rataru (purple kand), cut into 2-inch-sized pieces
- 2 cups of fresh sweet yams (purple, white, or orange), diced into about 2-inch pieces – do not peel
- 1 banana sliced into 4 pieces, with peel
- 1 cup fresh or frozen vaal lilva (optional)

Prepare the veggies:

If you are going to make undhiyu on the stove, you do not need to blanch any of the vegetables.

For oven cooking, in a 4-quart pot, add 3 quarts of water with ¼ teaspoon salt and ¼ teaspoon baking powder. Bring to a boil and add your cleaned or frozen papdi, kand, and potatoes to blanch. Bring to boil and remove from stove. Let rest in the hot water for about 10 minutes, then drain in a colander.

The stovetop and oven cooking will take the same length of time, but the oven cooking takes less oil and you do not have to keep attending to it.

INGREDIENTS FOR STUFFING:

- 2½ cups finely crushed raw peanuts
- ¼ cup fresh or frozen shredded coconut
- 1½ teaspoons salt (to taste)
- 2 packed tablespoons grated ginger
- 3–4 cloves garlic, grated

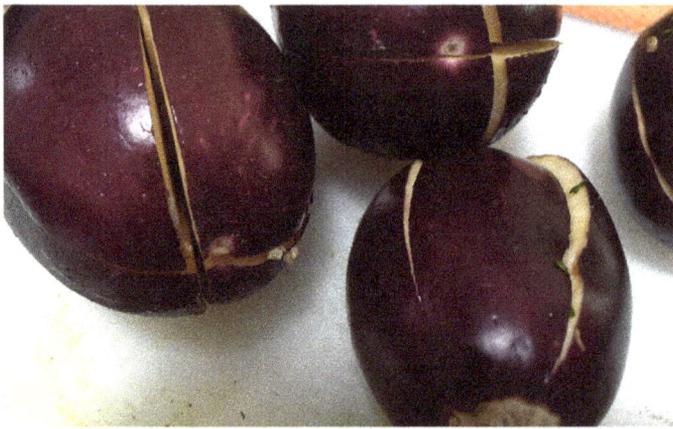

- ½ teaspoon red chili powder
- 1 teaspoon whole cumin
- ½ teaspoon turmeric powder
- 2 tablespoons coriander powder
- 5–6 green chilis (to taste – depends on how hot they are), grated
 2 teaspoons sugar
 ½ teaspoon baking powder or kharo
 1¾ cup oil (or more – the stuffing should not be dry; it should be moist and not fall apart)
- ¼ teaspoon hing (optional)
- ½ cup chopped cilantro
- 2 tablespoons fresh lemon juice

INGREDIENTS FOR VAGHAR:

½ cup of oil
1 teaspoon ajmo/ajwain
½ teaspoon hing
1/2 cup extra oil – set aside
1 cup water
extra cilantro and coconut for garnish

DIRECTIONS:

You can mix all the stuffing ahead of time, cover, and store in refrigerator. Mix all the stuffing

ingredients by hand, or using a food processor, adding the ingredients to the food processor in layers: first ginger, chilis, and cilantro, then peanuts and spices, then drizzle the oil through the funnel. Mix and pulse to get a fine-crushed mixture. This stuffing should be spicier than you like it, also sweeter, and you should be able to taste a little extra salt. The vegetables will need the extra spices. Tasting is very important.

Stuff the eggplants with 1 teaspoon of stuffing in each (omit this step if cutting them into pieces). Set the extra stuffing aside.

FOR STOVETOP COOKING:

Heat oil in a large heavy pot. Add ajmo, and let it roast for a few seconds until slightly red. Add hing. Add all the vegetables, add water, cover and let it cook at medium heat for about 10 minutes, stirring occasionally. Make sure it doesn't stick to the bottom. Add the extra stuffing on top, cover, and cook at low heat until all the vegetables are tender, stirring occasionally. Add a few tablespoons of water if needed to finish cooking. You may need more oil for stovetop cooking.

FOR OVEN COOKING:

Heat oven to 400 degrees. In a small stovetop pot, add oil, heat, add ajmo, roast until slightly red. Add hing, then pour this over the stuffing mixture and mix well.

Take half of the stuffing and mix into the papdi; put the other half into the remaining vegetables.

In a large, deep tray, start the 1st layer: take ½ of the papdi mixture and spread it in tray. 2nd layer arrange stuffe eggplants and all vegetables evenly. 3rd layer spread remaing papdi mixture and arrange cut bananas on top.

Drizzle with some oil, sprinkle water on top, and cover tightly with foil.

Place on middle rack in oven and cook at 400 degrees for 10 minutes, then lower to 350 degrees and cook for 45 minutes until all veggies are soft.

Serve hot and garnish with cilantro and coconut.

Serve this dish with kadhi, mango ras, shrikhand, and pooris. What a feast!

You can assemble this dish 1 day ahead, store in refrigerator, and bake later.

Gujarati Kobi nu Shaak
Cabbage with Veggie

This dish can be made with just cabbage alone, but I like to add other vegetables to it. This is cabbage at its best.

SERVES 3–4

INGREDIENTS:

- 1 small head of cabbage, chopped (yields 3 cups)
- 1 carrot, chopped
- 1 medium-sized potato, peeled and cubed
- ½ cup frozen peas
- ¼ teaspoon turmeric
- 1 teaspoon salt
- 2 teaspoon coriander powder
- 3 small green chilis (to taste), grated
- ¼ teaspoon red chili powder
- 2 tablespoons chopped cilantro

INGREDIENTS FOR VAGHAR:

- 2 tablespoons oil
- 1 teaspoon mustard seeds
- ½ teaspoon whole cumin seeds
- Pinch of hing (optional)

DIRECTIONS:

Discard the outside leaves of the cabbage. Cut cabbage head in half and then shred or cut finely, yields about 3 cups.

In a bowl, mix all spices except salt. Add cabbage and mix well; set aside and let it marinate for about 10–15 minutes.

Get all your vegetables ready, cleaned, and chopped.

In a frying pan, add oil and heat on medium heat. Add mustard seeds and let them pop. Add cumin and hing.

Add vegetables and cook, covered, on low heat for about 3–5 minutes or until they are done; check to see if the potatoes are cooked.

Add cabbage mixture and salt and mix, then turn off the stove and keep stirring. The cabbage should be crunchy and not overcooked.

Tip: Before serving you can reheat the cabbage; just give it a quick heat and stir. If you like your cabbage soft you can cook it longer, but I advise eating it half-cooked — more flavor and healthier.

Serve with another gravy vegetable and roti. Garnish with chopped cilantro.

Note: you can make this cabbage without adding any other veggies, or you can substitute the veggies for any others you prefer.

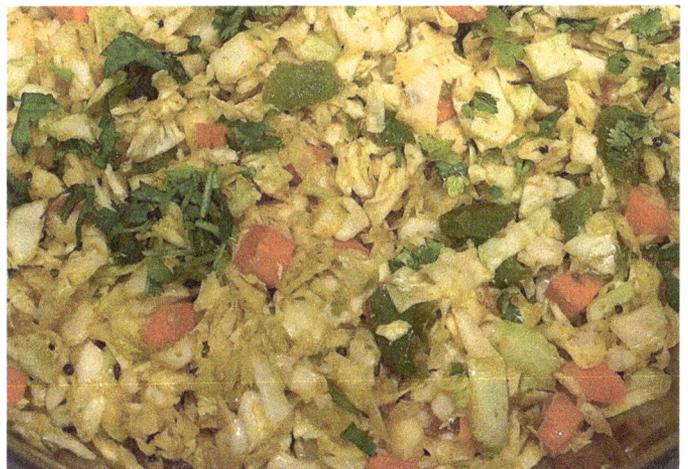

Bharela Bhinda nu Shaak
Stuffed Okra

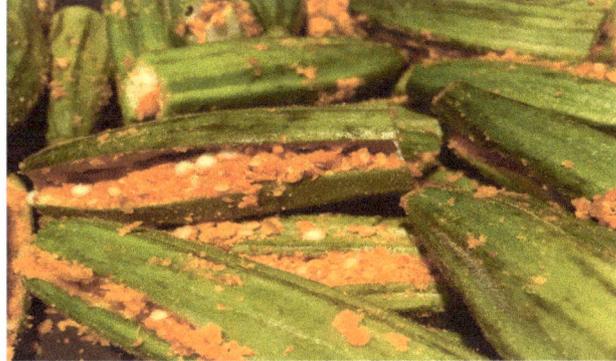

Okra (also known as bhindi or ladyfingers) are an Indian favorite – at least in my house. When buying okra, make sure they are green, thin, and firm. Do not buy if they are very big (too much fiber) or have black spots on them. They are very tasty if cooked the right way.

SERVES 5

Prep and cook time: 45 minutes

INGREDIENTS:

- 40–50 pieces of okra or 1½ pounds
- ¾ cup chana flour/besan flour
- 3 to 4 cloves garlic, grated
- ½ teaspoon turmeric
- ½ tablespoon salt (to taste)
- 2 tablespoons sesame seeds (or crushed raw peanuts)
- 1 tablespoon coriander powder
- ¼ teaspoon baking powder or kharo
- ⅛ teaspoon hing (opti onal)
- ½ teaspoon sugar
- 1½ tablespoons red chili powder (to taste)
- 1 teaspoon whole cumin seeds
- ¼ teaspoon whole ajmo seeds
- 5 to 6 tablespoons vegetable oil
- ¼ cup finely chopped cilantro
- ⅓ cup oil

DIRECTIONS:

Wash okra and pat dry. Cut off top and bottom tips and slit each down the center without cutting all the way through. Set aside.

Mix all the ingredients together by hand or in food processor, drizzle oil thru funnel until all the flour is coated with the oil, hand mix in chopped cilantro.

Taste the mixture; it should be slightly salty and spicy. Add more salt and red chili powder if needed. The mixture should not be too dry – add more oil if needed.
Stuff each okra with a small amount of the mixture.

Heat ⅓ cup oil in a large nonstick frying pan. Add all the stuffed okra and sauté them for about 2 minutes at high heat, then lower heat to low and cover for about 5 minutes. Remove cover and add any leftover stuffing, then continue cooking, uncovered, until soft, about 20 minutes.

Note: you can refrigerate the stuffed okra in an airtight container to be cooked the next day for a large party.

If you don't want to stuff each piece of okra, cut them into large pieces, heat your oil, add the okra, and sauté them for about 5 minutes at medium heat until they are soft. Spread all stuffing on top, cover, and lower to low. Let cook for about 5 minutes, then check to see if okra is soft, mix gently, and remove from heat. Keep covered until ready to serve.

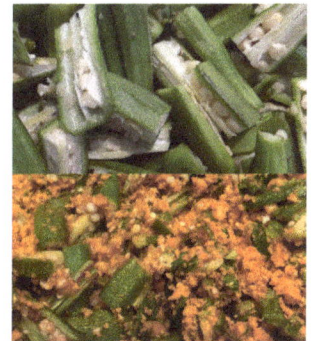

Bhinda nu Shaak
Okra

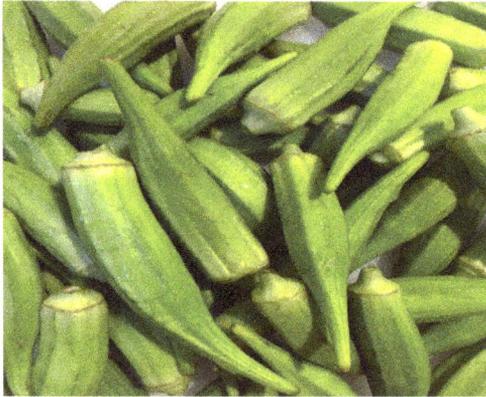

Okra, a simple veggie, fast and easy. Purchase 2 pounds of nice thin, green okra. Some of the okra might have a lot of fiber, so you may have to discard a few. If you are using frozen, thaw out on layers of paper towels for a few hours. When using fresh okra, wash in cold water; do not soak them. Cut off tops and a bit of the bottom. Cut into any shape you like, and let them air-dry for about 1 hour or more. Having a party? Prepare them ahead of time and refrigerate. This is a dry version.

SERVES 4

Prep and cook time: 1 hour

INGREDIENTS:

- 1½ pounds okra
- 3 cloves garlic, grated
- 1 tablespoon coriander powder
- ¼ teaspoon turmeric powder
- 1 tablespoon red chili powder
- 1 teaspoon salt (to taste)
- ¼ tablespoons oil (less if you fry them first)

INGREDIENTS FOR VAGHAR:

- 1 teaspoon mustard or fenugreek seeds
- Dash of hing
- Dash of baking powder (omit if okra is fried)

DIRECTIONS:

VAGHAR

Heat oil in a medium-sized nonstick frying pan. Add mustard seeds (let them pop) or fenugreek seeds (roast until red).

Add hing and baking powder, toss in your okra, mix well.

Cook at high heat for about 1 minute, then lower and add salt. Cook uncovered for about 3–4 minutes, stirring lightly, and add the spices.

Lower heat to low. The okra will be slimy, but it will cook off.

Stirring occasionally, cook until okra is soft; cook longer if you like it crispy.

Garnish with cilantro, serve warm.

Note: you can fry the okra lightly in hot oil first, and then follow the directions above to cook them. Also you can add diced potatoes and/or onions for a different variation.

Stuffed Tindora

A very unique Indian & Asian vegetable in the gourd family, found in Indian supermarkets. They look like tiny cucumbers and are delicious stuffed.

They can be stuffed a day ahead before your party. Refrigerate and cook before serving.

SERVES 4

Prep and cook time: 45 minutes

YOU WILL NEED:

- Deep dish or frying pan

INGREDIENTS:

- 1½ pound tindoras (60 pieces)
- ¼ cup finely grated coconut
- 4 cloves garlic, grated
- 4 green chilis, grated (to taste)
- 3 tablespoon coriander powder
- 1 teaspoon red chili powder (optional)
- 1 teaspoon crushed cumin
- 1 cup finely chopped fresh cilantro
- 1 teaspoon salt
- 7 tablespoons oil
- ½ teaspoon baking powder or kharo

DIRECTIONS:

Wash the tindoras in cold water, cut off top and bottom tips, and slit each down the center without cutting all the way through. Sprinkle salt over them and mix evenly. Set aside – this process is to make them softer, which makes it easier to stuff.

Mix all ingredients together with 3 tablespoons of oil. If the stuffing is too dry, add more oil; the stuffing should not fall apart.

Take about ¼ teaspoon of stuffing and stuff each one by hand.

Using a deep dish or frying pan, add 4 tablespoons of oil, heat at medium temperature, lay out your stuffed tindoras, and sprinkle with 2 tablespoons of water.

Lower the temperature, cover, and cook for about 10 minutes, stirring twice (make sure they do not break).

Uncover, then finish cooking for another 15–20 minutes or until soft.

Broccoli nu Shaak
Broccoli

A simple, tasty dish. Buy shredded cabbage or broccoli to make this dish faster, or chop it yourself. Serve with another side of vegetable and rotli.

SERVES 4

Prep and cook time: 30 minutes

YOU WILL NEED:

- Medium-sized frying pan

INGREDIENTS:

- 6 cups of chopped broccoli
- 1 tablespoon coriander powder
- 1 teaspoon salt (to taste)
- 3 green chilis, grated
- 3 cloves garlic, grated

INGREDIENTS FOR VAGHAR:

- 4 tablespoons oil
- 1 teaspoon mustard seeds
- Dash of hing (optional)

DIRECTIONS:

Add oil to pan and heat. Toss in your mustard seeds; as soon as they start popping, lower the heat.

Add hing, then mix in your broccoli.

Sauté for about 2 minutes and add your spices. Mix and cook another 2–3 minutes, and your dish is ready to serve.

Kanda Bhaji nu Shaak
Spinach with Onions

I know a lot of you say "Oh no!" to spinach. But this is not just boiled with some salt. Make it this way and you will change your mind about eating spinach.

I love to serve this with plain rice or khichari, with a side of raita (spiced yogurt). It is a must with kadhi, or it can be a one-dish meal.

Serves 2

Prep and cook time: 45 minutes

You will need:

- Large frying pan

Ingredients:

- 3 bunches of spinach
- 1 large white or yellow onion, chopped
- 4 green chilis, grated or finely chopped (to taste)
- 6–8 cloves garlic, grated or finely chopped ▪ ¼ cup oil
- 1 teaspoon coriander powder
- ½ teaspoon of salt (to taste)

Ingredients for vaghar:

- ¼ cup oil
- ½ teaspoon mustard seeds
- ⅛ teaspoon fenugreek seeds (optional)
- Pinch of hing (optional)

Directions:

Wash your spinach well; it might have a lot of sand in it. Finely chop it and drain for a while on paper towels.

In a mixing bowl, add spinach and ¼ teaspoon salt. Massage the spinach with the salt for a little while and let it rest for a few minutes. Spinach will start releasing water. Take small amounts of spinach at a time and lightly squeeze out excess water. Do not over squeeze. Set aside. If you like alot of gravy then don't squeeze out the excess water.

In a frying pan, heat oil, add mustard and fenugreek seeds. Let mustard seeds pop. Add hing powder.

Add onions, sauté for about 1 minute or so, then add spinach, chilis, garlic, and remaining spices. Cook on low heat for about 5 minutes.

Note: Want it spicier? Just add more chilis to taste.

Vatana & Lili Choli ni Dhokari
Peas with chinese string Beans - Pasta in Soup

A great one-dish meal, one of my favorites. Serve it hot or cold, with extra to eat the next day. A very Gujarati dish, this is a soup base with whole wheat spiced pasta added to it. Drizzle oil on top, serve with sliced onions and lemon. You can make this sauce and add vegetables of your choice; I like to make this with guvar sing, found in Indian groceries, cut up into small pieces. Try other vegetables, like fresh black-eyed peas, fresh papdi and lilva, tuvar, or mixed vegetables. Buy them frozen or fresh.

SERVES 4

Prep and cook time: 1 hour

YOU WILL NEED:

- 4-quart pot

INGREDIENTS:

Sauce:

- ½ cup fresh or frozen peas
- 1½ cups long beans, washed, tops and ends cut off , cut into ½-inch-long pieces
- 1 tablespoon grated ginger
- 3 chilis (to taste), grated
- 1 tablespoon coriander powder
- 1 teaspoon salt (to taste)
- ½ teaspoon turmeric powder
- ⅛ teaspoon baking powder
- 5 to 7 cups water
- Lemon juice or slices and cilantro to garnish

INGREDIENTS FOR VAGHAR:

- 5 tablespoons oil
- ½ tablespoon mustard seeds
- Dash of hing

INGREDIENTS FOR DOUGH:

- 1 cup whole wheat flour
- 1 tablespoon chana flour (besan flour)
- 1 tablespoon oil
- 1 teaspoon sesame seeds
- 1 teaspoon red chili powder or 1 chili, grated
- 1 large clove garlic or 1 tsp grated ginger
- ¼ teaspoon salt
- ½ cup warm water

DIRECTIONS:

In a bowl, mix the flours and oil together. Add the spices, mix, add water, and form a medium-soft dough.

Wash hands and oil them. Knead dough and divide into 4 parts. Form small round bowls, and fatten them and dust them with flour. Cover and set aside.

Add oil to pot, add mustard seeds, let them sputter.

Add hing, baking powder, peas, and chopped string beans (or vegetables of your choice). Mix together, add 5 cups of water (reserve the rest if needed for later), and bring to boil, then lower to simmer. Add all spices.

Taste for salt and spice; add more if needed.

Take one piece of dough, dust your board, and roll it out into an 8- to 10-inch circle. Cut into 1-inch pieces using a sharp knife or pizza cutter.

Add the pieces to the sauce, stir gently, and repeat the process until all dough pieces are done.

Cover and simmer on low for at least 30–40 minutes. Stir occasionally until pasta pieces are nice and soft. Add the remaining water to make more gravy if you desire (cook for about 10 minutes after adding water).

Garnish with chopped cilantro. Serve hot or cold, with other sides or alone. A one-dish meal!

Daal Dhokari
Sweet-and-Sour Soup with Homemade Pasta

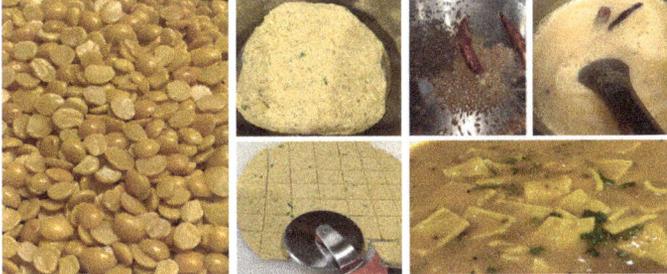

SERVES 4

Prep and cook time: 1–1½ hours

YOU WILL NEED:

- 4-6 quart pot or pressure cooker to cook dal

INGREDIENTS FOR GRAVY:

- 2 cups tuvar ni dal, washed, soaked for at least ½ hour
- 8 cups water
- 2 tablespoons grated ginger
- 3 serrano chilis (to taste)
- 1 teaspoon red chili powder
- ½ teaspoon turmeric powder
- 2 teaspoons salt (to taste)
- ½ large lemon, juiced
- ½ cup gol (jaggery)
- ⅛ teaspoon ajmo/ajwain seeds
- ½ cup whole raw peanuts

Ingredients for pasta dough:

- 1 cup whole wheat flour
- 1 tablespoon chana flour/besan
- ¼ teaspoon turmeric powder ▪ ½ teaspoon red chili powder ▪ ½ teaspoon ginger
- Dash of salt
- 1 teaspoon oil
- ½ cup of water

INGREDIENTS FOR VAGHAR:

- 5–6 tablespoon oil

- 4–5 dry red chilis (optional)
- 1 teaspoon mustard seeds
- 1 teaspoon cumin seeds
- ½ teaspoon fenugreek seeds (optional)
- Dash of hing

DIRECTIONS:

Wash the tuvar dal and add 4 cups water and bring to boil.

Lower to simmer and cook uncovered, skimming off the white foam with a spoon and discarding. Cook the dal until soft and breaking apart (about 20 minutes). Add water if needed.

While the dal is cooking, make your dough. In a small mixing bowl, mix flour and oil together and then add the spices, add water to make dough. Knead to make a soft dough, then grease hands and make 4–5 smooth balls and dust them with flour. Cover and set aside.

When dal is done cooking, blend the dal with hand blender until smooth. Then add the rest of the gravy ingredients. Add water if needed to make it thinner.

Using a small pot or butter warmer, do your vaghar: heat oil, add mustard seeds, and let them sputter. Add fenugreek and cumin seeds, roast for a few seconds.

Add hing, then slowly pour this mixture/vaghar into the blended dal. Stir.

Take one of the dough balls, dust a chopping board, and roll the dough out into a round 8-inch circle.

Using a pizza cutter, cut dough into diamond/ square 1inch pieces; add pieces a few at a time to the simmering dal. Stir before adding more pieces. Continue until all dough is added.

Cover and simmer on low for about 25 minutes, stirring and making sure that it doesn't stick to the bottom. It should have a lot of gravy. Add more water if needed and simmer.

Garnish with cilantro; drizzle with oil if desired. Serve with a side of rice or rotlas (tortillas), or just as a one-dish meal.

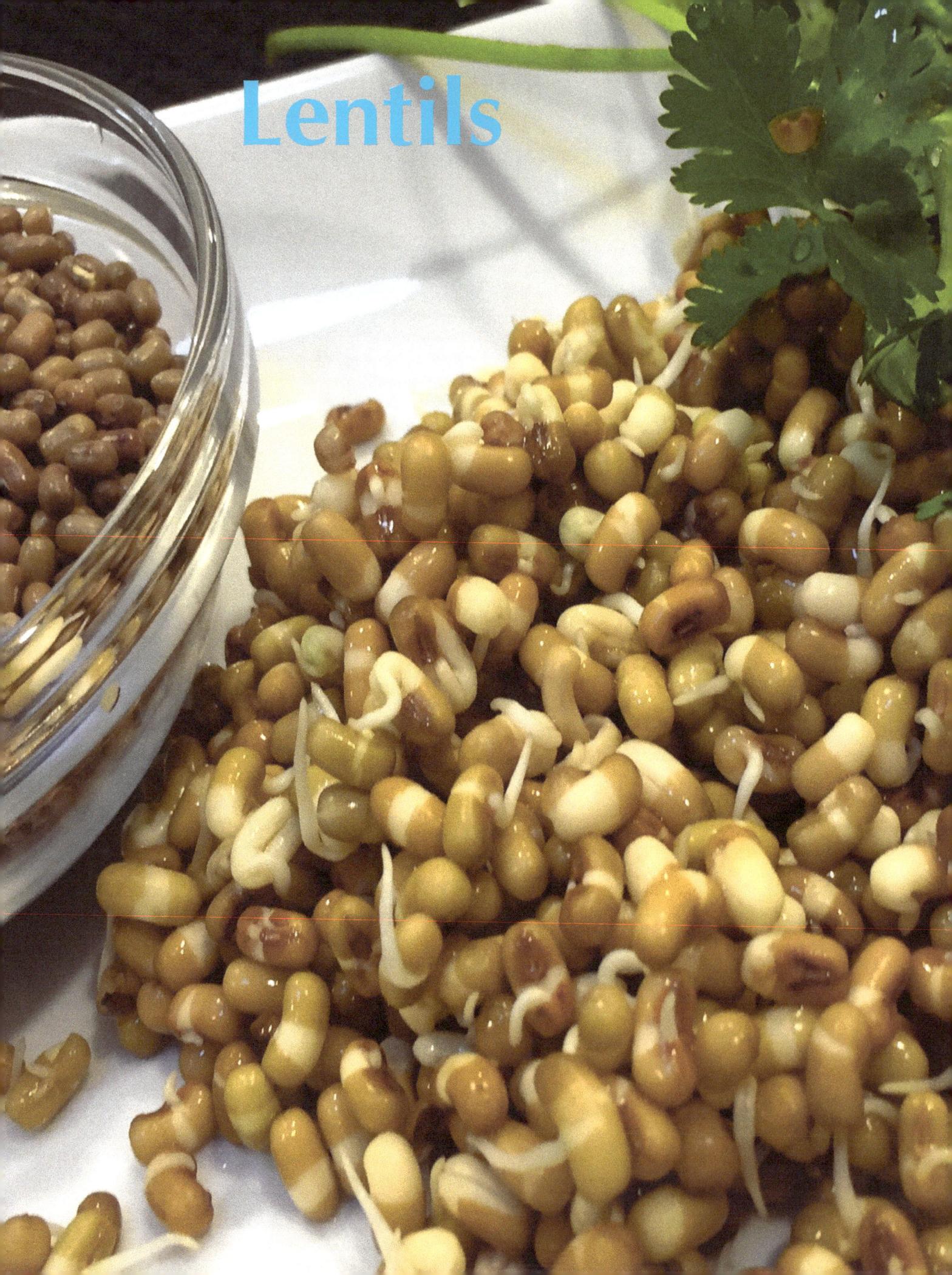

Lentils

Five Mixed Dals
Chevti Dal

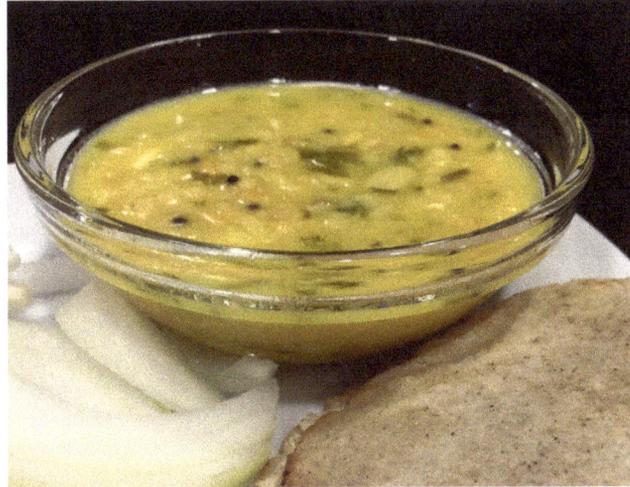

A dal packed with protein. A small amount goes long way! Tasty!

SERVES 4

Prep and cook time: 30 minutes–1 hour

INGREDIENTS:

- ⅛ cup of each of the following split lentils/dals: urad, yellow mung, orange masoor, chana, tuvar, about 4–5 pieces of vaal or vaal ni dal (optional)
- 1 teaspoon salt
- 1 tablespoon lemon juice
- Dash of turmeric powder
- 2 tablespoons grated ginger
- 2 green chilis (add more if needed), grated
- 1 clove garlic, grated

INGREDIENTS FOR VAGHAR:

- 1 teaspoon mustard seeds
- 4–5 tablespoons oil
- Dash of hing
- ½ cup plain yogurt

DIRECTIONS:

Mix all lentils and wash with water. Wash by rubbing the lentils in the water between your palms. Drain, add more water, and wash again. Do this process several times until the water is clear.

Soak if you have time for 1 hour or more in hot water, then cook. Separate the two cooking methods (To cook on stove top)

Method 1 : Using a pressure cooker, add dal to cooker add water ½ inch more them dal, cook until 3 whistles.

Method 2 : For stovetop cooking have at least 2 inches of water on top, or add more as needed. The lentils will take at least 20–25 minutes to cook. Bring to boil, then lower to simmer. Skim off white foam with a spoon. Continue cooking until lentils are tender.

After the dal is cooked, add all ingredients and let it simmer for about 5 minutes.

Make the vaghar: heat oil in a butter pan. Add mustard seeds, let them sputter, and add hing.

Pour this over your dal, mix, and fold in the yogurt. Cook the dal for a few minutes on low. Add more water to make dal thinner if you like.

Serve with another vegetable, roti, or warm tortillas.

Fungavela Mug
Sprouted Mung Beans

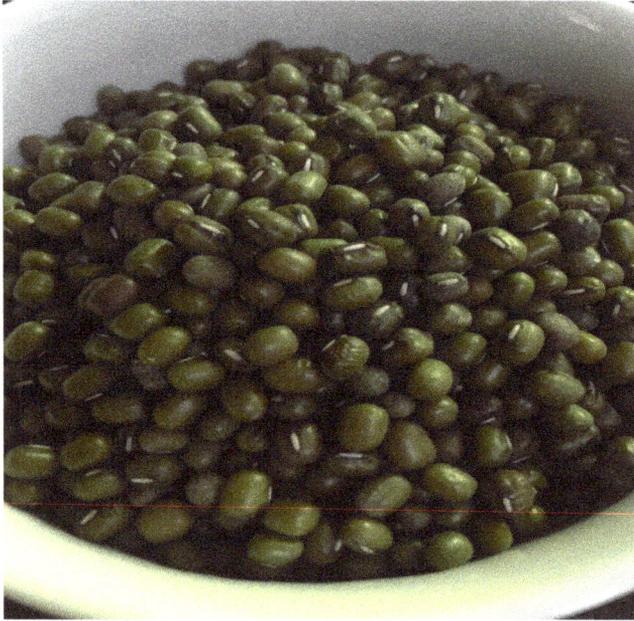

Sprouted mung beans – a different dish, one you will not find in a restaurant for sure! It is a two-day process, but worth it in the long run. You can store them in the refrigerator for a few days in a tight container, add them to salads uncooked, or prepare them as below. Healthy, simple, high in protein.

Yield: 6 cups after soaking

SERVES 4

INGREDIENTS:

- 2 cups mung beans
- 5 tablespoons oil
- 4 cups water
- 3 cloves of grated or chopped garlic
- 2 chilis (to taste)
- 1 teaspoon coriander powder
- 1 teaspoon salt
- extra-fi nely chopped chilis when serving
- Cilantro

DIRECTIONS FOR SOAKING:

Wash beans and soak in a large bowl with at least 3 inches of water on top. Soak overnight or at least 10–12 hours. Drain and check for hard ones: discard if any. (continue directions) Using a cheesecloth, wrap tightly, place in a colander, cover, and set aside for a day or two, or use a sprouting bowl. In hot weather, they do it in a day; in a cold climate they take 2 days. Sprinkle a little water the next day to help the sprouting process.

DIRECTIONS FOR COOKING:

Heat oil, add Mung sprouts,water and all ingredients, bring to boil, lower to simmer,cover and cook until tender. Drizzle with oil and chopped chillies before serving. Serve with Rotalas (tortillas) or Rotli.

Muth

A delicious lentil that can be sprouted,a great way to get protein into your diet.
This tiny lentil will take some time to sprout, at least one to two days.

SERVES 4

Sprouting: 12-18 hours

Cook time: 30 minutes

Ingredients

- 2 cups dry Muth
- 3 cloves of grated garlic
- 1 teaspoon salt
- 3 green grated chili's (to taste)
- ¼ teaspoon turmeric powder
- 1 tablespoon coriander powder.
- Fresh chopped cilantro to ganish.
- water

VAGAR/TEMPERING INGREDIENTS

- 1 teaspoon mustard seeds
- 4 tablespoon oil
- dash of Hing

Start by soaking 2 cups of Muth lentil in 6 cups of warm water overnight, or at least 12hrs. Drain in a colander and cover. Let it sit in a warm area for 24hrs. Check to see if you see sprouts, if not let them sit for one more day,another way to sprout them is to tied them into a cheesecloth for up to two days.

DIRECTIONS FOR COOKING:

Rinse the sprouted Muth under cold water, drain, using a small pan add oil, heat, add mustard seeds, let them sputter, toss in the hing powder, stir in the Muth, mix, add enough water to cover the Muth about ½ inch on top.

Bring to boil, lower to simmer, cover, simmer for about 10 minutes add in the remaining spices, cover and cook until Muth (10 minutes) are soft, add more water if needed to finish cooking, check by taking a piece and pressing it to see if cooked all the way thru.

Serve warm with rice,gujarati kadhi, rolti and a fresh green veggie or just serve as a one dish meal with roltala (tortilla's). Garnish with cilantro

Khatta Mug
Sweet and Sour Mung

This recipe is easy and quick. A great high-protein food to serve with another veggie, rice, tortillas, or just alone. Tasty, with a sweet-and-sour flavor.

SERVES 4–5

Prep and cook time: 45 minutes

INGREDIENTS:

- 1 cup mung beans, washed
- 2–3 cloves garlic or 1 tablespoon ginger, grated
- 3–4 green chilis (to taste), grated
- ½ teaspoon red chili powder
- 1 teaspoon salt (to taste)
- ¼ teaspoon turmeric powder
- Juice from 1 lemon
- $\frac{1}{3}$ cup gol/jaggery
- 1 cup chopped tomatoes
- 1 tablespoon coriander powder
- ½ cup fresh cilantro
- 9–10 cups water

INGREDIENTS FOR VAGHAR:

- 3 tablespoons oil
- ½ teaspoon cumin seed
- ½ teaspoon mustard seed

DIRECTIONS:

Bring 8 cups water to boil in a 3- to 4-quart pot and add mung beans. Cover partially and lower to simmer (15–20 minutes). Check occasionally and add more water as needed. Cook until tender; they will split open. Do not overcook them.

Once the beans are cooked, using a blender or chopper, blend chilis, ginger or garlic, and tomatoes together.

Add to mung beans and mix well. Add more water if you would like it a little thinner.

In a small butter pan, add oil. Heat and add mustard seeds; let them pop. Add cumin seeds and roast 4–5 seconds.

Pour this over slowly into the mung beans. Let the mung simmer again for about 5 minutes.

Serve warm.

Note: you can use a pressure cooker to cook your lentils; you will need less water and it will require less cooking time.

Chana or Yellow Mung (Mug) Dal

Mug Dal

Chana Dal

For this recipe, you can use either chana dal or yellow mug dal – a great source of protein. Serve it with a dish of vegetables and rice, or just alone with rotlas or rotlis.

SERVES 4

Prep and cook time: 30–45 minutes

INGREDIENTS:

- 1 cup chana dal or yellow mug (wash several times until water is clear, then soak in hot or warm water for at least ½ hour with about 2 inches of water on top)
- 2 or more green chilis (to taste), grated
- 1 tablespoon ginger, grated with big-hole grater
- 2 cloves garlic, grated with big-hole grater
- ½ onion, chopped
- 1 medium tomato, chopped
- 8–10 curry leaves (optional)
- ⅛ teaspoon turmeric powder
- 1 teaspoon salt

Note: if cooking yellow mug dal, it cooks very fast; use less water and stir gently or it will break up.

INGREDIENTS FOR VAGHAR:

- 1 teaspoon cumin seeds
- 6 tablespoons oil
- Dash of hing (optional)

DIRECTIONS:

In a small pot, add water about 1 inch above dal and bring to boil. Scale off the white foam, lower to simmer, and cook, covering partially. Add more water if needed.

Once the chana dal is cooked halfway (check by taking a dal and pressing between two fingers; it should not be cooked all the way), make the vaghar: In a small frying pan, heat oil. Add cumin seeds, roast for a few seconds, then add curry leaves, onion and tomatoes, and the rest of the spices.

Now pour this on top of the chana dal, add about ½ cup water or more, and mix.

Simmer for about 5–10 minutes. Cook until dal is soft and cooked all the way through.

Make the dal to your desired thickness. Add more water to make thinner and simmer for a few minutes. Also taste for spice and salt.

Garnish with cilantro.

Note: chana dal will get thicker as it cools; reheat on low and add more water to make it you desired consistency.

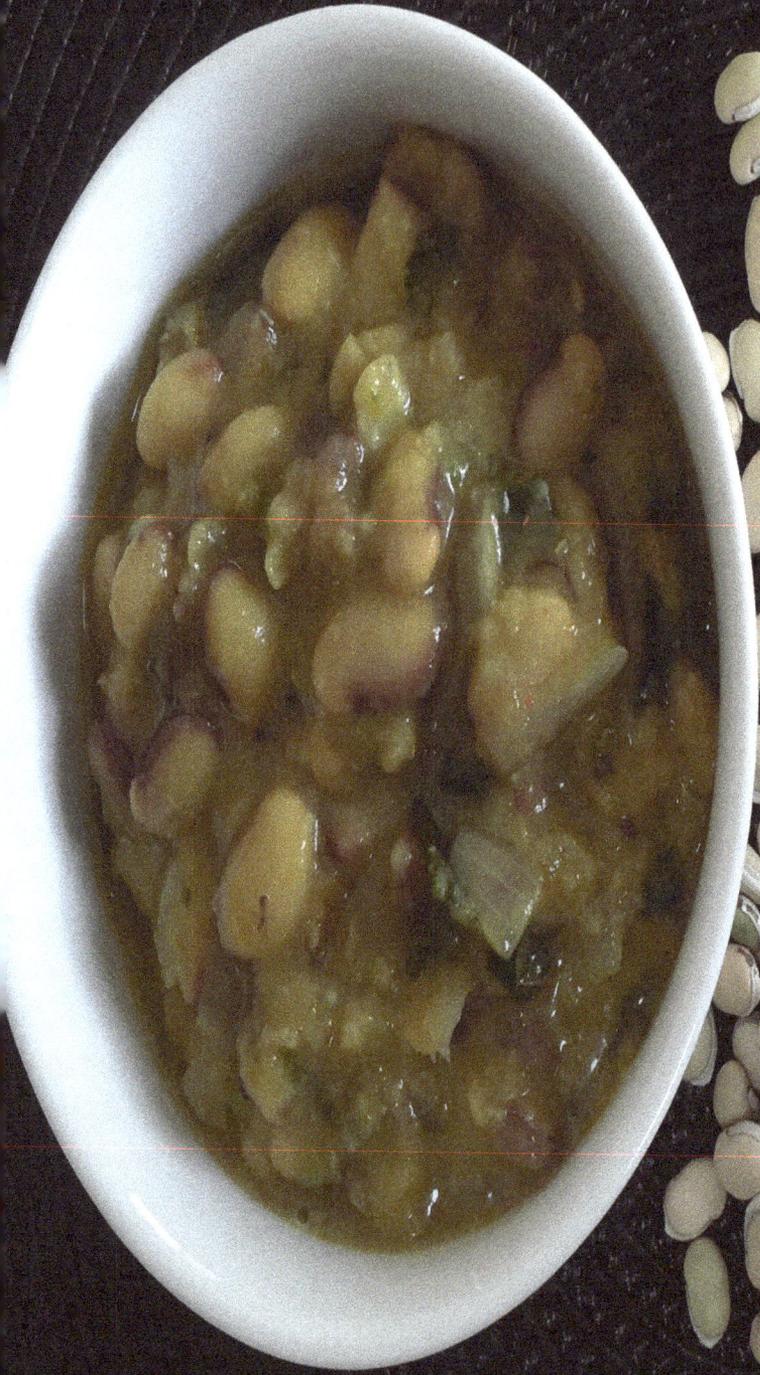

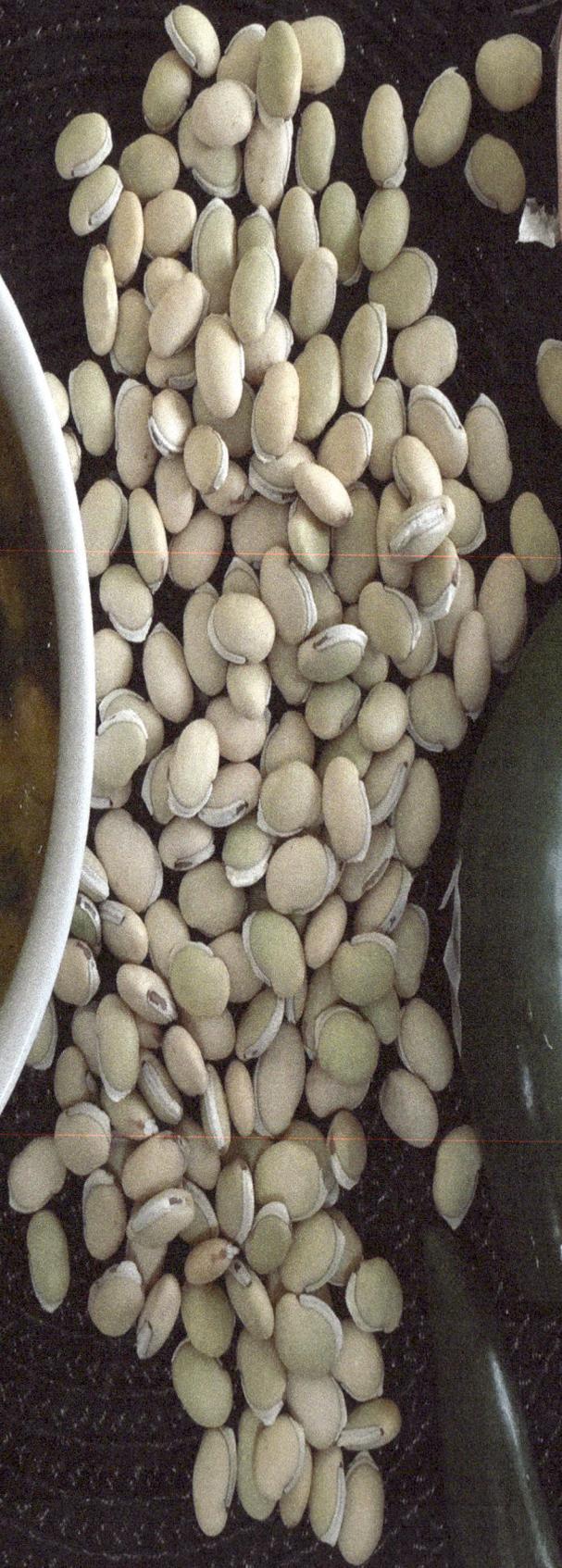

Mara Vaal - Field Beans

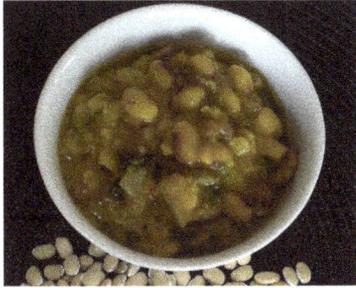

There are different types of vaal (the English name is hyacinth beans) popular in Gujarati homes. There are black ones, sweet green ones, and the ones in the picture, which are dry and slightly bitter, but very tasty. You can use any type of vaal (fava beans, lima beans, butter beans) for this recipe.

Sold in Indian grocery stores as surti vaal, the sweet ones are all white, while the slightly bitter ones have a greenish tint to them – both are tasty. Try both versions to see which one you like.

Vaals are a favorite in Gujarati homes. They are high in protein and fiber as well as Vitamin A, B, C, E, and H. Plan ahead of time to make this recipe.

You will need a pressure cooker for this recipe, or 1 hour or more of cooking time for the beans on the stove, with lots of water.

SERVES 3–4

Soak time: 7–12 hours

Cook time: 35 minutes to 1 hour

INGREDIENTS:

- 1 cup dry vaal, washed and soaked overnight or at least 7 hours in 6–7 cups of hot water with ½ tsp of baking powder. You can cut the soaking process down to 3–4 hours by adding hot water and microwaving for 7–10 minutes. (If using fresh green vaal, omit this process.)
- 1 medium white onion, chopped
- 3 cloves garlic, grated
- 3–4 green chilis (to taste), grated
- ½–1 teaspoon red chili powder
- 1 teaspoon salt
- ⅛ teaspoon turmeric powder
- 1 teaspoon coriander powder
- ½ cup chopped cilantro water

- ¼ cup fresh green garlic leaves or green onions (optional)
- ½ teaspoon sugar
- ½ teaspoon baking powder or kharo

INGREDIENTS FOR VAGHAR:

- ¼ cup oil
- 1 teaspoon ajmo/ajwain seeds
- 2 tablespoons crushed raw peanuts
- 1 tablespoon sesame seeds
- Dash of hing (opti onal)

DIRECTIONS:

Wash the vaals, drain in a colander, and check them carefully. Remove any that have black spots or have not soaked, usually found at the bottom.

If using a pressure cooker, add beans, baking powder, and 2–3 cups water (just depends on how big your cooker is). Once the whistle starts moving, lower the heat and cook for at least 10 minutes, or let it whistle 3 times. Remove from heat and let the cooker cool down before opening.

If you are cooking them on the stove, use a 3- to 4-quart pot. Add the beans, 6–7 cups of water, and baking powder, and cook until tender. Add more water as needed until cooked.

After the beans are cooked, rinse them with clean water, then mash up about ¼ of them and return all to the pot. This is to make a thick gravy.

Use a 3- to 4-quart pot to make the vaghar. Heat your oil, add ajmo, and let them roast until light red for a few seconds

Add hing, add onions, and sauté. Then add chili, garlic, salt, turmeric powder, coriander powder, and sauté for about 1–2 minutes. Add the cooked beans (val), mix, and add about 2 cups water.

Bring to a boil, lower to simmer, then add sesame seeds, crushed peanuts, fresh green garlic, and cilantro. Mix well.

Add more water if you want thinner gravy, and simmer for at least 10 minutes.

Garnish with cilantro, and serve with another veggie, rice, Gujarati curry, and rotli or rotlas (tortillas).

Note: If you like these a lot, make a large batch and freeze them in portions.

Lal Choli
Adzuki Beans

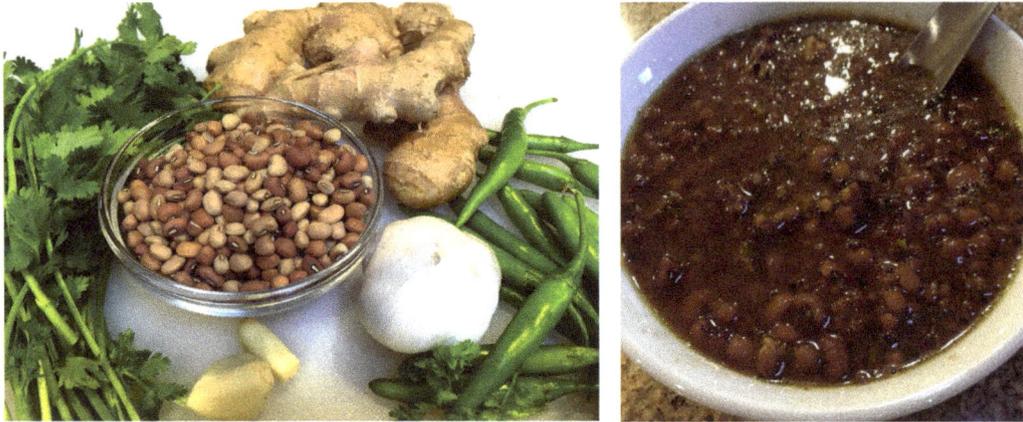

Red beans, also known as adzuki beans and lal chori, are a rich source of both fiber and protein. They are small in size, dark reddish-brown in color, and oval in shape. They have a wonderful nutty flavor. They can be purchased at any Indian grocery store or specialty store.

Any type of beans needs to be soaked overnight to make them nice, soft, and easy to cook in less time. Soak them overnight with about 4–5 inches of water on top; the beans will absorb the water as they soak.

Use a pressure cooker if you have one. If you do not have a pressure cooker, this recipe can easily be made on the stovetop or in a slow cooker (the cook time will be longer).

SERVES 2–3

INGREDIENTS:

- 1 cup dry red black-eyed peas (chori)
- Pinch of baking powder
- Water
- 3–4 green chilis, grated (to taste)
- 2 pieces of garlic cloves
- 2 tablespoons grated fresh ginger
- 1 teaspoon dry coriander powder
- Pinch of turmeric
- ½ teaspoon salt (to taste)
- 1 tablespoon chopped cilantro for garnish

INGREDIENTS FOR VAGHAR:

- ½ teaspoon mustard seed
- Pinch of hing (optional)
- 3–4 tablespoon oil

DIRECTIONS:

Wash and soak your red beans in hot water for a few hours or overnight.

Cook them in a slow cooker or a pressure cooker with water and baking powder, or boil them on the stove until tender.

Slightly smash the beans with the back of your spoon or potato masher.

Add grated serrano, ginger, garlic, salt, coriander powder, and turmeric. Mix well.

Using a small pot, heat oil on low, then add mustard seeds and let them pop. Add hing and pour over the cooked beans. Add more water if needed to make a gravy sauce.

Simmer and add more salt or serrano to taste.

Garnish with cilantro, and add sour cream or drizzle cream on top (optional).

Variation: add tomatoes or onions.

Rice, Kadhi, Daar

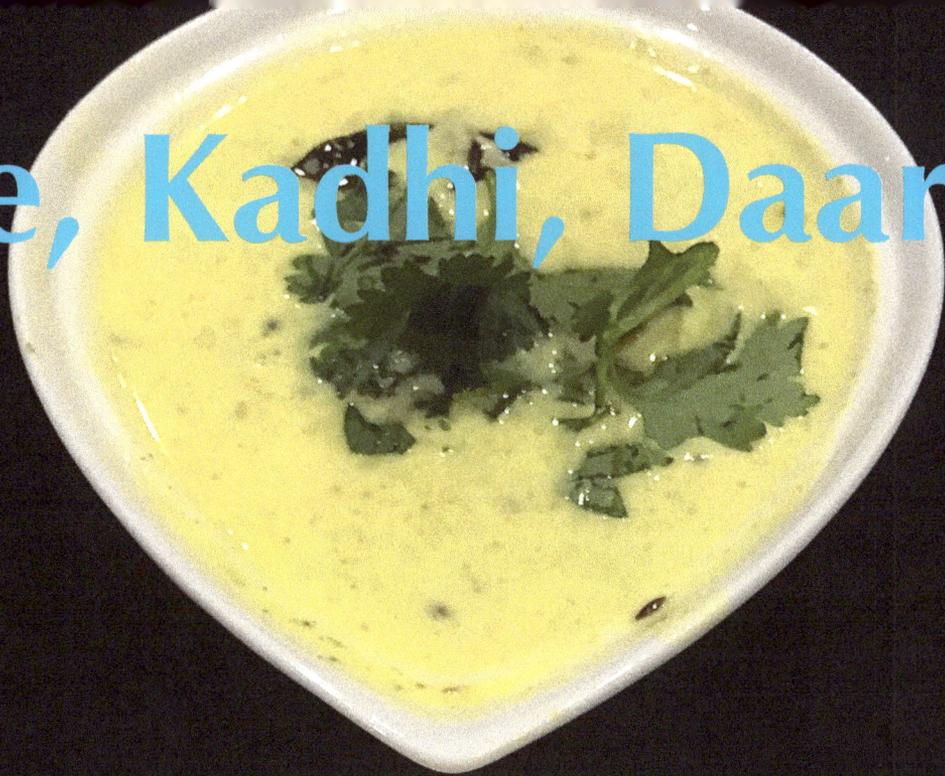

Gujarati Daar - Daal (for Daar-Daal Bhat)

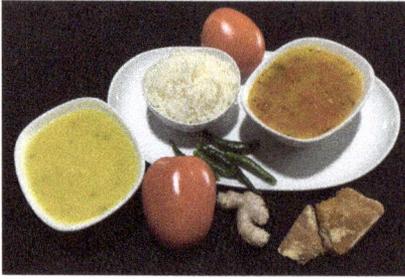

A specialty of all Gujarati homes, this sweet-and-sour soup is a great way to get your protein. One meal of the day always includes this thin soup-like dish served over basmati rice, topped with ghee. Wow, it really hits the spot! Left over daar tastes fantastic once it marinates.

SERVES 4

Cook time: 1 hour

INGREDIENTS:

- ¾ cup tuvar dal (tuvar ni dal)
- A small amount of any of the following two: celery, sweet potato, bitter melon, methi leaves, or ti ndoras
- 1 medium tomato, chopped
- 6 to 8 cups water total (for cooking and making soup)
- 1 inch ginger
- 3–4 chilis (to taste)
- ½ teaspoon hot red chili powder
- 1 teaspoon salt (to taste)
- 1 teaspoon coriander powder
- ¼ teaspoon turmeric powder
- 3 to 4 teaspoons fresh lemon juice
- 2 tablespoons packed Indian brown sugar (jaggery)
- ¼ cup whole or slightly crushed raw peanuts (optional)

INGREDIENTS FOR THE VAGHAR/TOPPING:

- 1½ teaspoons oil
- ¼ teaspoon fenugreek seeds (optional)
- ¼ teaspoon cumin seeds
- 3 pieces whole dry red chilis (optional)
- 3 pieces whole cloves
- 8–10 pieces curry leaves (optional)
- Dash of hing

DIRECTIONS:

Wash dal, rubbing the lentils between your hands under the water to remove the white residue. Repeat process several times until water is clear. Soak for ½ hour or longer in hot water if you can. Wash dal again before cooking. If using a pressure cooker, add dal with 2 cups of water and any two of the vegetables. Let it whistle 3 times.

If cooking in a pot, add dal with 4 cups of water in a 4-quart pot. Bring to a boil, then lower heat. There will be a white foam that forms on the top; skim off using a spoon and discard. Let dal simmer until done, covering the pot halfway only; otherwise it will boil over. Add more water if needed, and cook until soft, split, and tender (20 minutes or so).

After the dal is cooked and cooled, add all the ingredients into the blender or food processor except for the peanuts. Add only 1 cup of water. Blend until smooth.

Taste the dal for sourness, sweetness, spice, and salt. It should be a little sour, sweet, and spicy. Add more spices to taste. Add enough water to make a thin-bodied soup, and simmer on low for about 5–10 minutes.

Wash and dry the pot you cooked the dal in, and use it to make the vaghar (optional). Heat oil, then add dry chilis and let them roast until they start turning slightly brown. This is a fast process so be prepared with all ingredients.

Add mustard seeds and let them pop, then add fenugreek and cumin seeds, cloves, curry leaves, and hing. Pour your blended dal slowly into the pot.

Add the peanuts to the dal, bring to a boil, and simmer on low for 10–15 minutes. Adjust the dal to your thickness. Add more water if needed.

Serve with plain white or brown basmati rice.

Hot dal is usually mixed with rice and ghee and served with a vegetable like cabbage, cauliflower, potato, okra, etc., and rotli.

Note: to make it a jain version, omit the fresh ginger and use 1 teaspoon dry ginger powder and 1 teaspoon garam masala.

Kadhi
Gujarati Kadhi

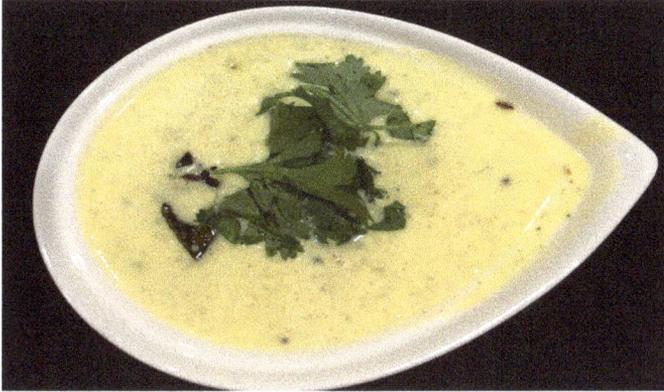

Gujarati kadhi, great with any meal and a "must" in Gujarati households. A very staple part of the meal.

Gujarati's eat vegetables, salad, and rotli first, with kadhi served on the side. They finish their meals by eating rice, topped with a dollop of luchka dal (recipe in book) and mixed with kadhi at the end.

Make a large batch if you wish. Uncooked kadhi can be made ahead of time and stored in the refrigerator for up to 4 days. Heat as much as you need daily.

SERVES 4

YOU WILL NEED:

- 2-quart pan

INGREDIENTS:

- 3 cups water
- 1 cup plain yogurt
- 1 tablespoon sour cream (optional)
- 3 green chilis (to taste)
- 1/2 tablespoon of grated ginger
- ½ inch of white turmeric (optional), can be purchased in Indian grocery stores
- Dash of turmeric powder (optional)
- ½ teaspoon whole cumin seeds
- 1 tablespoon chana flour
- 1 teaspoon salt
- 10 curry leaves

INGREDIENTS FOR VAGHAR:

- 1½ teaspoon ghee
- 2 dry chilis (optional)
- ½ teaspoon mustard seeds
- 1 teaspoon of whole cumin seeds
- 2 pieces of whole clove (optional)
- 5–6 curry leaves
- 2 tablespoons chopped cilantro
- Dash of hing (optional)

DIRECTIONS:

Using a blender or food processor, add all ingredients and 1 cup water. Blend together into a smooth batter. Add the remaining water and blend again.

Heat the ghee in a 2-quart pan on medium heat. Add mustard seeds; when they start popping, lower heat. Add cumin, clove, curry leaves, hing, and cilantro. Remove from heat and pour your kadhi mixture in.

Stir. Set aside until ready to serve. Heat and bring to boil slowly, stirring constantly. Serve hot with your meal over rice.

Variations: you can add any of the following items for a different kadhi flavor: small amount of white or red onion, dill, sugar, or 2 inches of ripe banana.

Bhinda Bhaji ni Kadhi
Okra and Spinach Curry

Great as a one-dish meal. Very filling, especially on a cold, rainy day. Eat with tortillas, rotli or rice.

SERVES 4–5

Prep and cook time: 45 minutes

INGREDIENTS FOR KADHI:

- 3 cups water
- 2 cups plain yogurt
- 1 tablespoon sour cream
- 2 green chilis (to taste)
- ½ inch of white turmeric (opti onal), can be purchased in Indian grocery stores
- ½ teaspoon cumin seeds
- 1 tablespoon chana fl our
- 1 teaspoon salt
- 10 curry leaves
- 1/2 tablespoon of grated ginger

INGREDIENTS FOR VAGHAR:

- 1½ teaspoons ghee
- 2 dry chilis (optional)
- ½ teaspoon mustard seeds
- 1 teaspoon cumin seeds
- 8–10 curry leaves (optional, but gives it a great flavor!)
- 2 tablespoons chopped cilantro
- Dash of hing (optional)

INGREDIENTS FOR VEGETABLES:

- 15–20 pieces okra, diced round into ¼-inch-thick slices
- 1 medium bunch spinach, chopped (yields 4 cups)

- 1–2 cloves garlic, grated
- 1 green chili
- 1 teaspoon, coriander powder
- ⅛ teaspoon turmeric powder
- ¼ teaspoon salt
- 2 tablespoons oil
- ½ teaspoon mustard seeds or fenugreek seeds

DIRECTIONS:

Using a blender or food processor, add 1 cup water with all the yogurt mix ingredients. Blend together into a smooth batter. Add the remaining water and blend again. It should be like a medium-thick soup.

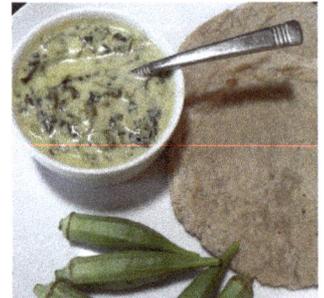

Heat the ghee in a small butter pan on medium. Add mustard seeds; when they start popping, lower heat. Add cumin, curry leaves, hing, and cilantro. Remove from heat; pour your yogurt mix in.

Mix well. Set aside.

IN A 3- TO 4-QUART POT

Add oil and heat on medium heat. Add mustard seeds, lower the temperature, and let them pop, or, if fenugreek seeds, let them roast to a light brown. Add okra and spinach, then spices for the veggies, and sauté for about 7–10 minutes until okra is cooked. Remove from heat. Add your kadhi sauce; mix together. Set aside. Garnish with cilantro.

Before serving, cook the kadhi. Bring to a boil, but constantly stirring slowly. Kadhi should be a thick soup. If you want a thinner kadhi, add more water.

Vagharelo Bhat
Refried Rice

What do you do with leftover cooked rice? Refry it! This is a great simple meal when you don't want to cook and you have rice in the refrigerator. If you like this, make extra rice every time you make rice!

SERVES 4

Prep and cook time: 15 minutes

INGREDIENTS:

- 2 cups cooked rice
- ½ cup yogurt (tart)
- 1 clove garlic
- 3 chilis (to taste)
- 1 white onion
- ¼ teaspoon salt (to taste)
- ⅛ teaspoon turmeric powder
- 1 tablespoon crushed raw peanuts (optional)
- ¼ cup water
- 3 tablespoons oil
- ¼ teaspoon mustard or fenugreek seeds
- Chopped cilantro for garnish

DIRECTIONS:

In a small frying pan or pot, add oil. Add your mustard seeds (let them pop) or let the fenugreek seeds turn light brown.

Add onions and sauté until they turn translucent.

Mix in rice, then add spices, water, and yogurt. Mix. Let it cook for about 5 minutes on low.

Garnish with cilantro and serve hot, alone or as a side.

Bhat with Lachko Daal
Plain Rice Topped with Lentil

Plain rice with luchka dal. This is a very Gujarati dish, eaten and served daily in Gujarati homes. It's tasty and another great way to get some protein into your diet. Make this and people are sure to be impressed!

SERVES 4

Prep and cook time: 30 minutes

MAKE PLAIN RICE:

- 1 cup regular basmati rice or brown rice
- ¼ teaspoon salt
- 1 teaspoon ghee (optional)
- 2 cups water (or more if needed)

INGREDIENTS FOR DAL:

- ¾ cup tuvar dal
- ⅛ teaspoon salt
- Dash of turmeric powder
- ½ teaspoon oil
- 1½ cups water

DIRECTIONS:

Wash your rice several times with rubbing motion until water is clear. Drain.

Add water, rice, salt, and ghee in a 2-quart pan. Bring to boil, cover, and simmer on low until rice is tender and soft. Add a little more water if you need to (a few teaspoons only). Turn off heat and leave rice covered to finish cooking. (Or use a rice cooker.)

Note: If making brown rice, you have to soak the rice for 1–2 hours in hot water. Brown rice takes longer to cook than regular rice, and you will also need about ¼ cup more water.

Wash dal several times with rubbing motion until water is clear. Drain.

In a 1-quart pan, add your dal and water; bring to boil and simmer. Skim off the white foam that will form on top with a spoon. Continue cooking until dal is tender and splits, stirring occasionally. Add a little more water if needed to finish cooking. Mix in spices and set aside until ready to serve. The dal will get thicker as it cools — add warm water to make it medium consistency before serving. It should not be runny.

How is it eaten? First put rice on a plate with a dollop of dal, then ghee on top. Mix together. Then mix in Gujarati kadhi. Yummy!

Vaghareli Khichadi
Rice with Protein Lentils

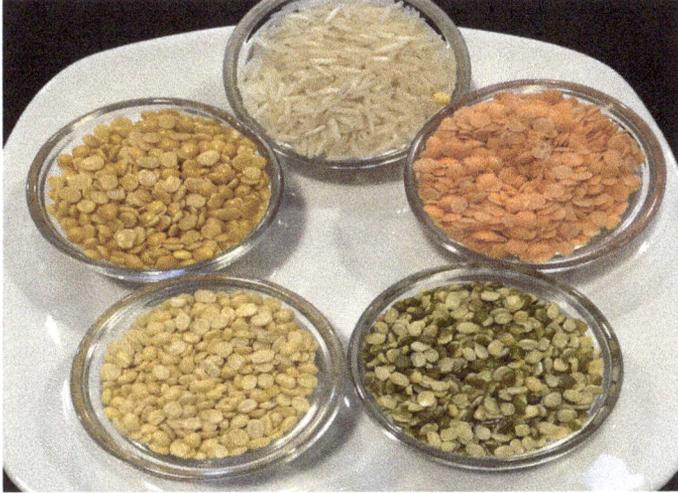

Delicious, and a favorite of many! It can be a one-meal dish, or serve it with your favorite sides – stuffed eggplant with raitu with Gujarati kadhi is the way to go. Four different kinds of lentils/dal and less rice makes it a high-protein meal.

SERVES 2-4

Serves 2 as a one-dish meal or serves 4 with extra sides.

YOU WILL NEED:

- rice cooker, slow cooker, pressure cooker, or nonstick pot

INGREDIENTS:

- ¼ cup basmati rice
- ⅛ cup mug dal with green skin
- ⅛ cup yellow mung dal
- ⅛ cup tuvar dal
- ⅛ cup orange masoor dal
- ½ teaspoon salt
- ¼ teaspoon turmeric powder
- 2 tablespoons grated ginger
- 2 to 3 green chilis, grated
- Water
- 1 small onion, chopped
- ½ cup chopped carrots
- ½ cup peas
- ½ cup chopped potato

INGREDIENTS FOR VAGHAR:

- 3 tablespoons ghee or butter
- 1 teaspoon cumin seeds
- 3 pieces clove
- 4 small sticks cinnamon

DIRECTIONS:

Mix all lentils/dal and rice, then wash 3–4 times in clean water, rubbing all the mixture with your hands to remove the white starchy residue. Soak in warm water for about ½ hour.

Heat ghee in the pot, add cumin seeds, and let them roast for a few seconds. Add cloves and cinnamon. Roast for about 10 seconds. Add onions and sauté for 2 minutes.

Add the rest of the vegetables, remaining spices, and lentil-rice mixture and stir. Add to the rice cooker, or cook on the stovetop in the pot that you started your mixture in.

Add water to about 1½ inches above the mixture. Bring to boil, cover, lower to simmer. Stir occasionally to see that it doesn't stick to the bottom. (You will not need to check if using a rice cooker.)

Add more water to make the khichari softer.

Remove from stove and let the khichari rest to continue cooking for about 15 minutes before serving; there might be some water on top, which will get absorbed.

Serve warm with one of the following: eggplant, onion, potato, spinach saak, etc., and with raitu, kadhi, and cilantro chutney on the side.

Pullao

Pullao rice is tasty and the aroma of the wonderful spices while cooking is heavenly. This dish is made especially when having guests over, or on a special day. It's an easy recipe to make.

SERVES 4

Prep and cook time: 30 minutes

INGREDIENTS:

- 1 cup white or brown basmati rice
- 1½ cups water
- ¼ teaspoon salt
- 1 cup frozen peas

INGREDIENTS FOR VAGHAR:

- 2 tablespoons ghee
- 1 teaspoon whole cumin seeds
- 4–5 pieces whole cloves
- 7–8 strands saffron
- 2 small sticks cinnamon
- 4–5 pieces whole cardamom pods

DIRECTIONS:

Wash rice and drain on paper towel. Set aside (if time permits, soak rice for 30 minutes or longer).

Heat ghee in a 2-quart pot, then add cumin seeds and roast until slightly red. Add in the remaining vaghar ingredients and roast for a few seconds. Add in rice and sauté for about 3 minutes on low.

Add in peas, salt, and water. Bring to boil, then lower to simmer and cover. Cook until rice is tender and soft; it should be nice and fluffy.

Serve with a side of cucumber raitu and other vegetable items. Garnish with tomatoes, browned onions, and cashews.

Rice with 3 Lentils

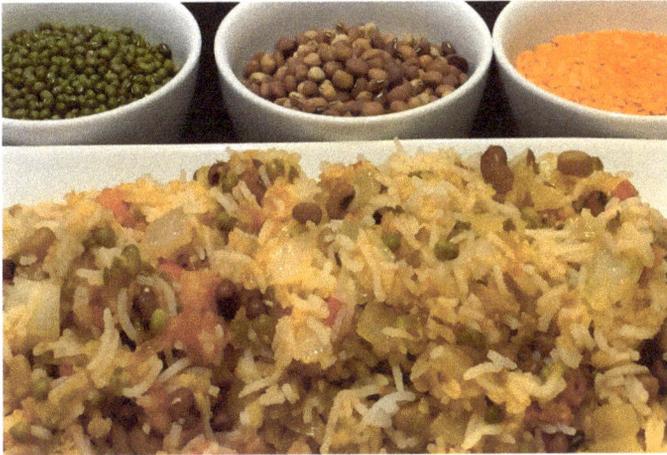

A great make-ahead recipe for dinner or parties. High in protein and so tasty!

SERVES 4

Prep time: 3 to 4 hours

Cook time: 45 minutes

YOU WILL NEED:

- 2- to 3-quart pot
- Casserole or deep dish to serve

INGREDIENTS:

- 3 cups of water
- ¼ cup whole masoor
- ¼ cup whole mug (moong)
- ¼ cup whole choli
- 1 cup basmati rice
- ¼ teaspoon oil
- 2 cups chopped tomatoes
- 2 cups chopped onions
- 1½ tablespoon ghee
- 1 teaspoon whole cumin
- 1 teaspoon salt
- 1 teaspoon red chili powder or less
- 2½ cups water for the rice
- Garnish with chopped cilantro

DIRECTIONS:

Wash and soak mug choli for 3–4 hours in hot water, in separate bowls.

Wash and soak rice in warm water with ¼ teaspoon salt. Soak for 1 hour.

If using stovetop, add 3 cups water and ¼ teaspoon salt to a 1-quart pot. Add choli and boil for about 5 minutes, then add the mug. Bring to boil, then continue cooking on simmer until lentils are soft (lentils have to stay whole). Cooking time will be about 15 minutes. Add more water if needed. Drain and set aside.

Or, if using a pressure cooker, cook choli and mug beans together with salt and 2 cups of water (2 whistles only; you want to keep them whole). Drain and run under cold water.

While your lentils are cooking, assemble all your ingredients and make the rice. Wash the masoor dal and add to rice. Cook in a 2-quart pot with 2½ cups of water, $\frac{1}{8}$ teaspoon salt, and ¼ teaspoon oil.

Bring to a boil, then lower to simmer and cover. Cook until rice is done, about 15 minutes; all grains should be separate.

Remove from heat and leave cover on for about 5 minutes. Fluff with a fork and remove to a dish and let cool. Set aside.

While the rice is cooling, chop the tomatoes and onion into 1-inch pieces.

In a medium-sized frying pan, add ghee. Let it melt at medium. Add cumin and roast for about 5 seconds.

Add in your onions and cook on medium heat until slightly red. Add tomatoes. Sauté for about 2 minutes, then add all the remaining ingredients and cook on high for about 1 minute.

Remove from heat and gently fold in the cooked choli and mug.

Let it cool for about 5 minutes, then fold in the cooled rice.

Reheat and serve warm, in a deep dish or casserole dish with plain yogurt on the side.

Khichadi

Plain rice cooked with one of the following lentils: tuvar, yellow mug dal, or green mug dal – great for toddlers. A great comfort dish for any age. This rice should be a little on the mushy side.

SERVES 4

Prep and cook time: 30 minutes

INGREDIENTS:

- ¾ cup regular basmati or brown rice
- ¼ cup dal (split mung dal or tuvar dal)
- 1 tablespoon ghee
- ½ teaspoon salt
- ⅛ teaspoon turmeric powder
- 1 tablespoon grated green chili or ½ teaspoon of red chili powder (optional)
- 1 tablespoon grated fresh ginger (optional)
- 3 cups of water (more if you want a softer khichadi)

DIRECTIONS:

Wash the rice and lentils several times with a rubbing motion until the water is clear.

Add all the ingredients to a pot or rice cooker. Bring to a boil, then lower to simmer and cover, until rice is cooked all the way through. Add more water if needed to finish cooking.

Serve with Gujarati kahdi, raitu, or plain yogurt with a vegetable of your choice, and more!

Jeera Rice
Cumin Flavored Rice

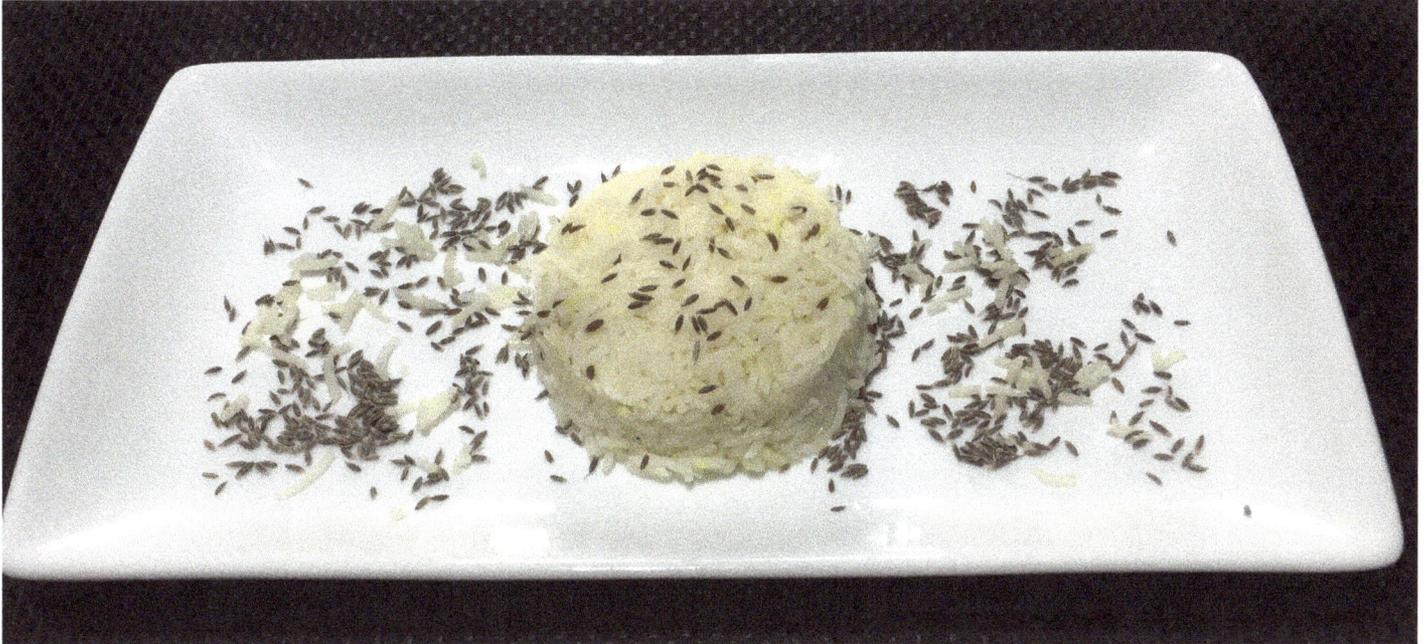

A simple rice dish, with a lot of flavor and aroma. A dish that will complement any vegetable. The addition of ghee will give it a nutty favor.

Prep and cook time: 30 minutes

SERVES 4-5

INGREDIENTS:

- 1 cup basmati rice
- 2 teaspoons cumin seeds
- 1 tablespoon ghee
- 2 cups water
- ½ teaspoon salt

DIRECTIONS:

Wash rice with a rubbing motion, changing water several times until water is clear.

You can use a rice cooker or pot. If cooking on stovetop, in a 2-quart pan, add ghee, let it heat on low heat. Add cumin seeds and let them roast until slightly brown. Add rice, salt, and water, then mix. Bring to a boil and simmer on low heat. Cook until tender.

Before serving, heat the rice and fluff and mix the rice using a fork.

Note: If you are cooking for a party, you can have the rice ready with water and set it aside. Cook 30 minutes before serving. Garnish with chopped cilantro and green onions, or sauté onions and cashews.

Breads

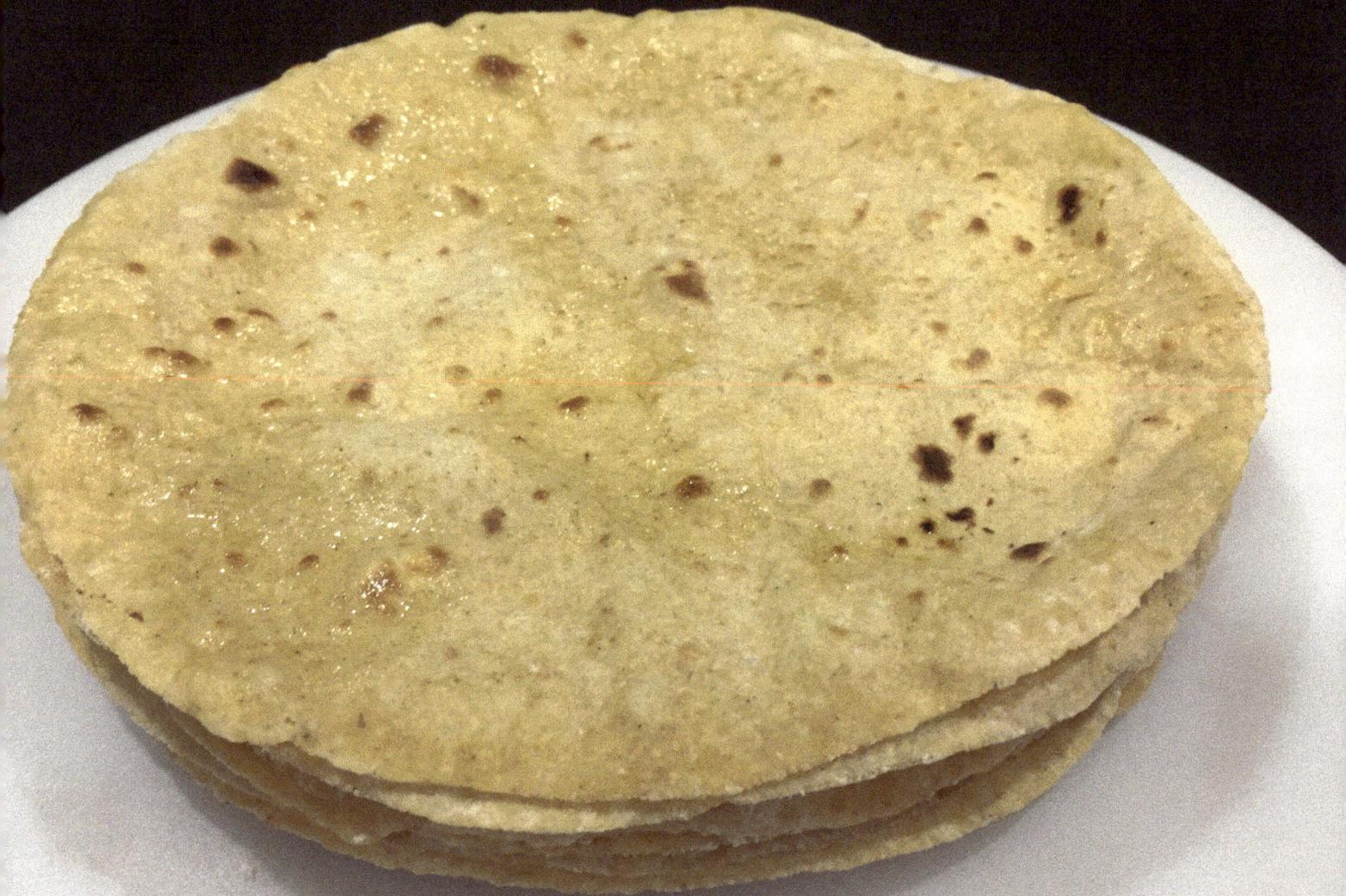

Breads

ROTLI

A staple bread in India, known as roti chapati , or, in Gujarati , as rotli.

Rotli is a staple in Gujarati homes, eaten by everyone. Soft and tasty, these flatbreads are eaten with vegetables at the beginning of a meal, since lots of Indian food is eaten by hand. You still need your rotli to help you scoop up the vegetables, broken into bite-sized portions. These rotlis are made from Atta-Whole wheat flour that is easily available at Indian stores and supermarkets. The flour has to be fine to help in rolling out each one in a very smooth texture to be cooked on a talva or flat griddle. They will puff up if they are rolled evenly and round, spread butter or ghee and serve them hot.

They are hard to roll out, but with a little practice, one can master it. Nowadays you can buy a tortilla or roti maker to help you.

POORI - PUFFED BREAD

Deep-fried breads puff up to look like balloons after you drop them in hot oil. A favorite of young children and great to serve when one is having guests over. Made at all festive occasions: weddings, etc. Served with sweet items in Gujarati and to eat with vegetables.

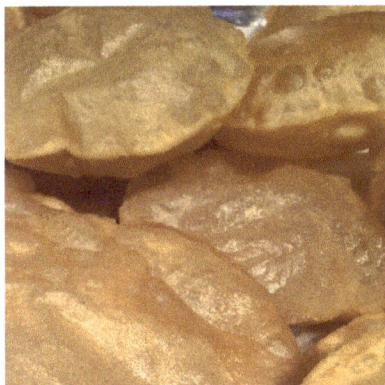

TORTILLA- ROTLAS

Making fresh tortillas or rotlas is time-consuming! But they taste so much better than the store-bought ones. They are also preservative-free. Tortillas or rotlas can be stored in the refrigerator for up to one week in a tight container lined with a paper towel.

Originally, women made them by using both hands and pressing and flipping them from palm to palm; many people still make them like that still. It is an art.

The Indian tortillas are made from juwar (sorghum) or bajara flour, which is much healthier.

You can invest in a tortilla press, sold in most Mexican markets or on the Internet (the heavier the better).

BHAKHARI

Bhakhari's are harder and thicker than rotli. Make it tastier by adding salt and cumin powder. You can also make it plain or sweet by adding jaggery or gol..

Rotli

An everyday soft flatbread, also known as chapatis, to eat with your vegetables. It starts the meal; make bite-sized pieces to help in picking up gravy and veggies. A must in Indian homes.

Gujarati rotlis are much thinner and smaller. Roll out by hand or use a tortilla maker to help you roll them, but still cook them on a griddle to puff them up. I love the smell of fresh-made rotlis. Making round rotlis takes some time and practice.

Yield: 15–18 pieces

SERVES 4

Prep and cook time: 1 hour

YOU WILL NEED:

- Griddle
- Screen
- Chopping board or round rolling pin.

INGREDIENTS:

- 2 cups whole wheat flour
- 2 tablespoons oil
- 1–1½ cups very hot water
- Ghee or butter to spread
- Extra flour or all-purpose flour to dust and roll

DIRECTIONS:

In a mixing bowl or food processor add, flour. Add oil, mix well, then add 1 cup water slowly while mixing and kneading, or mix in food processor until a smooth ball is formed.

Add more water if needed by teaspoon and knead dough until smooth. The dough should not be too soft, more on the stiff side.

Cover and let the dough rest for about 15 minutes or longer until you are ready to make the rotlis.

Grease your hands with ghee or oil. Knead until smooth and make small golf-ball-sized pieces (15–18).

In equal parts, roll and flatten them by pressing them into the palm of your hands. Dip and dust each one in flour; cover them.

Heat your griddle on medium heat.

Dust your board with flour. Working with one ball at a time, roll out in a 5- to 6-inch circle.

Place rolled rotli on your hot griddle and cook for 1 minute, then flip it over and cook on other side. Flip over again and help to puff up by pressing gently and flip over again. (If you have a screen, as in the picture, first cook on the griddle, flip it over, let it cook, then place the rotli on the screen.) Cook about 15 seconds, flip over and cook for about 30 seconds – your rotli is done! Do not flip over too many times more than specified above or they will not puff up and will become hard.

Spread ghee or butter and continue to next one until all are done; make a stack. Cover and serve warm on a dish or wrapped in foil lined with a paper towel. Place in a warm oven until ready to eat. (Should not be in the oven more than 1 hour or they will dry out.)

Serve with all meals. Can be stored up to 1 week in the refrigerator. Can be reheated

Rotala

Rotla's, Indian tortillas, are just a different type of bread. They are mostly made from juwar flour (sorghum), but you can use yellow or white corn flour or even oatmeal flour for a healthier version.

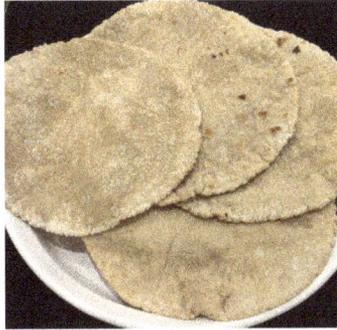

You can roll them out on a board dusted with flour using a rolling pin or on a piece of paper towel. You have to roll them out evenly into a 5-inch circle.

The key to having perfect tortillas is not to overcook them, and if you can get a tortilla to puff up, it will taste perfect

After eating the homemade rotlas, you will say, "Wow!" How yummy they are!

Note: make 5–6 extra rotlas, then see my recipe "Vagarelo Rotalo" when they are a day old.

Prep time: 10 minutes

Cook time: 30 minutes

Yields: 8

INGREDIENTS:

- 2 cups juwar or white corn flour
- 1¾ cups boiling hot water
- ½ cup cold water (on side)
- Flour for dusting

DIRECTIONS:

Boil water in microwave or on stove (the hot water makes the rotlas soft).

In a mixing bowl, add flour and use a fork to mix. If the water is too hot to touch, use a food processor. Add 1 cup of hot water slowly and mix well until a soft dough is formed. If using a food processor, remove from machine and knead.

Add more water if needed to make a stiff dough that you can work with. Knead by using wet hands to make a soft, not sticky, dough. The more you knead, the softer and smoother it will get.

Cover and let dough rest 10 minutes or more.

Take the dough and form a smooth ball, then divide into 8 portions. Roll each into a ball and make it flat using the palm of your hands. Dust with flour.

Roll them out with a rolling pin until approximately ⅛-inch thick on a board or paper towel, or use a tortilla press.

Preheat flat griddle or frying pan, heat at medium-high heat.

Place into the hot skillet and cook. Let it cook for about 2 minutes, flip, let it cook again for 1 minute.

Continue cooking until golden on the other side. Continue rolling one rotalo at a time and place it on the skillet. Let it cook for about 1 minute and turn it over. Let it cook and turn it over again until it fluffs up. To help it puff up, press on it gently with a spatula.

Brush ghee or butter on top.

Do not stack at first; overlap them with a little room in between. Stack after they cool a little.

Note: If using corn tortilla flour, you will need more water. You can also use oatmeal flour to make rotala, but use less water.

Bhakhari

Bhakari's are a little thicker than rotlis, made using whole wheat flour. They can be eaten alone, with chutneys, pickles, and vegetables. They will keep longer than rotli.

SERVES 4 (10 PIECES)

Prep and cook time: 1 hour

INGREDIENTS:

- 2 cups whole wheat flour
- 9 teaspoons oil or ghee
- ½ cup of hot water

DIRECTIONS:

Mix flour in a bowl with oil or ghee, then add water slowly and form a stiff dough. Let it rest.

Now add a little water at a time and knead bhakari dough. Knead thoroughly for better result. Or use a food processor or KitchenAid mixer. This dough will need a lot of kneading to form a dough; if you need to add water, add by teaspoon only to form your stiff dough.

Divide dough into small balls (8–10), flatten, cover, and let them rest for about 5 minutes.

Heat a flat skillet at medium heat, then lower temperature to low.

On a board, roll out each bhakari ball into a 6-inch circle. One at a time, cook them on the skillet without oil. Flip to other side after a minute or so, let it cook, flip over again, and brush with oil or ghee.

Flip over again, brush with oil or ghee, and press and roast for a few minutes, making sure that it doesn't burn. Cook by flipping them over several times and using the press and turn motion; they should be evenly red when done.

Poori
Puffed Bread

Pooris across India are everyone's favorite bread, served at all festive occasions. These light and airy small round breads are delicious and easy to make, and you can quickly devour quite a few of these in no time. This is a deep-fried bread that is a staple across India. Relish this bread with your favorite shaak (vegetable) or sweet side dish like shikand, baundi, fruit salad, mango ras, and more. Gujarati pooris are smaller and thinner than the average pooris from other parts of India.

Yield: 25–30

SERVES 4

Prep time: 1 hour

INGREDIENTS:

- 3 cups of whole wheat flour
- 2½ tablespoons ghee or oil
- Dash of salt
- 1 cup water

DIRECTIONS:

Using your hands or a mixer, add flour to bowl, mix in ghee or oil, and add water slowly.

Work to form a stiff dough, knead to make it smooth. If you need more water, add about a teaspoon. Knead well until all of the flour is incorporated.

Cover and let it rest until you are ready to make the pooris, just before serving. To make good pooris the dough has to be on the hard side, not soft like rotli dough.

Knead again and divide into small golf-ball-sized pieces. Round into a ball and flatten by pressing the ball between the palm of your hands. Cover them. If you are not able to make them round, take 2–3 pieces of dough and make it into a round ball, roll into a large 6- to 8-inch circle, and use a large round cookie cutter to make them (or a small lid will do).

Heat oil in a deep pan to a very hot level (350 degrees). Test the oil by dropping a piece of dough into the oil; if it comes up right away, you are ready to fry. You will have to let the oil heat back up from time to time; it has to be hot for the pooris to puff up. Fry 2–3 pooris at a time, press on them gently to help them puff up, flip over and cook about 1 minute. Remember, this is a fast process.

Drain on a paper towel and continue making them all. Serve them piping hot with your favorite meal.

Palak ni Poori
Spinach Poori

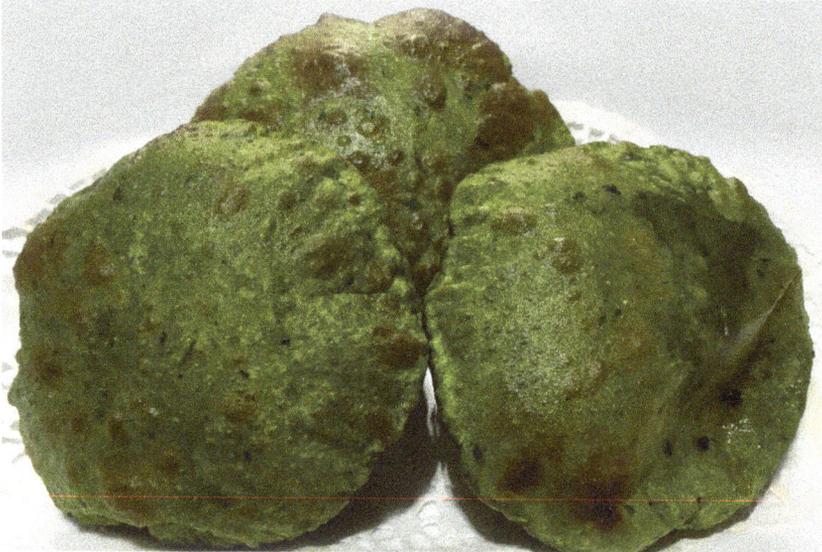

The first time I made these, my family just loved how nice they tasted, and the look is so different. I made them for Christmas. I made red ones using a beet root. These will be the highlight of your party. They are delicious. Make all three: red, green, and plain. Makes a colorful platter!

SERVES: 4 (15–18 POORIS)

Prep and cook time: 1 hour

INGREDIENTS:

- 1½ cups whole wheat flour
- 1 packed cup chopped fresh spinach
- 1½ tablespoons ghee or oil
- 1 tablespoon green chilis (optional)
- 1 teaspoon salt
- Oil to fry

DIRECTIONS:

Wash and drain spinach in a colander, cut off the ends, and chop into big pieces. Blend with salt using a blender or food processor until liquified.

Put your flour in a bowl and add ghee or oil and mix well. Add blended spinach to make a stiff dough (do not add water). This mix has to be made within 10–15 minutes of forming the dough; otherwise it will get soft.

Knead again and divide into small golf-ball-sized pieces. If you are not able to make them round, take 2–3 pieces of dough and make a large ball, round into a 6- to 8-inch circle, and use a large round cookie cutter to make them (or a small lid will do).

Heat oil in a deep pan to a very hot level (350 degrees). Test the oil by dropping a piece of dough into the oil; if it comes up right away, you are ready to fry. You will have to let the oil heat back up from time to time; it has to be hot for the pooris to puff up. Fry 2–3 pooris at a time, press on them gently to help them puff up, flip over and cook about 1 minute. Remember, this is a fast process.

Drain on paper towels and continue making them all; serve them piping hot with your favorite meal.

Puran Poli-Gali Rotli Vedami-Sweet Stuffed Rotli

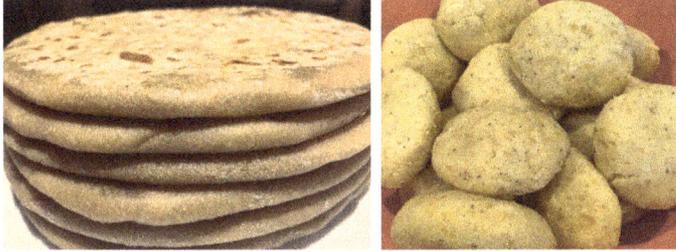

Sweet rotlis filled with a sweet lentil filling made from tuvar ni dal; very popular in Gujarat. It is eaten with the main part of the meal. Serve with melted ghee drizzled on top.

SERVES: 8 (16 PIECES)

Prep and cook time: 1 hour

YOU WILL NEED:

- Nonstick pot
- Flat grilling surface

INGREDIENTS FOR STUFFING:

- 2 cups tuvar dal, washed several times in hot water and soaked for 1 hour or more
- 10–12 cups water
- 3 cups sugar
- 1 teaspoon ground black pepper
- 1 teaspoon finely ground cardamom
- ¼ teaspoon ground nutmeg.
- 3 tablespoons ghee

INGREDIENTS FOR DOUGH:

- 2 cups whole wheat flour
- 2 teaspoon oil
- 1 cup hot water
- Extra flour for dusting and rolling
- Extra ghee for cooking and brushing

DIRECTIONS FOR STUFFING:

In a large nonstick pan add your washed and soaked dal with 10 cups of water. Add more water if needed to finish cooking later. Bring to boil and simmer until done. Take a spoon and remove the white foam. Continue cooking at low temp for up to 25 minutes until the dal is soft and mushy.

If you have a pressure cooker, cook dal in pressure cooker with 3 cups of water for step 1. Once the dal is cooked completely and is soft and mushy, remove mixture to a nonstick pan.

Add sugar and mix. The sugar will release water, but continue cooking until the mixture thickens. The mixture will splatter, so cover it partially and be careful to work at a low heat. Make sure that the mixture does not stick to bottom of pan and get scorched. The color of the mixture will change from a light to a darker shade. The mixture has to be formed into a soft dough.

Let the mixture cool enough to fold in black pepper, cardamom, and nutmeg, and mix well with hands. It will be sticky at first. Don't let the mixture completely get cold, otherwise it will be difficult to mix in the ingredients.

Wash hands and grease them with ghee or oil and form one large ball, then divide the filling into small round balls (about 16 pieces). Cover. Set aside. You can make this stuffing ahead of time and refrigerate up to 1 week, or freeze them for later use. Thaw a few hours before use. Mix the dough, kneading until soft and not sticky. Grease hands with a little ghee or oil and divide into 16 equal pieces. Roll into small balls and flatten them with the palm of your hand, dusting with flour.

Dust your cutting board with flour, roll out to a 4-inch circle, and place 1 stuffing ball in center. Take the edges, bring them to the center, and seal by pressing ends together (it will look like dumpling). Dust with flour, set aside, and make them all until dough is gone. Cover as you make them so they do not dry out.

Heat your grill to medium. Take one of the covered balls, dust with flour, flatten lightly, and roll out lightly with rolling pin to a 5- to 6-inch circle.

Place the puran poori on your warm grill and cook for at least 2 minutes. It will change colors. Flip it over, spread 1 teaspoon ghee over it, then flip again and spread ghee on the other side. Cook until a light golden color or until you see some brown spots. Serve hot with kadhi, rice, and your choice of vegetables.

Rava Meda ni Poori
Semolina all purpose flour Poori

These puris are a favorite at weddings. Served with shrikhand or busudi, or just have it with tea. Spread with some lemon pickle, chutney, or a cream cheese spread. Have a snack; you need only your imagination to eat them.

You can make the dough by hand, but I like to use my free standing mixer or a powerful food processor with the dough blade.

Yield: 25–30
Prep and cook time: 1½ hours

INGREDIENTS:

- 3 cups all-purpose flour
- 1¼ cups fine rava or fine semolina
- ½ to ¾ cups very hot tap water (or microwave for 1 minute)
- 1 cup ghee
- 6–8 cups of oil for frying

DIRECTIONS:

Heat oil to 257 degrees.

Using a mixer or by hand, mix flour and rava together for about 30 seconds or more, then slowly add ghee. Mix well for about 1 minute until all the flour is coated with the ghee.

Slowly add your ½ cup of water and let the mixer mix for about two minutes. Stop the machine, let dough rest for about 5–10 minutes, then see if you can form a stiff dough. If not, turn mixer on again and add remaining water, about 2 teaspoons only, until you can form a stiff ball. This dough has to be hard to get the good texture of the pooris, like a short bread.

Empty into a mixing bowl and knead until smooth. Cover and let the dough rest for about 5 minutes.

Uncover dough and knead for about 2 minutes until smooth. Divide into two parts for easy handling, then into small donut-sized balls; it will yield about 25–30 pieces. A stiff dough is hard to work with, but it will make better pooris.

Take a fist-sized piece of dough and make a smooth ball between your hand, then press flat using your palms. Do this with all the pieces, covering them as you go, then take each dough piece and roll out into 2- to 3-inch circles. If the side of the poori looks cracked, that is fine; the pooris will be flakier. With a fork, poke holes in the pooris so they don't fluff up when you fry them.

Add oil to a deep flying pan and heat to about 275 degrees on low heat. Add a few pooris and fry them until a light golden color, turning them continually until done. Repeat this process until all pooris are fried. Heat the oven to 170 degrees and line a tray with about 6–7 layers of paper towel. Line up the pooris on the tray after frying them and place them in the oven for about 1 hour. This is to drain the excess oil from them. Cool and store in an airtight container lined with a paper towel.

You can make them different flavors, like salty or spicy, by adding 1 teaspoon salt with 1 teaspoon ground cumin powder or 1 teaspoon red chili powder to taste and a dash of turmeric powder for yellow coloring. Try the different variations.

Pickles & Chutneys

Dhana ni Chutney
Cilantro Chutney

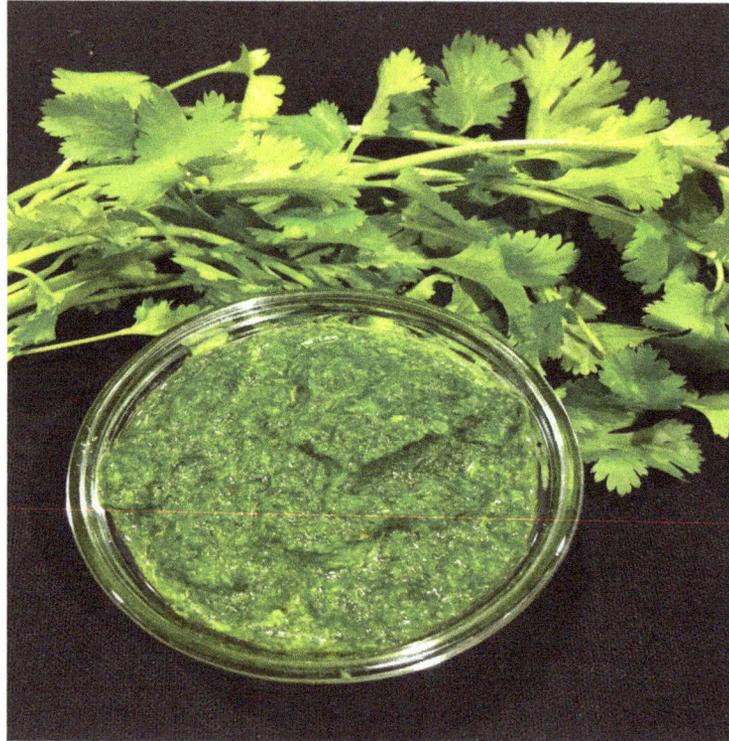

The most popular chutney in a Gujarati home. Fresh, spicy, and it gives that "kick" to any dish. Easy to make. You will serve it always.

SERVES 4

INGREDIENTS:

- 2 packed cups chopped cilantro
- 1–2 small cloves garlic
- 1 teaspoon oil
- ½ teaspoon salt
- 1 teaspoon fresh lemon juice (or more to taste)
- 2 small thai chilis or 1 serrano chilli (to taste)

DIRECTIONS:

In a small blender, add all ingredients. Blend until a smooth texture. Taste for salt.

Serve with all your dishes. Fresh is the best way to serve, but it can be refrigerated for 2 days.

Variations: Use ginger instead of garlic, add some fresh coconut or dariyas, or add fresh green garlic instead of garlic cloves. Make the chutney as above and mix with 1 cup yogurt to use as a dip.

Basil - Cilantro Chutney

SERVES 2-3

Prep time: 15 minutes

INGREDIENTS:

- 1 tablespoon chana dal or dariyas
- 1 cup chopped cilantro
- 1 clove garlic
- 2 small fresh serrano chilis
- 10–15 leaves of basil
- 1 teaspoon oil
- ¼ teaspoon salt (to taste)
- 1 teaspoon fresh lemon juice

DIRECTIONS:

Wash and soak dal in warm water for about ½ hour.

Wash cilantro and cut about 1 inch off the tops; chop them. Remove leaves of basil from stems and wash.

In an electric chopper or small blender, add all ingredients except oil. Blend until smooth, but not super fine. Serve in a bowl and mix in oil. Refrigerate until ready to use.

The chutney is good for 2 days. It will last 2–4 days but the taste will not be the same. Serve as a condiment or use as a spread on sandwiches.

To make a spread, add yogurt or mayonnaise, mix well, and spread on your favorite bread.

Yogurt Cilantro Chutney

Great as a dip with anything. Make it fast in the blender!

SERVES 4

Prep time : 15 minutes

INGREDIENTS:

- 2 cups plain yogurt
- 1 teaspoon sour cream (optional)
- 2 small serrano chilis (to taste)
- ½ teaspoon salt
- 1 cup chopped cilantro
- 1 clove garlic

Add all the ingredients into a blender and blend until chilis and garlic are blended. Empty into a bowl.

Serve cold and add your choice of garnish. Refrigerate until ready to serve. Will keep fresh up to 2 days.

Variations: You can add fresh coconut, fresh mint, or soaked dhariyas for a different taste and texture. You can top it off with vaghar: heat 1 teaspoon oil, ½ teaspoon mustard seeds (let them pop), and curry leaves. Pour over the chutney; do not mix until serving.

Serve as a dip for parties, with dhokla, bhakaro, sandwiches, etc.

Cranberry Chutney

One of my favorite chutneys. I learned to make this from my mother. I am always so excited and can't wait to make it once fresh cranberries arrive on the market. The color, aroma, and tangy, sweet, and spicy taste is just exciting. Serve this with your next lunch or dinner. Impress your friends at Thanksgiving.

SERVES 3–4

Prep and cook time: 20–30 minutes

INGREDIENTS:

- 1 cup fresh firm cranberries, washed
- ½ cup chopped white or red onions
- 1 teaspoon whole cumin seeds
- ½ teaspoon salt
- ¼ cup jiggery/gol or sugar
- 1 clove garlic
- ¼ serrano chili or 1 Thai chile, grated (optional)
- Water (optional)

INGREDIENTS FOR VAGHAR:

- 1 tablespoon oil
- ¼ teaspoon whole cumin seed

Wash cranberries; use firm ones only. Add all the ingredients in a food processor, chopper, or blender. Blend until fine, not like a paste. Add about a tablespoon of water if needed.

Heat oil for about 10 seconds on medium heat in a small 1-quart pot or butter pan. Add cumin seeds and let them roast for about 15–20 seconds. Add the blended cranberry mixture, mix well, and cook the mixture until the sides start bubbling. Remove from heat, let it cool, and marinate for a few hours at room temperature or overnight before serving. Serve with your favorite food. Stores up to 1 week in the refrigerator.

If you feel that the chutney is too thick, add water to make it your desired consistency.

Karela ni Chutney
Bitter Gourd Chutney

This chutney is different, sweet and bitter-tasting. It can be eaten alone wrapped in a toast or rotli, or eaten as a side with your meal. Very healthy and easy to make. Make ahead for parties and store it for days in the refrigerator.

Buy long, green, thin bitter melon. Do not buy fat ones; they will have seeds in them that you do not want. There are two kinds of bitter melon, ones with very rough skin and another one with rough & scaly skin. Both are good.

SERVES 4

Prep and cook time : 45 m-1 hr

INGREDIENTS:

- 6–7 pieces of bitt er melon
- 1–2 cloves garlic, grated
- 2 green chilis, grated (to taste)
- ¼ teaspoon turmeric powder
- 2 tablespoons crushed raw peanut
- 1 tablespoon sesame seeds
- 2 teaspoons sugar (or more to taste)
- 1 teaspoon salt
- 3 tablespoons oil
- ½ teaspoon mustard seeds

DIRECTIONS:

Wash bitter melons and cut off ends. Take a large-hole grater and grate all of them in a bowl.

Mix the salt in the grated melons and set aside for at least half an hour. Water will be released from the gourd. Squeeze out the water through a cheesecloth or with your hands.

In a nonstick medium-sized frying pan, heat oil, add mustard seeds, let them pop, and add the bitter gourd.

Sauté at high heat for a few minutes, then lower heat and sauté until slightly red. Add garlic, chilis, and turmeric powder. Continue cooking until slightly crispy.

Add sesame seeds, crushed peanuts, and sugar. Mix well. Cook for a minute or so, then remove from heat.

Serve warm or cold, as a condiment with dinner or with toast or rotli.

Khajur Amli ni Chutney
Date Tamarind Chutney

The combination of sweet and sour makes this a chutney that you want to serve with all your favorite appetizers. One of the best ambali (tamarind) chutneys you will eat and simple and easy to make. Make a large batch and freeze for later use.

SERVES 4

Prep and cook time : 2-3 hrs

INGREDIENTS:

- 1½ cup dates/khajur (preferably without pits)
- 4 tablespoons amli (tamarind) paste (buy at Indian grocery)
- Pinch of red chili powder
- 1 teaspoon whole cumin
- 1¾ teaspoon salt
- 2 cups water
- ½ teaspoon chaat masala (optional)

DIRECTIONS:

Cut dates into small pieces and soak in 2 cups of warm water for 2–3 hours.

Add store bought tamarind paste or make your own paste by buying seedless Amil and soaking it in warm water for 2-3 hours, blend in the blender with a little water to make paste.

Add all ingredients to a blender and blend until smooth. Let it marinate for about 30 minutes and serve.

Refrigerate or freeze for later use.

Amba Haldar
Turmeric Pickles

One of the healthiest pickles that one can eat. Turmeric is from the ginger family, and is packed with vitamins and minerals that help your body grow, repair itself, and boost your immune system. Have a few pieces on the side with all your meals. You have to acquire a taste for it; it's strong in taste, especially the yellow one. Let's get healthy!

When buying, look for nice, fresh, hard ones without black spots. Make sure they are not all dried up.

8-10 servings
Prep time : 1 hr

INGREDIENTS:

- ½ pound white turmeric
- ½ pound yellow turmeric
- ¼ pound tender ginger (without fiber)
- ½ cup freshly squeezed lemon juice (about 5–6 lemons)
- 1 teaspoon salt
- 1 teaspoon oil

DIRECTIONS:

Peel white and yellow turmeric and ginger. Cut to your desired shape (long thin strips or thin round ones). Rinse again in cold water after peeling and drain. Add salt and mix well, then add lemon juice and oil.

Store in an airtight glass container. Let it marinate for a day or two outside, giving it a stir once a day. Now it's ready to eat. Refrigerate – it will stay fresh for up to 4–5 weeks.

Serve as a condiment with lunch or dinner. Eat a few pieces a day to stay healthy.

Note: you can add deseeded chilis and 2 teaspoons crushed mustard seeds to make it a spicy pickle.

Cucumber Raita

A wonderfully refreshing, cool yogurt dish to serve with any meal, as a dip with raw veggies, as a sandwich spread, and especially with rice/khichari or briyani. Use your imagination!

SERVES 4

Prep and cook time: 15 minutes

INGREDIENTS:

- ¾ cup grated cucumber
- 1¼ cups plain regular yogurt
- 1 tablespoon sour cream (optional – gives it a full-bodied flavor and smoother texture and takes some of the tartness out of the yogurt)
- 1 teaspoon whole cumin, slightly crushed in grinder or by hand
- 1 green chili, grated, or ½ teaspoon red chili powder
- 1 small clove garlic, grated (optional)
- ½ teaspoon salt (to taste)

DIRECTIONS:

Grate cucumber (squeeze out water if your yogurt is thin, draining with a cheesecloth if necessary).

Mix all ingredients and add cucumber. Refrigerate. Serve cold. If you are making boondi raitu, add boondi just before serving.

Note: Raita can be made with just onions, just plain boondi (sold in Indian grocery stores), or chopped mint leaves with onions, bell peppers, or carrots. Some people make it with fruit also. Try the different variations.

Rai na Marcha
Pickled Chilis with Mustard

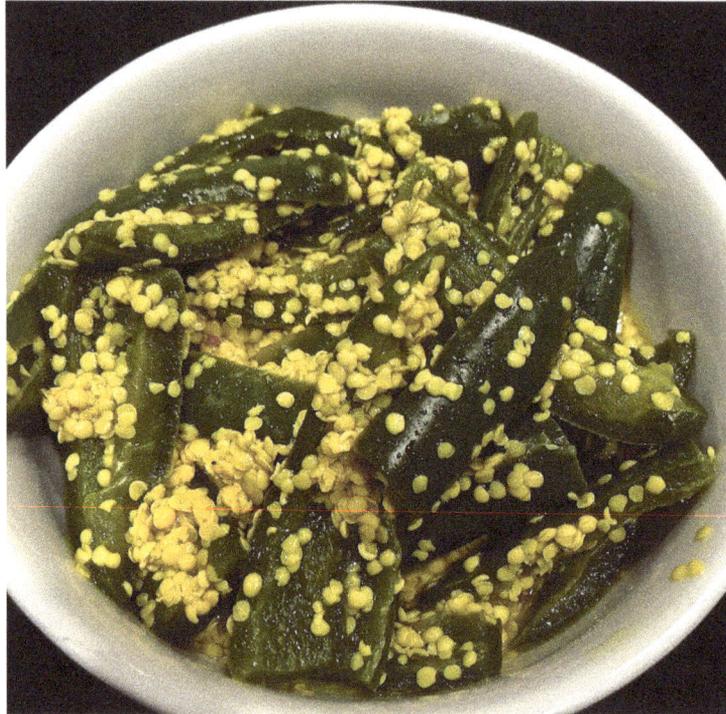

Spicy, with a bit of a bite to it. Serve this pickle as a side with everything. Simple and easy to make, it keeps fresh for weeks in the refrigerator.

Prep and cook time: 30 minutes

INGREDIENTS:

- 4 large jalapeño chilis
- 1 teaspoon salt
- ¼ cup crushed mustard seeds (sold at indian grocers)
- $\frac{1}{8}$ teaspoon hing
- ¼ teaspoon turmeric powder
- 1 tablespoon oil
- ¼ teaspoon lemon flakes

Wash and pat the jalapeños dry with a paper towel. Remove the stem. Cut in half and remove the seeds. Cut in long strips, 3–4 strips per half, and then cut each strip in half. You will have 16 pieces total from each chili (long 1-inch pieces).

Mix all pieces in bowl with the rye masala. Cover and let them marinate for 1–2 days at room temperature and then serve.

Refrigerates well for up to 3 weeks.

Amba Haldar Chutney
Turmeric Chutney

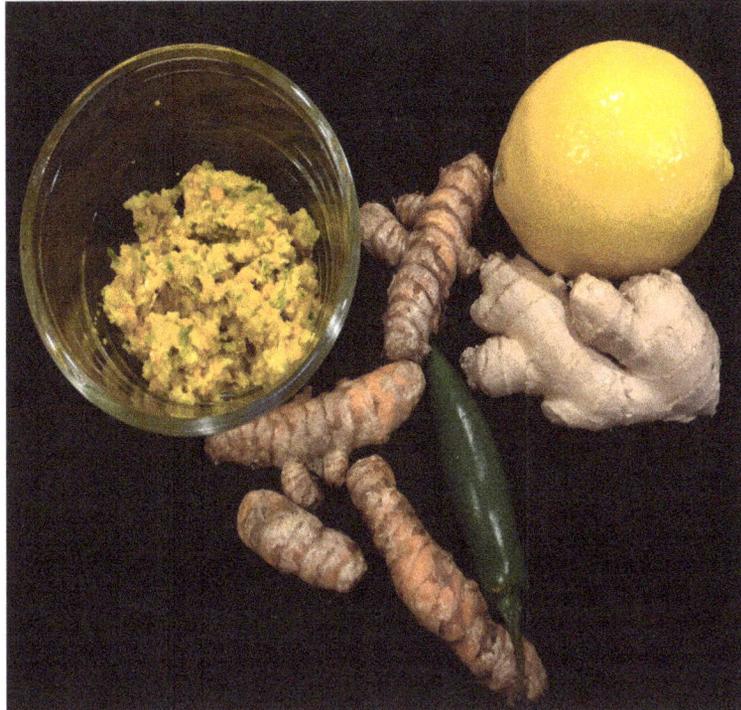

The newest and latest cancer-prevention spice is the biggest thing in the Western world that everyone is talking about. However, in India, it has been used for centuries, as an antioxidant, to drink for cold and cough treatment, to boost your immune system, and even in paste form to treat cuts, sores, etc.

I love to make this in a chutney form, but one must acquire a taste for it. It has a strong taste. It might take a few times before you really start liking it, but it is super healthy and tasty, as well as easy and fast to make. Make ahead and let it marinate for a few hours or a few days.

SERVES 4

Prep time : 20 minutes

INGREDIENTS:

- 2 yellow medium-sized turmerics
- 2 white medium-sized turmerics (or use all yellow turmeric if white is not available)
- 1 tablespoon grated ginger
- 2 green chilis
- ½ teaspoon salt (to taste)
- ½ of a medium lemon (to taste), juiced
- 1 teaspoon oil

DIRECTIONS:

Peel the turmeric and ginger. Wash and add all the ingredients to a small blender. Blend until coarse. Or you can grate turmeric, chili and ginger with a fine grater. Add the rest of the ingredients and let it marinate for a few hours or days before serving as a condiment.

Can be store up to a few weeks in the refrigerator. So, make a large batch, and eat daily!

Beverages

Chai

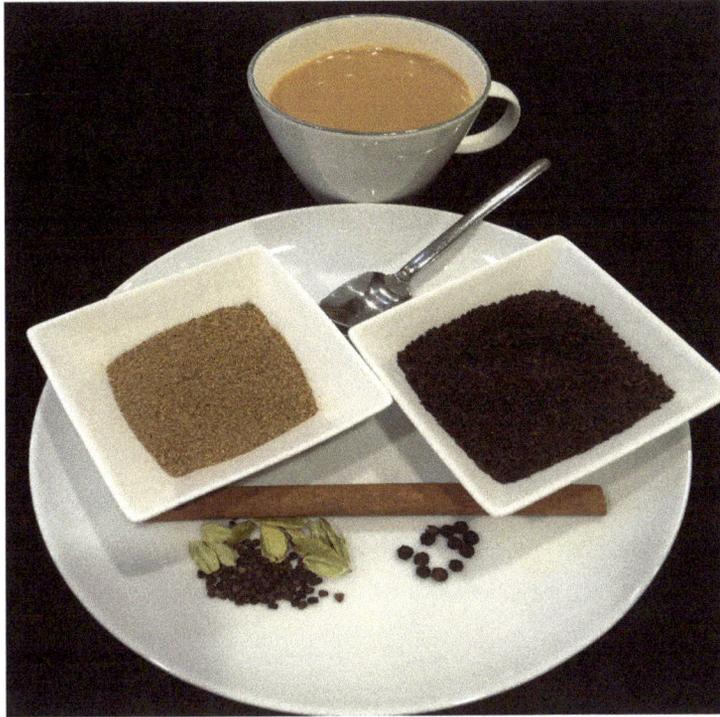

Chai is the ultimate drink of India. It has a deep cultural history and is famous world-wide. Drinking chai is a part of daily life in India and has gained huge popularity in the West. Indian grocers carry a large variety of mumri chai teas and masalas. It is made with milk, chai spice (masala), and black tea, and is sweet with a robust taste.

Chai is prepared in a variety of ways – some like it with half milk; other variations use less milk and more water. You can add a kick to your chai by grating in fresh ginger, adding cardamom and cinnamon powder, or trying different variations like lemon grass or mint.

SERVES 2

Prep and cook time: 10 minutes

CHAI #1 – HALF MILK, HALF WATER

- 1½ cups water
- 1 cup milk, whole milk or your preference
- 2 teaspoons black loose tea
- 2 teaspoons sugar or sweetener (to taste, or optional)
- Grated fresh ginger, ½ teaspoon chai masala, or both

CHAI #2 – LESS MILK

- 2½ cups cold water
- 1½ teaspoon loose tea leaves (an Indian brand if possible)
- 1 teaspoon or more sugar-or sweeter (optional)
- ¼ cup whole milk (your choice)
- 1 teaspoon grated fresh ginger, or tea masala (recipe in my book)

DIRECTIONS:

Using a 1-quart pan, add water and loose tea and bring to boil. Lower the temperature and simmer for 3 minutes. Add milk, spice, and sugar. Bring to boil and then lower to simmer for about 3–4 minutes until a nice golden color. Strain into a teapot or cups and serve.

Enjoy!

Note: you can add more milk and less water if you desire; the more milk you use, the more tea leaves you need to make it stronger.

Chai Masala

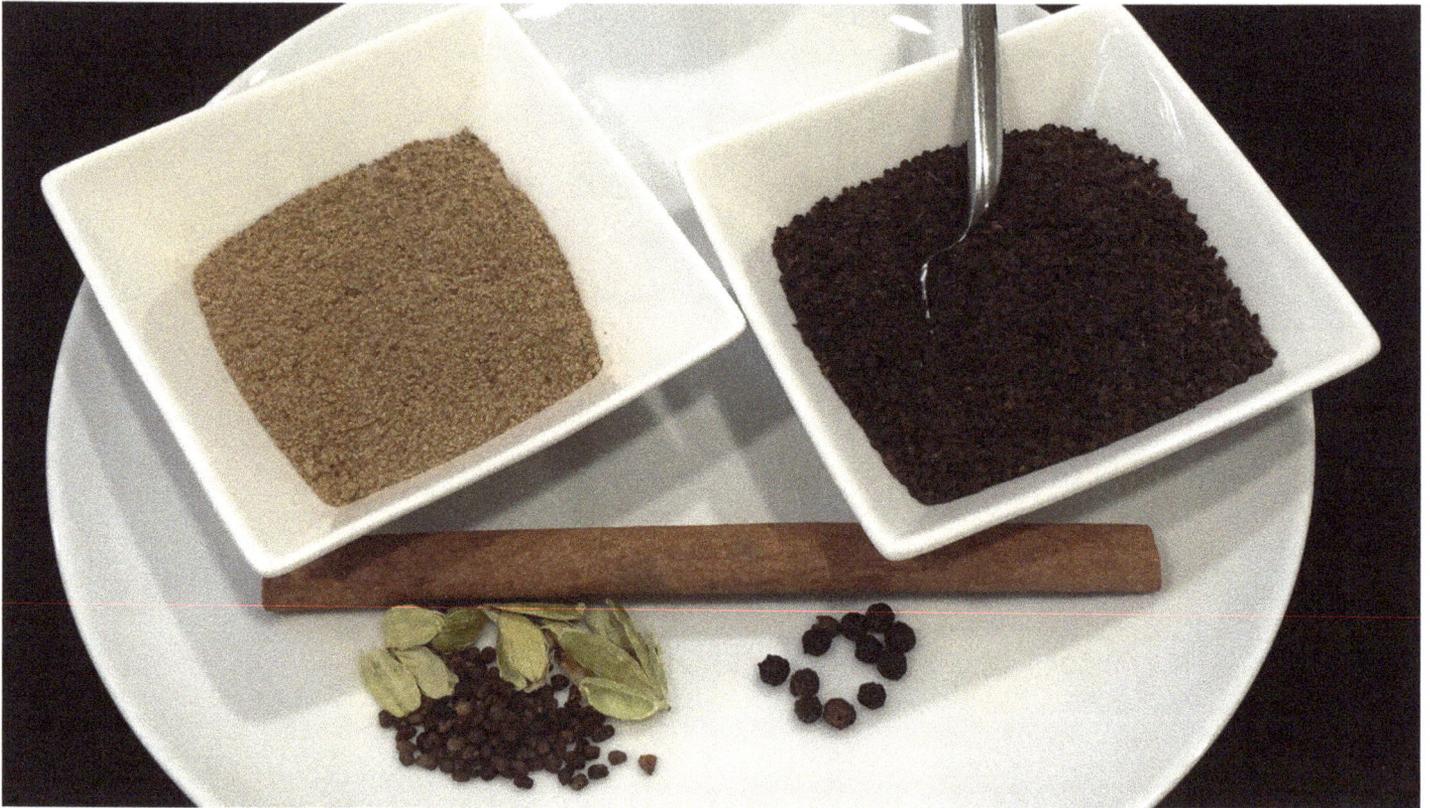

Chai masala. Add this to your morning or anytime tea and you will not drink tea without it again.

Grind your own in a coffee grinder, or buy already ground-up spices and mix it all together. Store in the refrigerator to keep the freshness. Keep some chai masala near your tea box.

GRIND OR MIX TOGETHER THE FOLLOWING ITEMS:

- 1 cup cardamom powder
- ¼ cup black pepper powder
- ¼ cup white pepper powder
- ¼ cup cinnamon powder
- ⅛ cup ginger powder

Mango Lassi

Mango lassi, salty or sweet – for generations this has been the drink or smoothie of India.

A chilled, cool, creamy tropical mango yogurt drink that is very popular and served everywhere in India and restaurants worldwide. Drink it with a meal, or just because it is the best drink to have on a very hot summer day. Serve it at your next party! Made with fresh or frozen mangos or canned alphonso pulp found in your local grocer.

SERVES 3–4

Prep time: 10–15 minutes

HOW TO CUT A FRESH MANGO:

Mangos have a very large, hard pit in the center, so you can't slice it down the middle. It is like an avocado. Peel the mango, place it on its side, and slice off the sides as close to the pit as possible (it will be slippery). Now you will have two large slices and some pulp left on the pit. Cut into cubes and cut as much of the rest off the pit as possible to get all the meaty pulp from it. Or make it fast and simple: use frozen or canned alphonso mango pulp. If using frozen or canned mango, omit the sugar from the recipe.

INGREDIENTS:

- 2 cups mango cubes or mango pulp, canned or frozen
- 1 cup plain yogurt
- Milk (½ cup or more for thinner lassi)
- 3 tablespoons sugar (optional; if using canned pulp taste before adding sugar)
- ¼ teaspoon cardamom powder (optional)
- A few strands of saffron (optional)

DIRECTIONS:

Using a blender or hand blender, blend yogurt and mango cubes together until smooth. Add milk and sugar, blend for a few seconds. Add cardamom powder. Pour into glasses and serve. Garnish as desired.

Rose Syrup Falooda

Pink and pretty in color, cool and sweet in taste, what a great drink to indulge in in the heat!
Is it a beverage or a dessert? It can be both. A little heavy, but still a drink,
it has a rose flavor with crunchy seeds with gel-like noodles.

The origins of falooda go back to ancient Persia, where a similar dessert, "faloodeh," was popular. This beverage came to India a century ago during the Mughal Empire and became a very popular drink to beat the heat.

Falooda sev is a vermicelli made from arrow root or cornstarch, called agar.

SERVES 5-6

Prep time: 45 minutes

INGREDIENTS:

- 2 cups falooda sev or rice noodles (make as directed on package; cut into small pieces)
- 2 tablespoons tukmaria, also known as sabja basil seeds (soak in warm water for ½ hour or more)
- 4 glasses of regular milk
- 3 cups softened vanilla ice cream
- ¾–1 cup rose syrup (to taste)

Garnish ideas: whipping cream or ice cream, chopped pistachio, almonds, rose petals

DIRECTIONS:

Add tukmaria in a bowl. Add warm water to cover the seeds only. Let it soak for at least ½ hour; they will turn translucent. There should not be any black spots on the seeds.

Take your falooda sev and make as directed on package.

Add falooda sev and tukmaria seeds in a large bowl. Add ice cream and milk; stir in the rose syrup. Taste and add more rose syrup if desired. Chill and serve with some ice in a tall glass.

Garnish!

Masala Chaas - Spicy Lassi

This is a chaas/lassi you will find in Gujarati homes, made from yogurt. Served with khichari on a very hot summer day in place of kadhi. The taste is different from the regular chaas/lassi. Make it ahead and let it marinate for 1 hour or more to really bring out the flavor of the spices. It is served cold.

SERVES 2-3

Prep time: 10 minutes

INGREDIENTS:

- 1 cup thick plain yogurt
- 1 teaspoon whole cumin
- ½ teaspoon salt
- 1½ cups cold water
- 1 small garlic (optional)
- ½ green chili
- A few sprigs of cilantro

DIRECTIONS:

Add all ingredients into a blender except for the water. Blend together until smooth. Add water. Marinate and serve with your rice dish.

Salty Lassi
Refreshing Yogurt Drink

A yogurt-based, salty, refreshing drink for a hot summer day.

SERVES 3–4

Prep time: 10 minutes

INGREDIENTS:

- 2 cups plain yogurt (use tart yogurt if possible)
- 3 cups cold water
- ½ teaspoon salt (to taste)
- 1½ teaspoons freshly ground cumin
- 8–10 cubes of Ice

In a blender or hand blender, mix all ingredients together, add ice, and serve cold. Garnish with fresh mint leaves and cumin.

To make a sweet lassi, omit the cumin and salt and just add sugar to taste.

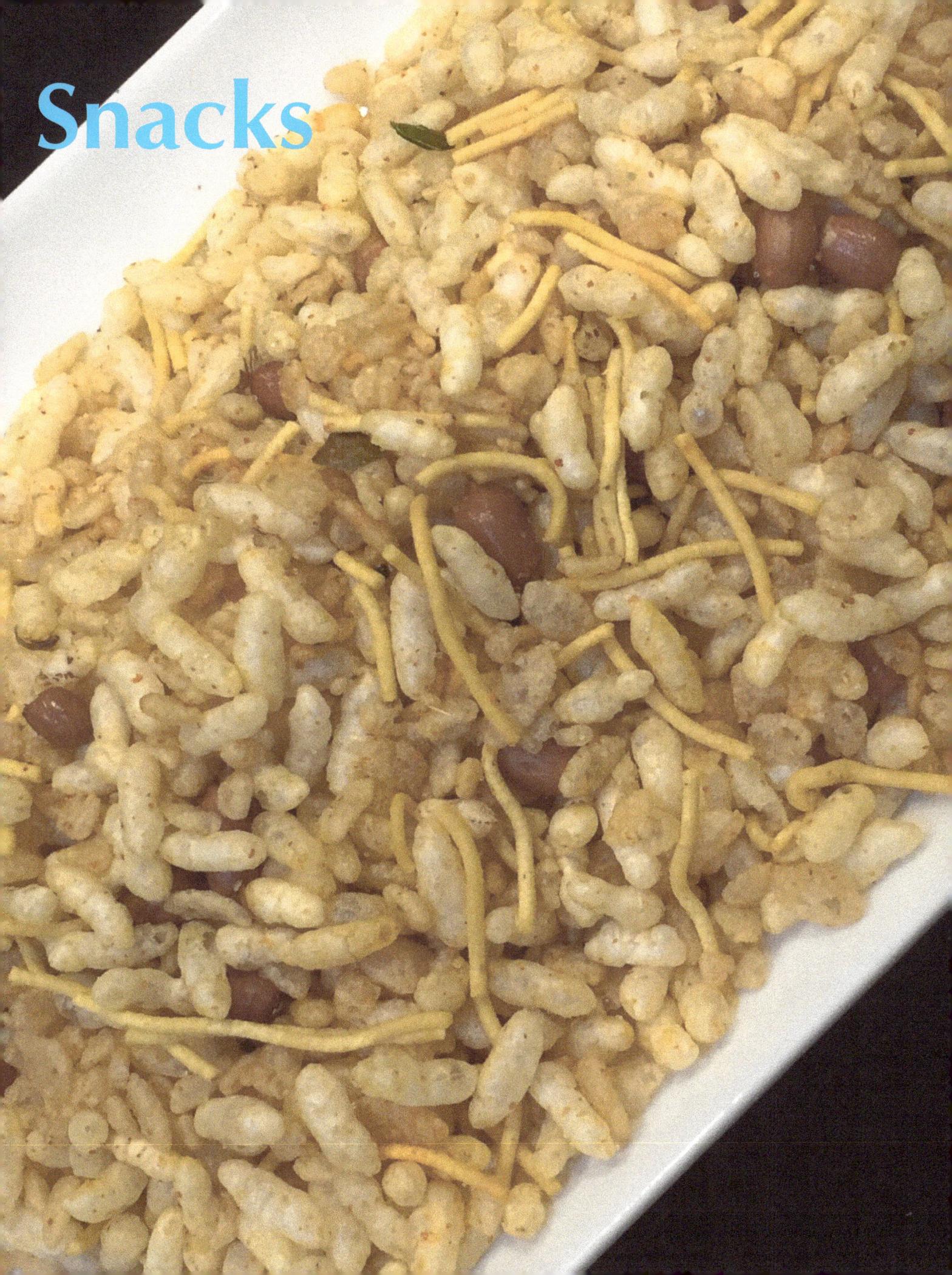

Snacks

Poha Papad
Flat Rice with Papadum

It's a tasty, easy snack to make. A favorite of many. Baked in the oven with roasted pappar.

8-10 SERVING

Prep time: 6-8 hours Cook time: 15 minutes

INGREDIENTS:

- 2 pounds thin nylon puva (Poha)
- 10 pieces plain white chili pappars, roasted
- ⅓ cup sesame seeds
- ⅛ teaspoon turmeric powder (optional)
- 1 teaspoon salt
- 1 teaspoon red chili powder
- ¾ cups oil

DIRECTIONS:

Put your puva in a colander and gently stir them with your hands to remove the tiny particles.

In a large tray or steel bowl, bake in the oven at 180 degrees for 6–8 hours. Mix occasionally. This process is long and important because the puvas have to become very crispy. It is a stress-free process. If it takes longer than 8 hours, do not worry.

Once the puvas are crispy, roast the pappars on the stove: use a screen over the low flame and roast the pappar by turning them over several times. They should not burn.

After all the pappars are roasted, crush them into small pieces. Add them to the crispy puvas. Add salt and chili powder.

Heat oil on medium in a small pot. Add sesame seeds and turmeric powder and roast them to a light red color. Remove from heat and drizzle over the puva mixture. Mix right away, gently, until all the puvas are coated with the oil.

Cool. Store in an airtight container.

Enjoy!

Rice Krispies Chevdo

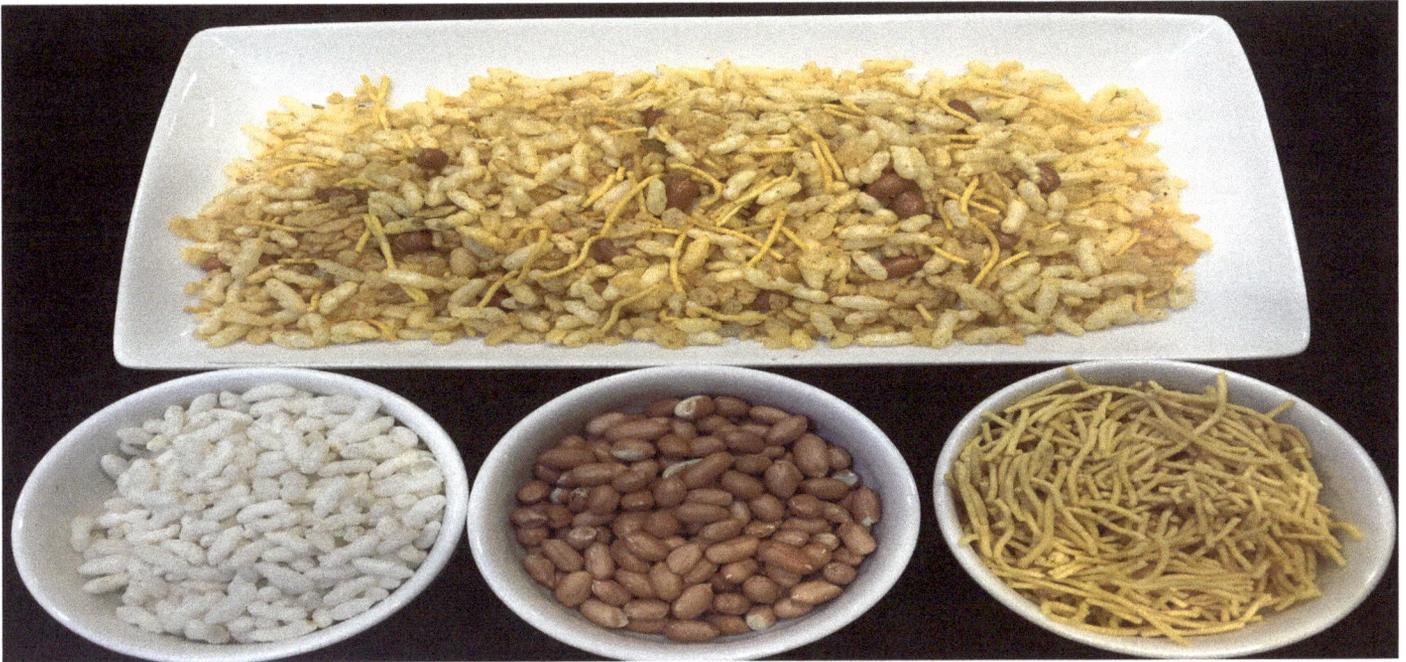

A light anytime snack – morning, afternoon, or in a lunchbox like my grandchildren love to pack. Make it and store it in an airtight container. Enjoy it for weeks. A great on-the-go snack. Add roasted cashews, ghantiyas, or potato fried sticks if you like. Simple is better and healthier.

8-10 SERVING

Prep and cook time: 1 hour

INGREDIENTS:

- 4 cups of Rice Krispies
- 8 cups of Mumra/puffed rice
- 4 cups of homemade or buy spicy medium thickness
- surti sev at indian grocer
- 1 cup raw peanuts
- ½ teaspoon salt or to taste
- 1 teaspoon red chilli powder(to taste)
- ¼ teaspoon sugar (optional)
- 1 teaspoon coriander powder
- ⅛ teaspoon turmeric powder

INGREDIENTS FOR THE VAGHAR:

- ½ cup of oil
- 1-½ teaspoon mustard seeds
- ¼ cup sesame seeds
- 1 tablespoon fennel seeds
- 12 to 15 pieces of curry leaves washed and cut into half pieces

DIRECTIONS:

Preheat oven to 180 degrees and roast the mumra in a large tray or steel bowl to make them crunchy. It will take about 1 hour. Mix them in between. Taste a few pieces; they should be very crunchy. Remove from oven.

Heat oil on medium in a small frying pan. Add peanuts and sauté at low heat until they start splitting – do not over-roast. Drain on a paper towel.

Using a large mixing bowl, stir all ingredients except vaghar together. Using a 1-quart pot, heat oil. Add mustard seeds, let them sputter. Remove from stove and add curry leaves, a few at a time (they will sputter, so be careful).

Return to stove, add fennel seeds and sesame seeds. Roast for a minute and pour this mixture all over the chevro mixture. Using a large spoon, gently mix until all the oil has coated all of the Rice Krispies & mumra mixture. Enjoy!

Flaky Banana Poori's

Another great snack! These pooris are flaky and airy with crispy layers of deep-fried dough. The layers, made from rich flour and ghee, always leave you wanting more! It's a great snack, simple to make for a party and not made with tons of butter.

Prep and cook: 2 hrs, _You will need:_

- Mixer, food processor, or you can make dough by hand
- Rolling Pin
- Deep frying pan or deep, small wok
- Tea strainer (optional) to sprinkle cornstarch with
- Board or counter to roll dough
- Large cookie sheet with a 9x11 edge
- Paper towels

INGREDIENTS:

- 2 cups all-purpose flour
- 6 teaspoons unsalted butter or ghee, softened
- ½ teaspoon baking powder (optional)
- 1 tablespoon finely crushed cumin (jira)
- ½ teaspoon salt
- ⅛ teaspoon turmeric powder
- ½–¾ cup hot water

INGREDIENTS FOR PASTE:

- ¼ cup oil or ghee
- Cornstarch or rice flour to sprinkle
- Oil to fry
- Extra flour
- Pastry brush
- Towel or plate

DIRECTIONS:

Add all main ingredients to mixer or food processor or mix in a bowl by hand.

Add ½ cup water and knead to form a soft, pliable dough (like pizza dough); add extra water by teaspoon to make it soft as needed.

Divide dough into 3 balls and flatten, cover, and let them rest. While the dough is resting, get your items for the paste ready and add about 3 inches of oil in a deep frying pan or small, deep wok.

Take one ball of dough, dust your board or counter with flour, and roll out to an even, thin 14-inch circle. Make sure that the middle of the circle and edges are thin.

Dip a pastry brush in oil and spread it onto the dough. Sprinkle evenly with cornstarch.

Roll into a log, cut into about 18 pieces, take each piece and rest on sides. Press with your finger and then roll out each piece into a 1-inch-wide by 2-inch-long strip in one motion. Place each piece on towel or plate and cover. Repeat until all balls are done.

Heat oven to 170 degrees. Line cookie sheet with 6 layers of paper towels.

Heat your oil on medium and lower to low. You must fry at low to make them flaky so they will cook all the way through. Fry until light and slightly red. As they fry, you will see the layers separate!

Drain on a paper towel and let them cool so you can handle them. Place them on the cookie tray lined with paper towel in rows. Put them in the oven and repeat this process until all pooris are fried.

Leave in oven for 1 hour or more. This is to remove excess oil from the pooris.

Remove from oven, cool, and store in an airtight container.

Enjoy them for a few weeks. To keep them fresher, store them in the refrigerator and take out as needed.

Variations: Omit cumin, add ground cardamom, and sprinkle with powdered sugar.

Tikhi Masala Puri

Small Savory Puri's, A very common snack to be eaten with Indian "Chai" or served commonly in the morning with other items, eaten as a anytime snack, great to pack in lunch boxes or on the road. Stays fresh packed in a container for weeks.

Prep time: 1 hr

Makes 50-60 pieces

INGREDIENTS

- 3 cups of All Purpose flour (maida) or ½ whole wheat and ½ All Purpose flour
- 1-¼ cup fine rava (semolina)
- 2 Tablespoon Chana flour
- ¾ cup Ghee
- 1 Tablespoon cumin powder
- 2 Teaspoon red chili powder (to taste)
- 2 Teaspoon crushed black pepper
- 1-½ Teaspoon salt
- ¾ to 1 cup warm water
- 3 cups of oil for frying.
- small deep wok

The dough can be made by hand (will need kneading) or use an electric mixer.

Combine all the dry ingredients together, mix well, add the ghee and mix, slowly add ¾ cup water and form a stiff dough, add remaining water if needed,if using an electric mixer, remove and knead dough until dough is smooth.

Cover and Let the dough rest for about 10 minutes.

Divide dough into 3 parts,smooth into balls. Take each ball of dough and break them into small pieces, and then take each small piece and smooth them into round flat patties,cover them so they do not dry out.

Take each piece and roll them out into 2 inch circles and using a fork, make holes in three different places on the puri, continue doing this with all the pieces, cover the puri as you work.

Heat oil to 275 -300 degrees. or add a small piece of dough to test the oil, it will start sizzling slowly, your oil is ready.

Fry small batches of 5-6 puri at a time,turning them over several times to get a nice slightly red color, on medium heat, drain on a paper towel.

To remove more oil from them, use a tray lined with 4 layers of paper towel, line up the puri on the tray and place them in the oven at 150 degrees for 30 minutes.

Remove from oven, cool, store them in a tight container lined with paper towel. Enjoy.

Variation: Add crushed ajwan, or omit the red chili powder and add more black pepper, or just make them with salt and cumin powder (double the amount of cumin powder to recipe).

Shakarpara
Sweet Diamond Shaped Treat

A popular easy snack or treat to make. Stays fresh for a long time, a great lunch box treat for the sweet tooth.

SERVES 8

Prep time: 1 hr

INGREDIENTS:

- 2 cups of all purpose or whole wheat flour
- 2 tablespoon sesame seeds (optional)
- 1/8 teaspoon salt
- 4 Tablespoon melted Ghee
- ½ cup milk
- ½ cup sugar
- For Frying:
- 2 cups oil for frying
- a small wok

DIRECTIONS:

Warm milk and sugar, stir until sugar dissolves. Set aside and cool to touch.

In a mixing bowl add flour and mix in ghee, sesame seeds and salt.

Mix in sugar mixture and form a soft dough, the dough will be sticky, let it rest for 5 minutes coved.

Lightly grease hands with ghee, knead until smooth and divide dough into 2 balls.

On a flour dusted board roll out each ball into a 10-11 inch even thickness round circle.

Cut into small diamond shapes pieces, first cut horizontally into 1-inch stipes and then cut in slanted strips, air dry on a paper towel for 10 minutes.

Heat oil in a 10-inch-deep wok heat to about 275 degrees, fry in 4 batches until a light golden color, drain on paper towel, cook, store in an air tight container. Enjoy!

Desserts

Gajjar Halwa - Carrot Halwa

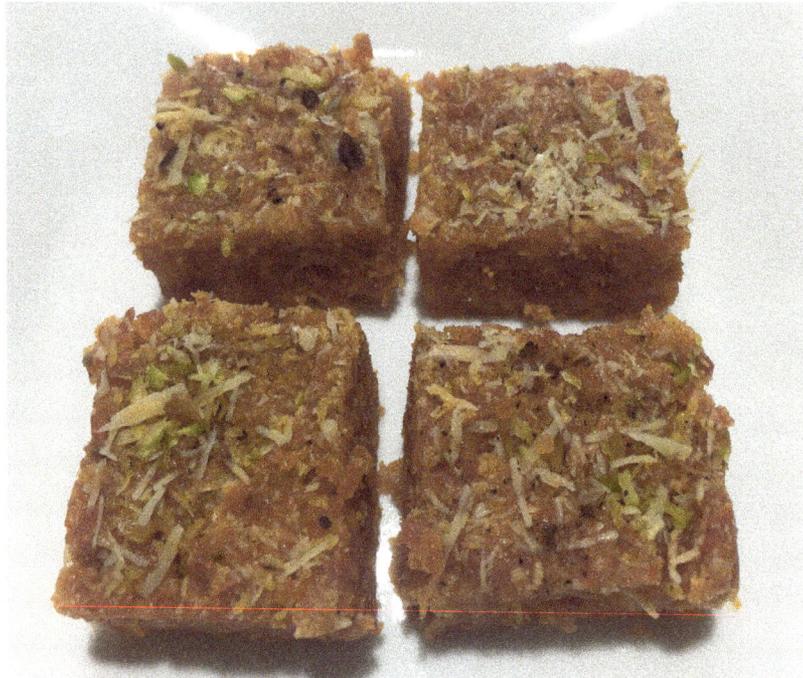

Having a dinner party? A must-serve dessert! Sweet, tasty, easy make-ahead dessert. Make a batch and have a little at a time over days. A favorite of many!

SERVES 5-6

Prep time : 2 hrs

INGREDIENTS:

- 8 cups grated gajjar (carrot)
- 8 cups half-and-half milk or enough to cover the carrots
- 2 cups sugar
- ¼ cup ghee
- 1 teaspoon each crushed cardamom, almond, and pistachio
- A few drops of rose essence

DIRECTIONS:

Wash, peel, and grate carrots with a large-hole grater.

In a nonstick pot or large deep-frying pan, add your grated carrots. At medium heat, stir until carrots start cooking. Cover for a few minutes.

Add milk, stir at a lower heat, and let it simmer. Stir at short intervals and scrape sides of pot. It will take at least 35–45 minutes until all of the milk evaporates. The mixture will become thick.

Add sugar and cook at low heat, stirring to make sure it doesn't stick or scorch at the bottom of the pan.

The mixture will become thick and a little solid. Add ghee, mix, and let it cook for about 1 minute, then remove from heat and let it cool. Add rose essence and half of the rest of the spices, then mix.

Store in a covered bowl and serve warm, or if you want to make square pieces for a party, press it down in a tray. Garnish with the rest of the cardamom, almond, and pistachio.

To serve cold, refrigerate for a few hours or overnight. Cut into squares of your desired size and serve cold.

Stores up to 1 week in the refrigerator, or you can freeze for a longer period.

You can serve this with ice cream on the side.

Dudhi Halwa

Dudhi halwa is a north Indian sweet dish prepared from grated dudhi (bottle gourd), cooked with sugar, ghee, and spices like cardamom. A delicious dessert that can be served warm in small bowls, or spread into a pan, cooled, and cut into small squares to be served cold. A great make-ahead dessert!

If making your own homemade mawa, as shown below, first make the mawa, then prepare the dudhi.

SERVES 6–8 OR MORE IF SERVED WITH ANOTHER DESSERT

Prep and cook time: 1 hour (10–15 minutes for homemade mawa)

YOU WILL NEED:
- 4-quart nonstick pan
- Cheesecloth
- Colander
- 9×11 tray

INGREDIENTS FOR HALWA:
- 12 cups or 4 pounds of peeled, grated dudhi squash and sweeze out the water (bottle gourd)
- 2½ cups sugar or more to taste
- 4 tablespoons ghee
- 2 teaspoons ground cardamom
- 3 tablespoons sliced pistachios, sliced almonds, and ground cardamom, mixed together (for garnish)
- 3 cups of mawa (homemade or store-bought; in brick form, known as khoya, at your Indian grocer, it must be shredded)
- 2–3 drops of green food coloring (optional)

INGREDIENTS FOR MAWA:
½ gallon half-and-half milk (do not use fat-free or 2% milk – if using whole milk, the yield will be smaller)

5 tablespoons fresh lemon juice (if bottled lemon juice, you may need a little more)

DIRECTIONS FOR MAWA:

Place colander in a bowl to catch water and line with cheesecloth.

In your nonstick pot, bring milk to boil and lower to simmer, making sure you attend to it at all times (otherwise it will boil over).

Add lemon juice, stir gently. The milk will start curdling, and the water that is left will be clear-yellowish in color – it should not be white. This will take about 4–5 minutes. Remove from stove, and empty into the cheesecloth-lined colander.

Wrap the cheesecloth around the mawa and put a heavy weight on top, or once it has cooled, squeeze out the excess water, and break up the mawa (curdled milk) into small pieces using your hands or a smacker. Make it as smooth as you can.

DIRECTIONS FOR HALWA:

Wash and use the same nonstick pot. Add dudhi and cook until dudhi heats up. Stir, then lower to medium heat, gently stirring until all the water has evaporated. It will take about 15–20 minutes. Keep stirring and mixing it; you don't want it to scorch or burn. The dudhi mix will start looking translucent.

Add your homemade or store-bought mawa to the dudhi. Mix together, breaking up any big pieces of mawa if any. Cook for about 10 minutes.

Add food coloring, ghee, and sugar. Cook the mixture until it is a semi solid. There should be no water from the sugar; it should be well incorporated. This will take about 20 minutes. Once it cools the green color will get darker.

Remove from stove and fold in ground cardamom.

Grease the 9x11 tray with ghee, spread the mixture evenly in the tray, and garnish with the pistachio mixture. Press down lightly so the pistachio mix sticks to the halwa.

Let it cool and serve warm, or store in the refrigerator and serve cold – it tastes better if marinated for a day. Keeps fresh for up to 2 weeks.

Cut into pieces, square or triangle shapes and serve.

Shrikhand

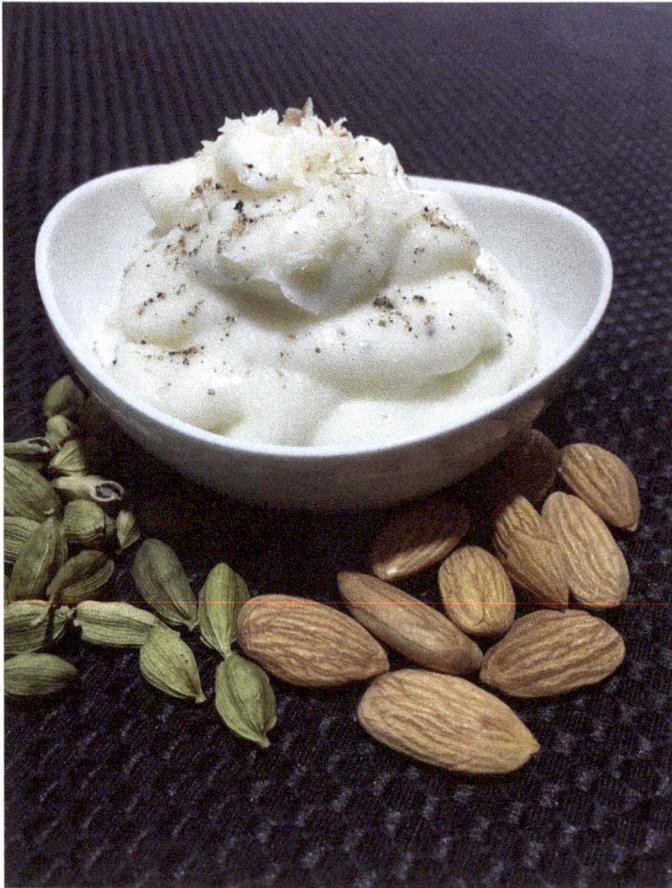

- Cheesecloth
- Lots of newspapers
- Paper towel
- A heavy weight (use weights or food can)

Shrikhand is a popular homemade Gujarati dessert that is made from yogurt. Invented way before flavored yogurt, it is one of the most popular festive sweets. In Gujarat, it is served as part of the main meal. Shrikhand can be served with roti or poori. Shrikhand can be made in different flavors, like mango or kesar (saffron). Add diced fresh fruit to the shrikhand or just follow the original recipe below.

Before you make this recipe, buy the yogurt a day or two ahead, and leave it out for a day to make it slightly tart. Shrikhand tastes good when it is slightly tart and sweet. Another great make-ahead dessert

SERVES 10–12

Prep time: 7–8 hours

INGREDIENTS:

- 4 pounds plain regular yogurt or 5 pounds homemade yogurt from regular milk
- ½ pound regular sour cream
- 1½ pounds regular sugar or powdered sugar (to taste – if your yogurt is very tart, you will need more sugar)
- Cardamom

DIRECTIONS:

First, we start with a colander lined with a cheesecloth. Empty in your store-bought plain yogurt or homemade yogurt. Add sour cream, tie it into a ball, and put the colander on top of a bowl to catch the water. Place a heavy weight on top to speed the draining process. Let this drain for about 1 hour or more.

Now take newspapers and pile them on a counter about 15–20 pages high. Place a paper towel on top to cover newspapers. Take the yogurt tied in cheesecloth and place in the middle of the newspaper pile.

Open the cheesecloth and spread the yogurt gently with a spatula over the full length and width of the newspapers. Leave it like that for about 1 hour and then check to see if the water has gone through to the bottom layer of the newspaper.

Once all the papers are wet, remove them and do a second pile. Repeat this process about 3–4 times. You will see that the yogurt spread is getting thicker, heavier, and dryer.

You will know when the yogurt is thick enough if it peels off the cheesecloth when you lift it and it just rolls. It will have a semi-cheese texture. This is just what it is like – cream cheese! From 5–6 pounds of yogurt you will end up with about 2½ pounds of yogurt cheese.

Take the yogurt and put it in a large bowl. Now you are going to fold in the sugar. After adding the sugar, the yogurt will release some water, which is normal. Using a whisk or a mixer, blend or whip it until it is light and fluffy. Or you can tie a cheesecloth onto a large steel bowl (tied into a knot at the bottom) and rub the yogurt-sugar mixture through the cheesecloth (this is the original way, before blenders).

Refrigerate, covered with a clear wrap.

Serve cold. Before serving, mix in cardamom powder, finely chopped pistachio, and almonds. Serve in small bowls with my thick rava meda pooris or plain pooris. Serve Gujarati style with your meal, or serve it as a dessert.

Shrikhand can be frozen up to 6 months in the freezer; thaw before serving.

Make the different flavors mentioned above and see which one you like the most.

Shiro - Semolina Halwa

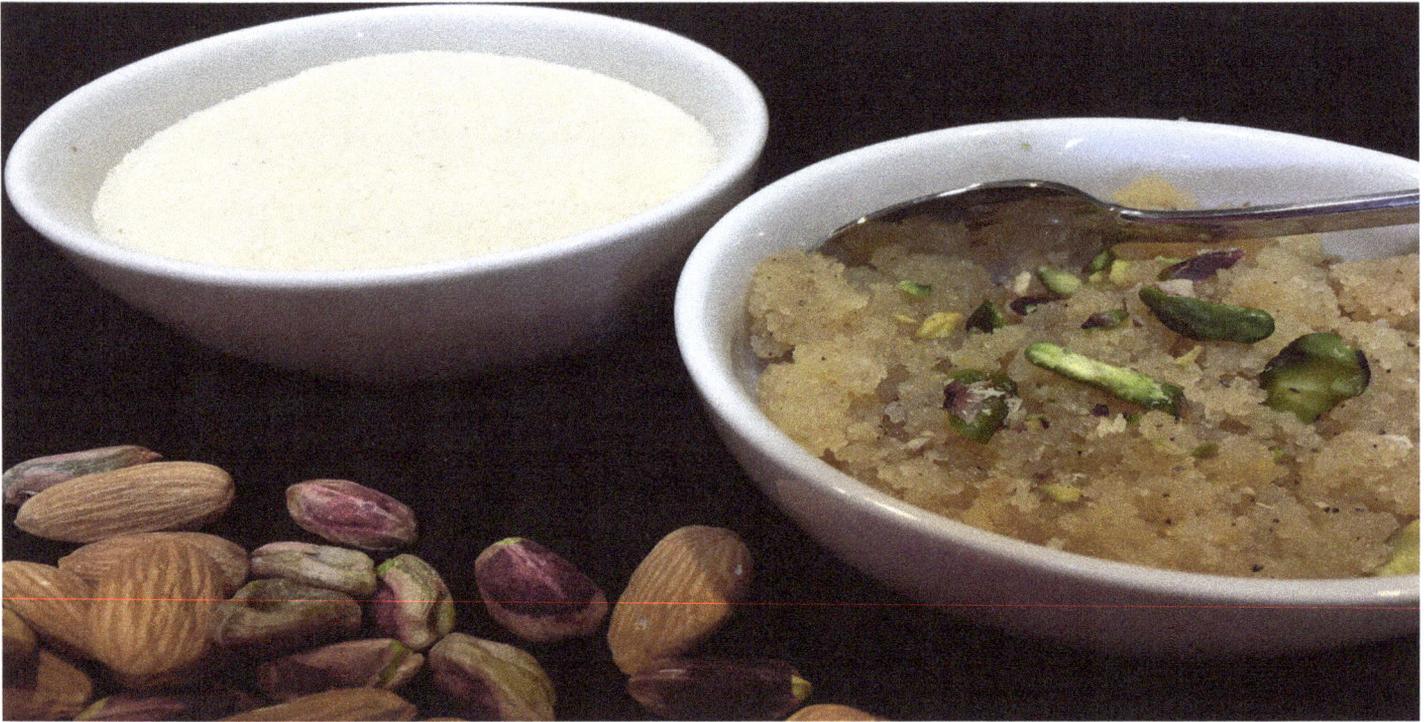

This is another Gujarati sweet, which is mostly made as a prasad (offering) at any festival, but still can be served with Gujarati meals, or just when you want something sweet that is quick to make. Serve with fruit on the side to give it more appeal.

SERVES 6

Prep and cook time: 35 minutes

INGREDIENTS:

- 1 cup coarse rava (semolina)
- 1 cup sugar
- ⅓ cup ghee
- 1½ cups milk plus 1 cup water – mix together
- 8–10 strands of saffron
- 1 teaspoon cardamom powder
- Raisins (optional)

DIRECTIONS:

Add ghee to the pan, let it melt. Add the sooji & rava and sauté at medium to low heat until it turns slightly red (about 15 minutes). You will smell the wonderful aroma as it cooks.

Lower the heat to the lowest position, then slowly pour in the milk-and-water mixture. Mix well; it should be free of lumps.

Cover for about 1 minute, stir again, cover, and then let it cook for another minute. All the milk-and-water mixture will get absorbed. Cover again for 1 minute.

Stir and add in sugar and raisins. Let it cook again until all the sugar water is absorbed. You will see that the ghee is releasing from the mixture.

Remove from stove and keep covered for a few minutes and add the remaining spices. Cover and serve warm. Reheat at low temp or microwave. Garnish with almonds and pistachios.

Lapsi

Sweet, nutty lapsi (cracked wheat) is a favorite of Gujarati desserts. It's a very traditional dish, served at all auspicious celebrations. Lapsi is a roasted medium bulgar cracked wheat, cooked in ghee with spices added. Try to make this recipe a day or a few hours ahead of serving; the spices need to marinate into the lapsi and give it a smooth texture. You have to have bulgar #3 grain to make this dish. Purchase in the Middle Eastern food section of the supermarket or an Indian grocery store.

SERVES 4

Prep time: 1 hour

INGREDIENTS:

- 1 cup medium bulgar wheat – wash several times and air dry on paper towel for about 10–15 minutes, or a day ahead. Washing the wheat will give it a nice light color (optional).
- ½ cup of sugar
- 3–4 almonds, finely chopped
- 3–4 pistachios, finely chopped
- 5–6 raisins
- 3–4 pieces of clove
- 1 teaspoon ground cardamom seeds
- 4–5 small cinnamon sticks
- 10–15 strands saffron
- ¼ cup ghee
- 2½ cups water or more if needed
- ¼ cup milk

DIRECTIONS:

In a nonstick or heavy-gauge 2-quart pot, heat your ghee. Add the cracked wheat and sauté at high heat until the ghee starts bubbling. Lower heat to low and roast cracked wheat for at least 5–8 minutes, until you hear a crisp sound. The color will change slightly, and it will release a wonderful aroma.

Add the cloves, cinnamon, and raisins. Add the water slowly, bring to boil, cover, and lower heat to low.

Cook for at least 15 minutes. The cracked wheat will become fluffy and light, and all the water should be absorbed. Check by taking a piece of it between your fingers and pressing; it should be soft all the way through. If needed, add a few teaspoons of water and continue cooking until soft. The cracked wheat has to be soft before adding the sugar.

Mix in the sugar and saffron and let it simmer for about 15 minutes. Cover and mix occasionally. You will see that the ghee has now separated from the cracked heat. Mix in the milk, almonds, and pistachios.

Turn off heat and let it stand covered until ready to serve, or heat oven to 150 degrees and keep in oven for 2 hours. This will make the lapsi fluffier and will cook any cracked wheat that is slightly undercooked. Reheat and serve warm. Fluff up with a fork. Garnish with more almonds and pistachios.

If serving the next day, cool and store in a cool place or refrigerate. Reheat on low heat and serve warm, with the meal, Gujarati style, or as a dessert.

Note: Cracked wheat can be cooked plain and mixed in salads or eaten like rice with veggies and lentils. A great substitute for rice.

Note: if pressure cooking: whistle, and then do the first 2 steps, then follow the third and fifth after opening pressure cooker.

Kansar
Fine Bulgar Halwa

Another quick dessert, my son's favorite! Want something sweet, quick, and satisfying? This is the dish. Gujartis eat this with their main meal with dal bhaat. Also served on holy festival days. Simple and quick.

SERVES 4

Prep time: 15 minutes

INGREDIENTS:

- 1 cup cracked wheat #1
- 2 cups water
- 3 teaspoons oil
- ½ cup ghee
- ½ cup powdered or regular sugar (to taste)
- ½ teaspoon of ground cardamom

DIRECTIONS:

In a small pan, heat water to boil, add oil. Add the cracked wheat to the water, mix well, and make sure it is not lumpy. Cover and cook on low.

When all the water is absorbed, press a granule between your fingers; it should be soft. Add a little more water if needed. Cook for a few extra minutes until done. Remove from heat and fold in the ghee and sugar and cardamom. Cover and set aside.

Serve warm. Reheat on low.

Sweet Sev Vermicelli

A very quick dessert to serve at a party or to stop your craving for something sweet. A little sweet, nutty, and buttery with a hint of cardamom. You are in heaven!

SERVES 4

Cook time: 15–20 minutes

INGREDIENTS:

- 4 cups vermicelli, broken into small pieces
- $\frac{1}{3}$ cup ghee
- ½ cup sugar
- 2 cups water
- ½–1 teaspoon crushed cardamom seeds
- Dash of saffron (optional)

DIRECTIONS:

In a 3-quart pan or small, deep frying pan, add ghee and let it melt at low heat. Add vermicelli and stir slowly, roasting on low until the vermicelli is an even golden brown, about 5 minutes or so. The vermicelli is crisp but will soften once it cooks.

Add water slowly and mix well. Lower heat to simmer and cover, stirring a few times. Cook until all the water is absorbed and vermicelli is tender (7–8 minutes).

Fold in sugar, stir gently, cover, and cook on low until all the sugar is absorbed (4–5 minutes).

Add cardamom and saffron, then remove from heat, cover, and let it rest for a few minutes before serving. Fluff with a fork before serving warm.

If you make it ahead of time, it will get clumpy when it gets cold; heat on stovetop or microwave.

Serve warm and garnish!

Gulab Jaman

A traditional Indian dessert, spongy milky balls are soaked in saffron & cardamom and scented sugar syrup. No other word but "delicious" can describe them. If made with the recipe below, you will never eat restaurant ones again. Make them fancier by garnishing with a silver leaf foil on top of each serving.

Serves 8-10

Prep and cook time: 1 hour

INGREDIENTS FOR DOUGH:

- 2 cups Carnation milk powder
- 1 cup Bisquick mix
- 3 teaspoons ghee
- ¼ teaspoon baking powder
- ¼ teaspoon cardamom powder
- ¼ teaspoon grated fresh nutmeg
- 1 cup milk (more as needed) half-and-half or regular
- 6 cups of oil to fry

INGREDIENTS FOR SYRUP:

- 5 cups sugar
- 4 cups water
- 8–10 strands of saffron
- 1 teaspoon finely crushed cardamom

DIRECTIONS:

In a 6-quart pot, add sugar and water and bring to a boil. Lower to simmer and simmer for about 5 minutes or until you get to one strand from the mixture. You can test this by dropping some sugar mixture on the counter or plate. Touch the mixture and pull your finger upward slowly and you will see one sticky strand. If you get this, it is done. Let the mixture cool to lukewarm.

Directions for the dough:

Melt ghee. In a medium bowl, mix all the dry ingredients together, add the ghee, and mix well again. Slowly pour in your milk, lightly mixing to make a very soft mixture. Let it rest for a few minutes; the mixture will absorb all the milk and form a soft dough.

Smooth dough by kneading it with ghee-greased hands. Make them into small marble-sized balls (20 pieces) and place them on a dish.

Wash your hands, grease them again, and take each ball again and smooth them into a perfect round shape. Remember, the balls will double in size once they are fried and soaked.

In a deep pan, add oil halfway and heat to warm, not hot. Add a few balls to the pan and fry them at medium to low heat. If they don't come up, try to move them around constantly unti l golden brown all the way around. They will become bigger in size as you fry them.

Drain and cool the balls for at least 10 minutes on a paper towel. Conti nue frying the rest of them.

Add them to the warm sugar syrup. You will think that you have a lot of syrup but the balls will absorb it. You may have to make more syrup. You have to keep the syrup on low and warm all the time.

Set your oven to 150 Degrees. Put them in the warm oven for 1 hour. Check the gulab jaman balls to see if they have absorbed the syrup all the way through. Check by splitting one ball in half; if any part of the center looks white, that means that they are not soaked all the way through. If you have enough syrup, then reheat with the gulab jaman on the stove. Serve warm or chilled.

Ghoogara
Sweet Semolina filled Turnover

A sweet dessert, a favorite during diwali. It's easy, but you will need time to make this special dessert that can be stored for weeks. A special treat for the holidays!

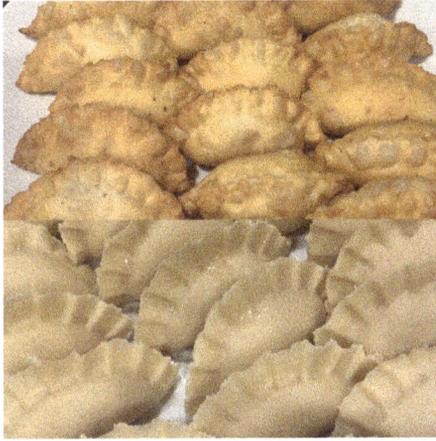

Yield: 50–60 pieces

Prep and cook time: 2 hours

YOU WILL NEED:

Dumpling press, small size, available in many stores

Deep frying pan and 4 cups of oil to fry

INGREDIENTS FOR FILLING:

- 2 cups semolina or small rava
- 1 cup chana flour
- ½ cup ghee
- ¼ cup dry, unsweetened shredded coconut
- 1 cup regular sugar or powdered sugar
- 6–7 almonds, crushed or finely cut
- 8–9 fresh unsalted pistachios, crushed or finely diced
- 1 tablespoon ground cardamom seeds
- ½ nutmeg, grated

INGREDIENTS FOR DOUGH:

- 3 cups all-purpose flour
- ¾ cup ghee
- ¾ to 1 cup warm water (as needed)

DIRECTIONS:

In a medium-sized frying pan, add ghee and melt at medium heat. Add rava and roast for at least 5–7 minutes at low heat.

Stir in chana flour. Continue roasting until the mixture turns a light orange color (10 minutes). You will know when the mixture is thoroughly cooked from the wonderful aroma.

Remove from heat and add almond, pistachio, cardamom, coconut, and nutmeg. Let mixture cool for at least five minutes, then add sugar.

While the mixture is cooling, make your dough: take 3 cups all-purpose flour and add ghee to the flour. Mix together well, then add water slowly as needed to form a nice soft dough. Cover the dough and set aside for ½ hour (or use food processor or mixer).

Check to see if your mixture has cooled down. Once it has cooled, form at least 60–62 nice small balls and then flatten them out. Work with about 10 pieces at a time.

Roll each piece out into an 8-inch circle. Now take one circle and place in into the center of the dumpling press.

Take a spoonful of the mixture, place it in the center, and pack the mixer into the dumpling press.

Spread some water around the edges of the dumpling press, fold the dumpling press over, and this will form your dumpling with the sweet in the center. Open press. Set your ghoogara aside and continue until you have formed all the dumplings. This process may take up to one hour – it just depends on how fast you are!

Now we are ready to fry. Heat the oil on medium heat (oil should not be hot and smoking) and toss a piece of dough in to test if the oil is ready. If the dough gets red right away, then the oil is too hot. Dough should simmer in the oil for at least a minute before turning red.

Add 6–7 of your dumplings. Fry and turn them over constantly until a golden brown. Drain them on a paper towel and repeat until all dumplings are fried.

Let them cool and enjoy them! They can be stored outside at room temperature or refrigerated.

Basudi

Gujarati basudi is a rich and delicious dessert of thickened reduced milk, very similar to rabri. Serve it plain with the spices, or add different fresh fruits to make it more delicious. Basudi tastes better after you let it stand for a day or two, so the essences of cardamom, almond, and pistachio have time to mingle together.

Makes a great make-ahead dessert! Stays fresh for up to 10 days in the refrigerator. Serve warm or cold. (I love it cold!)

SERVES 8

Cook time: 1 hour

YOU WILL NEED:

6-quart nonstick pot

INGREDIENTS:

- 1 gallon half-and-half milk – do not use whipping cream
- 1¼ cups regular sugar
- 2 teaspoons finely ground cardamom
- 4 almonds, ground
- 4 pistachios, ground
- Extra chopped or slivered pistachios and almonds for garnish

DIRECTIONS:

Add milk to the pot and bring to boil. Lower heat, stir, and scrape bottom and sides to make sure it doesn't stick and scorch. Lower heat and stir at intervals, watching the milk at all times. Do not cook milk at high heat; otherwise the color will change to a beige color. You want the basudi to be as white as possible. Continue simmering until the volume of milk is reduced to half.

Once this is done, remove from heat, transfer it to a glass bowl, and let it cool until warm. Mix in the sugar, cardamom, and ground-up almonds and pistachios. Cover and refrigerate until you are ready to serve.

The basudi will thicken as it cools; the thicker the better!

Serve in individual bowls or in a large bowl. Garnish with more pistachios and almonds.

Serve with traditional thick or thin pooris.

Dar na Ladva
Shooji Sweet Treat

Ladvas in Gujarati and ladoos in Hindi, these are easy, fast, and tasty sweets made from semolina and whole wheat fl our, eaten all over India. It is a make ahead dessert, to serve at holy celebrations or at parti es. These ladvas will keep fresh up to a few weeks.

Yield: 25–30
Prep time: 1 hour

INGREDIENTS:

- 1 pound fine whole wheat fl our
- ¾ pound small rava or semolina
- ¾ pound sugar
- ¾ to 1 pound of ghee
- 1 teaspoon fi nely ground cardamom
- 10–15 strands saff ron (opti onal)
- 1 Teaspoon grated nutmeg (opti onal)

DIRECTIONS:

Using a large nonstick pan, melt the ghee and add the rava/semolina. Toast rava at low heat for about 5 minutes, stirring and mixing constantly.

Add in the whole wheat flour, slowly mix, and stir at low heat for at least 20 minutes. Also remember to scrape the sides of the pan to incorporate all the rava and whole wheat with the ghee.

As it cooks it will get fluffier and lighter, and it will have a wonderful aroma as you get to the end. Once it is a light brown, remove from the stove and set aside and let it completely cool.

Take sugar and spices and mix well, like you are whipping it up with your hands; this will take at least 5 minutes or more. (Or use a kitchen mixer at low speed for about 2 minutes.) Add the cooked rava and incorporate it into the sugar mix, and mix on low for about 30 seconds.

Form your ladvas. Take small portions and roll them into small golf-ball-sized balls. Continue doing this until all the dough is finished. Place them on a tray or plate.

Garnish with ground pistachios or almonds. Serve with other desserts or just alone. Enjoy!

Store in airtight container.

Ras Malai

This is an easy recipe to make, a few steps but well worth it. Ras malai is a very popular dessert in India. The original version is made with paneer, but this is a shortcut American version. It consists of sugar, spices, and ricotta cheese. I love to make this when I have guests because I can make it ahead of time, simple and fast. The end result is that it's tasty. Not high in calories. Serve cold.

SERVES 4

Prep time: 1 hour

INGREDIENTS FOR RICOTTA BAKE:

- 16 ounces ricotta cheese
- ¼ cup sugar
- ¼ teaspoon finely crushed cardamom seeds
- Ghee or butter

MILK INGREDIENTS:

- 1 pint half-and-half
- ¼ pint whipping cream

OR

- 1 quart half-and-half (boil, reducing until slightly thick, to 3 cups)
- ¼ cup sugar (to taste)
- ¼ teaspoon finely crushed cardamom
- 2 drops rose essence (optional), a good concentrated brand, or rose water
- Saffron, almond and pistachio to garnish

DIRECTIONS:

Preheat oven to 350 degrees. In a mixing bowl, gently fold sugar and cardamom into ricotta.

Grease a small baking tray or cake pan with light ghee or butter, then evenly spread the ricotta cheese about ½ inch thick.

Bake for 5 minutes, then lower temp to 325 and bake for about 30 minutes. Check that it does not

burn. It should be lightly brown on top. The water will burn off.

While ricotta is baking, get your milk ready. Mix whipping cream and half-and-half milk together. Bring to boil, remove from heat. Mix in the saffron, sugar, and cardamom. Set aside. (If using the reduction method above, add in saffron, sugar, and cardamom now.)

Remove ricotta from the oven and let it cool for at least 10 minutes.

Cut into 1×1 inch square pieces.

To serve in individual cups:

Put 2 pieces in each cup and add enough milk to cover them. Sprinkle a few strands of saffron on top and let it set for 1 hour, adding more milk if needed. Garnish with almond and pistachio.

Or use a large bowl – add milk and the baked ricotta, sprinkle with saffron, and let it soak in for 1 hour at room temperature. Add more milk before serving and garnish with almond and pistachios.

Be very careful when serving to make sure that the ricotta pieces don't break when serving.

Serve Gujarati style with main meal or as a dessert. Make ahead and store in refrigerator for up to 5 days.

www.ingramcontent.com/pod-product-compliance
Lightning Source LLC
Chambersburg PA
CBHW040318100426
42811CB00012B/1473